IMAGES
of America

AROUND
CLEAR LAKE

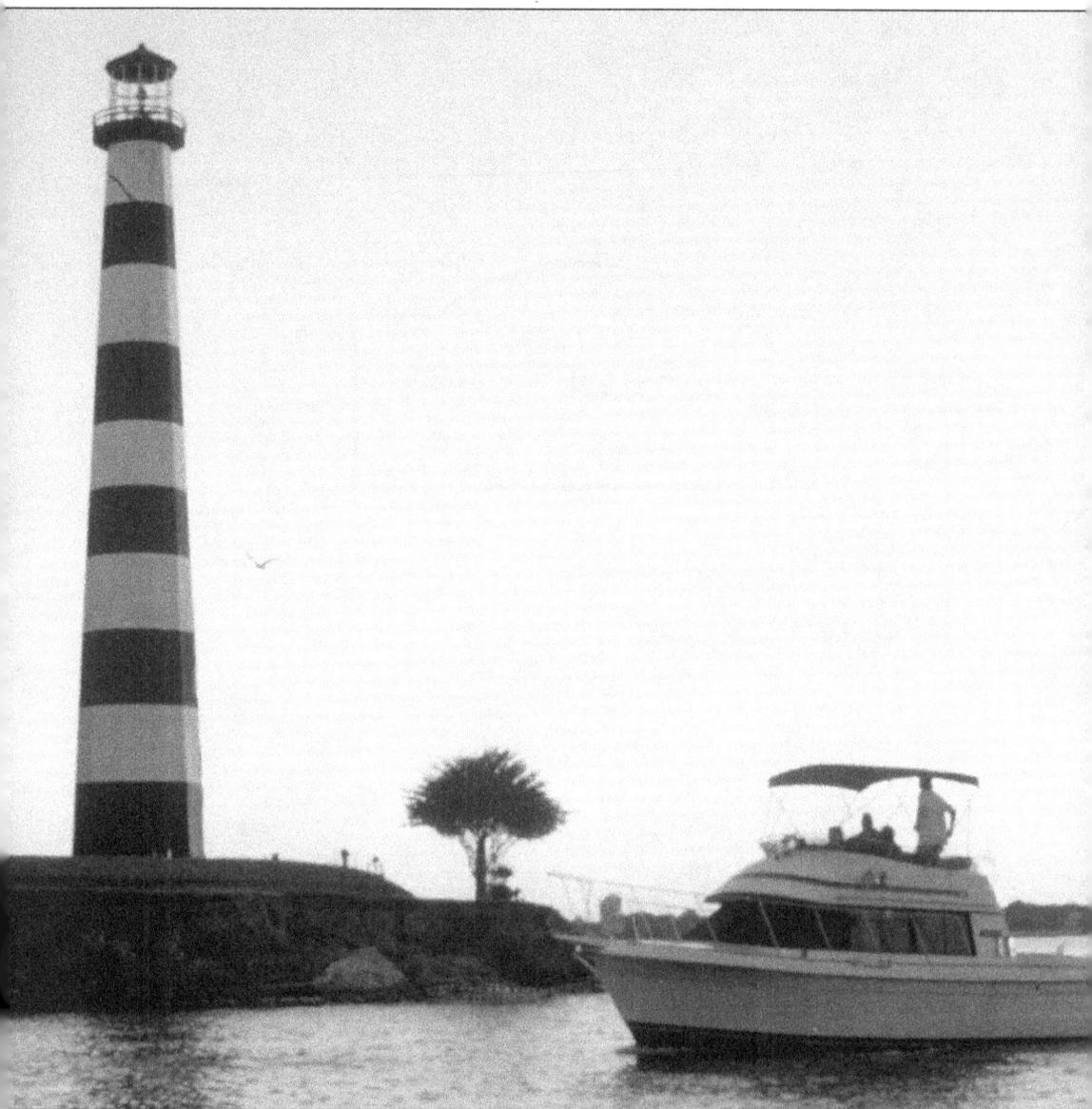

The South Shore Lighthouse is a working lighthouse at the entrance to the South Shore Harbour Marina on Clear Lake. It first stood on the north shore of Clear Lake, across from the Johnson Space Center, in the early 1980s, as the beacon for the Lighthouse, a restaurant and bar built in front of the Ports of Call Mall. The mall was anchored by Sakowitz, a high-end department store from Houston. Robert Sakowitz created a splash with his grand opening for the NASA elite. (Courtesy of Ruth Burke.)

ON THE COVER: This photograph was taken by Mrs. Evan Kerr of Shoreacres. She enjoyed sailing with her husband, Henry, and friends on Galveston Bay in the early 1960s. They would sail through Clear Creek Channel to Red Fish Island, just inside the Intracoastal Waterway. At that time, Red Fish Island was a crescent mound of oyster shells with a beach. Boaters would anchor in the calm waters and paddle in a dingy to the island for a picnic, as seen in the photograph. (Courtesy of Evan Kerr.)

IMAGES
of *America*

AROUND
CLEAR LAKE

Ruth Burke and Rebecca Collins

ARCADIA
PUBLISHING

Published by Arcadia Publishing
Charleston, South Carolina

Library of Congress Control Number: 2013945668

For all general information, please contact Arcadia Publishing:
Telephone 843-853-2070
Fax 843-853-0044
E-mail sales@arcadiapublishing.com
For customer service and orders:
Toll-Free 1-888-313-2665

Visit us on the Internet at www.arcadiapublishing.com

We dedicate this book to the people of the Clear Lake Area, past and present, who shared in the dream of developing earth and space.

CONTENTS

Acknowledgments 6

Introduction 7

1. In the Beginning 11

2. Farming, Ranching, Fishing, and Oil 21

3. Recreation Hot Spot for City Dwellers 43

4. The Space Age and Technology 63

5. Clear Lake City Development 77

6. Clear Lake Events 111

ACKNOWLEDGMENTS

We would like to thank the many individuals, businesses, and organizations that helped in providing photographs and information that became part of this book. We would like to thank the Clear Lake Area Chamber of Commerce, noted as CLACC in the book, for its assistance in locating many of the photographs of the early years of the Clear Lake Area, historical events, and the Johnson Space Center. We thank Webster Presbyterian Church and the Bay Area Museum for their assistance with the photographs of the Japanese rice farmers and early farming communities, which provided an invaluable piece of early history to this book. We thank the League City Helen Hall Library for its diligence in preserving the history of early communities in the area.

We thank Tom Kartrude, director of Armand Bayou Nature Center, for his assistance with providing photographs of Hanson House and giving us a glimpse of Armand Bayou Nature Center history, and Jean West, the nephew of James Malachi Martyn, for sharing early family photographs of Martyn Farm and the early settlement of Middle Bayou. We also thank the Alfred Neumann Library of the University of Houston–Clear Lake for providing historical photographs and information about the beginnings of the Clear Lake Area's prestigious university.

As coauthor, I, Ruth Burke, am honored to share the photographs I have taken chronicling the development of the Clear Lake Area since the 1970s. The energy of expanding horizons in space contrasted with quaint fishing villages and natural coastal environments teeming with magnificent water birds captured my eye. I was unaware that history was unfolding in front of my lens, with sweeping changes in the nine cities that make up the Clear Lake Area. Photographs noted courtesy of Ruth Burke are actual images that I have taken. They can be licensed or obtained from my store the Seaside Gallery or my website, ruthburkeart.com. Photographs noted courtesy of Seaside Gallery are part of the print collection available at the gallery.

Coauthor Rebecca Collins is the owner and editor of the *Bay Area Observer*, a weekly newspaper that features news and current events for the cities around Clear Lake. She has been instrumental in promoting the arts in the area as the president of the Art Consortium of the Texas Gulf Coast, located in and supported by the City of Seabrook. The Art Consortium brings together artists, organizations, and art enthusiasts to advocate, promote, and provide opportunities to create and celebrate the arts for all Texas Gulf Coast residents and visitors.

INTRODUCTION

The same things that brought the original settlers to the shores of Clear Lake and Galveston Bay are still bringing people here: the lure of the open seas, commercial and recreational fishing, an expanding and ever-changing economic climate, and a casual waterfront lifestyle. Step back in time 500 years to 1528, when Cabeza de Vaca and Robert Cavalier were the first white men in the Clear Lake Area. The moon was still an object of superstition, and the Karankawa Indians populated the land. There were nomads roaming from the Coastal Plains to Corpus Christi. They were tough, strong, relatively large people, nut and berry gatherers, hunters, and fishermen who ate anything they could capture, including alligators. Their shell middens were located in Seabrook, around Taylor Lake, and throughout the Clear Lake Area. The shell middens were clearly visible in the Pine Gully area of Seabrook until Hurricane Ike came through in 2008.

While Indians still inhabited the Clear Lake Area in the early 1800s, pirates were also seeking refuge on Galveston Island and in Galveston Bay. The best-known pirate of the bunch was Jean Lafitte, who established a settlement of about 1,000 people on Galveston Island and named it Campeche. Lafitte and his men ran several fully armed vessels, capturing cargo and slave ships. He and his men frequented the Clear Lake territory, and legends of buried treasure along its banks are still told. Taylor Bayou, which feeds into Clear Lake from the north, bears the name of Anson Taylor, a Lafitte pirate who remained in the area until his death. It is well known that Lafitte found the Karankawas a considerable nuisance, referring to them as "demons from hell." By the mid-1800s, the tribe had vanished, leaving behind oyster beds, which were later used to build roads in the area, and small game for the pleasure of contemporary Clear Lake residents and visitors.

After the pirates and the Native Americans came the pioneers. The governments of Coahuila and Texas in Mexico offered choice land grants to those who would settle them. Stephen F. Austin, an American pioneer and the founder of the state of Texas, was the first to make a business of bringing colonists to the part of Texas near Clear Creek. On November 14, 1832, Ritson Morris was granted one league of land from the Mexican government at the site that later became Seabrook, bordered by the north shore of Clear Lake and Galveston Bay to the east and by Taylor Bayou to the north. To the west of Taylor Bayou was the David Harris league. Harris's brothers were John Richard Harris and William P. Harris, the latter of whom is the namesake of Harris County.

In 1836, the Republic of Texas won its independence from Mexico on the banks of the Houston Ship Channel, just a short drive from Clear Lake. By the mid-1850s, a "Yankee peddler" named A.H. Kipp traveled up and down Clear Creek selling goods to the settlers. In 1879, there was a one-boat express line hauling items to be shipped down the creek and along Galveston Bay. In those days, the crystal-clear waters of Clear Lake held bountiful oyster beds, shrimp, redfish, and trout. By 1882, the Bradford and Kipp families subdivided their land on Galveston Bay and the south side of Clear Lake, naming the settlement Kemah, an Indian word meaning "wind in the face."

James Webster brought a group of English colonists to Clear Lake about 1879. They established a settlement named Garden Town not far from what is now the intersection of Bay Area Boulevard and Highway 3. By 1882, the settlement had grown sufficiently to require a post office, which was designated as Websterville, the forerunner of the present city of Webster, located to the west of Clear Lake near the mouth of Clear Creek. In 1903, the Houston Chamber of Commerce invited Seito Saibara, the first Christian member of the Japanese parliament, to come to Webster with his family to study the possibilities of improving rice growing on the Texas coast. The idea was feasible, and he leased land just south of where NASA One and Highway 3 are today. Then, in 1904, Rinei Onishi brought a gift from the Emperor of Japan to Saibara: 300 pounds of *shinriki*, or "God Power," seed rice. This rice could yield 34 barrels per acre, compared to the 18–20 barrels per acre American rice yielded.

John C. League purchased the large parcel of land remaining from the original Spanish land grants in 1890 and set out to develop a town on the south side of the lake. The town, originally named Clear Creek and now named League City, prospered, with several small businesses, churches, and a newspaper. Many Italians settled in the area in the early 1900s, bringing their farming skills and growing vegetables and strawberries. Butler Longhorns were named after the longhorn cattle on the Butler Ranch, in the League City area.

In the late 1890s, the Southern Pacific Railroad built a line connecting Galveston and Houston so that visitors from Houston could enjoy the coastal breezes of Galveston Bay. The line routed to the shores of Seabrook and Kemah, creating the first waterfront development opportunities. Named the Suburban, the line ran twice daily, and prominent Houstonians with names like Dow, Rice, Kirby, and Peden began building homes and estates in the area.

Devastation came to these newly developed areas in a great way with the 1900 storm. The earliest structure of note to be rebuilt, within a year of the storm, was Webster Presbyterian Church, which is now the home of Bay Area Museum. By 1906, the first restaurant on the bay, Seabrook Ridge, had opened to serve fish, oysters, crab, and shrimp. The first drugstore opened in 1905, complete with a soda fountain. There were hotels at Clear Lake and in Seabrook, two saloons selling beer and whiskey, a grocery store, and a post office, making Seabrook a thriving community.

By the 1920s, the Clear Lake Area had settled into farming and cattle ranching, with Kemah and Seabrook focusing on fishing. Then, another element entered the coastal life: gambling. Kemah, the northernmost town in Galveston County, became a mecca for Houstonians bent on gambling, and entertainment flourished in the small coastal town. Gambling was a large part of the economy until the Texas Rangers shut the operations down in the late 1940s and early 1950s.

James Marion West Sr., a self-made millionaire from Houston who made his early fortune in timber and then moved into ranching and oil, bought 30,000 acres north and east of Webster, where he raised cattle. In 1929–1930, he had a sprawling two-story masonry villa, constructed in the Italian Renaissance style and designed by Houston architect Joseph Finger, built on the north shore facing Clear Lake. The West Mansion was easily one of the largest houses in Texas at the time and was remarkable in its design and craftsmanship. In 1990, Stephen Fox, a Houston architectural historian, noted, "The exterior of the . . . villa is superlative, especially the cast concrete classical decoration." In 1980, the Houston Architectural Survey noted of the house's Palm Room, "[the] furniture and fittings were all in the zigzag Modern style, the finest Art Deco interior to be executed in Houston." The mansion boasted six bedrooms, a solarium, a sleeping porch, 12 bathrooms, a mahogany-paneled study, a ballroom, a huge dining room, a music room, a two-story living room, and a private barber's room. It was the crown jewel of the ranch that stretched from what is now Ellington Field to what is now Todville Road in Seabrook.

The West Mansion, a Harris County landmark since its completion in 1930, was a family home for less than a decade. The Wests sold most of their property to Humble Oil in 1939 for $8 million and extensive royalties but kept the mansion and the surrounding land. Humble Oil then developed the surrounding area into the Clear Lake community. In 1956, Humble Oil, which had by then acquired the mansion, donated 21.48 acres to Rice Institute. In 1961, it donated another 1,000 acres for the NASA Manned Spacecraft Center. In March 1962, Rice Institute purchased

another 78 acres from Humble Oil. The mansion continued to be vacant until 1969, when it was remodeled, at a cost of $580,000, to be the Lunar Science Institute, which was renamed the Lunar and Planetary Institute in 1978. The institute occupied the mansion until December 1991. The mansion is currently owned by Hall of Fame Houston Rockets basketball star Hakeem Olajuwon, and its use remains a secret.

At the height of the pre-Depression boom, developers began selling small, 20-foot-by-100-foot lots for weekend houses in an area called Clear Lake Shores, located on the southeast shore of the lake. With the advent of the Depression, the bottom fell out of the land boom, and the *Houston Post Dispatch* then took over selling the lots, offering them for $69.50 each with a six-month subscription to the newspaper.

During World War II, Navy vessels were constructed at the Seabrook shipyard, owned by the Fay family. Just to the north of the Clear Lake Area, Ellington Air Field was a major Air Force training base. After the war, the Clear Lake–Galveston Bay area continued to grow in popularity as a recreation destination, with the economic focus still on agriculture and oil until the early 1960s.

On September 19, 1961, officials of the National Aeronautics and Space Administration (NASA) announced the construction of the NASA Manned Spacecraft Center. Humble Oil and Rice University made the land for the site available at the behest of Vice Pres. Lyndon Johnson to serve Pres. John F. Kennedy's goal of putting a man on the moon by 1970. This goal was achieved on July 20, 1969, when astronaut Neil Armstrong's first words from the lunar surface were spoken to Mission Control at NASA: "Houston, Tranquility Base here. The Eagle has landed." From that point on, as they say, "the sky was the limit."

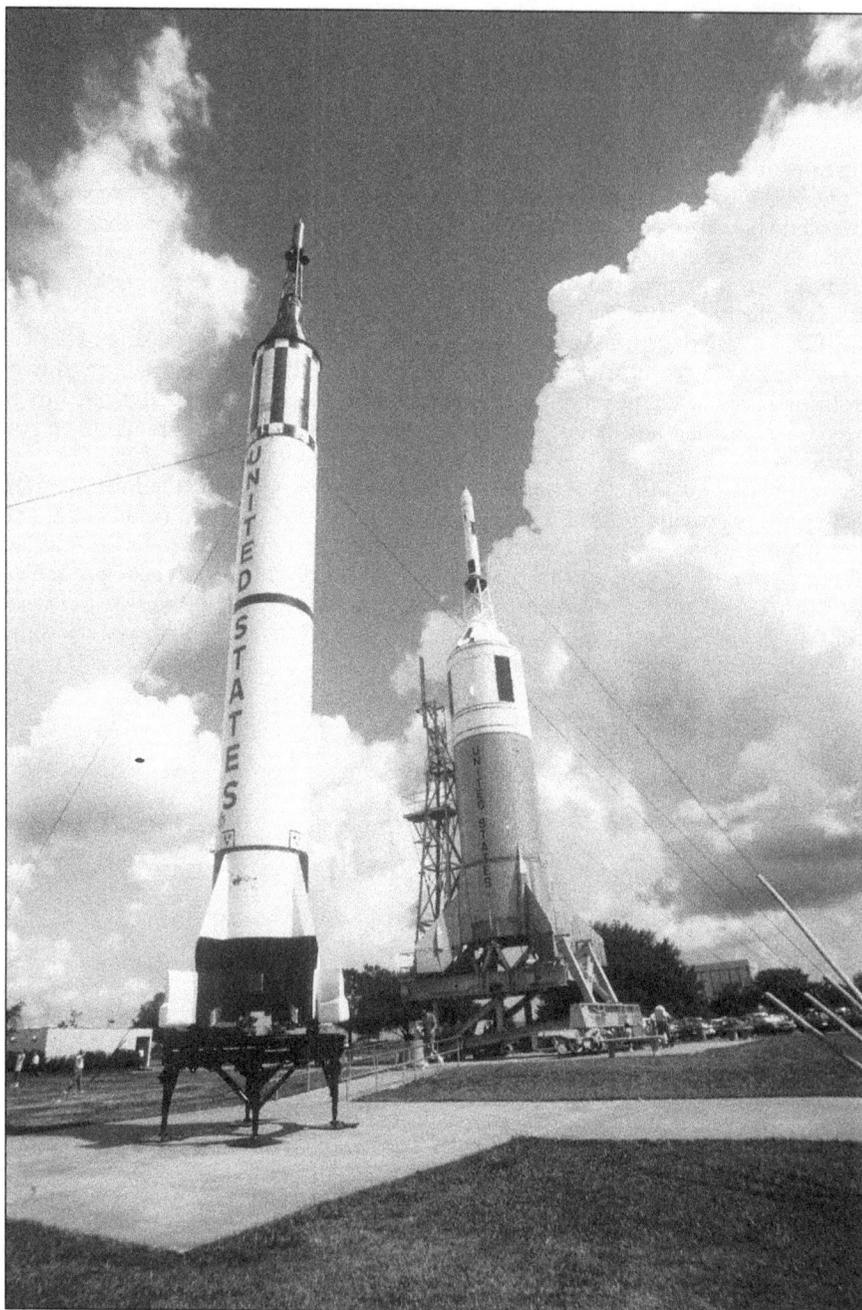

NASA's Johnson Space Center's Rocket Park contains a replica of astronaut Alan Shepard's MR-7, the Mercury-Redstone spacecraft booster (left), and Little Joe II with BP-22 (right). Used for six suborbital Mercury flights in 1960 and 1961 and designed for NASA's Project Mercury, the Mercury-Redstone was the first American manned space booster and launched the first American into space. Little Joe II was used for five unmanned tests of the launch escape system. It was also used to verify the performance of command module parachutes for the Apollo spacecraft. The smallest of four boosters used in the Apollo program, Little Joe II was launched from White Sands Missile Range in New Mexico. (Courtesy of CLACC.)

One

IN THE BEGINNING

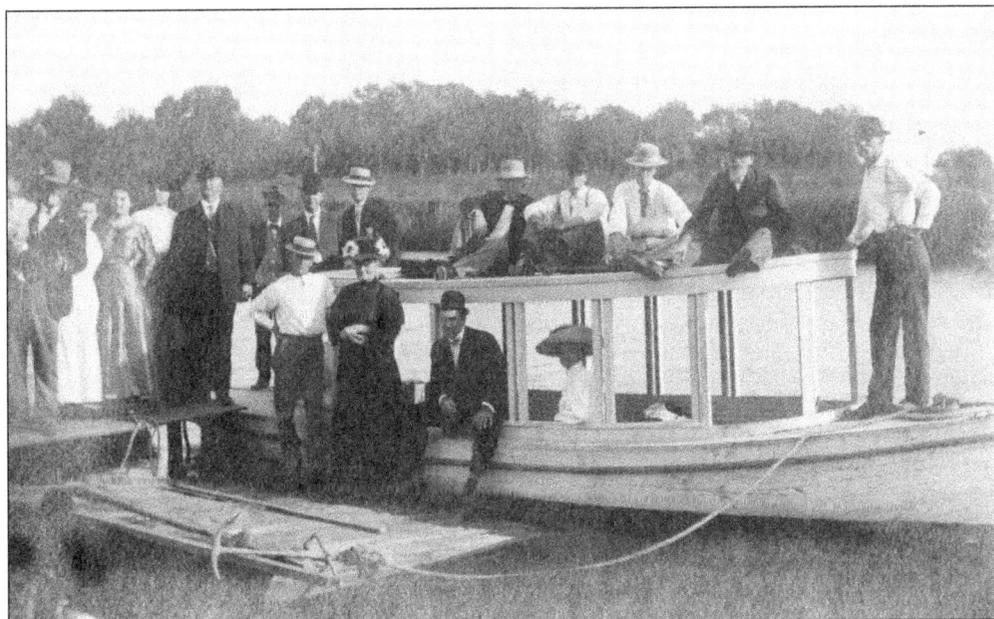

Luke Johnson and his guests are in festive attire as they enjoy a row in Johnson's new boat on Clear Creek in 1911. (Courtesy of League City Helen Hall Library.)

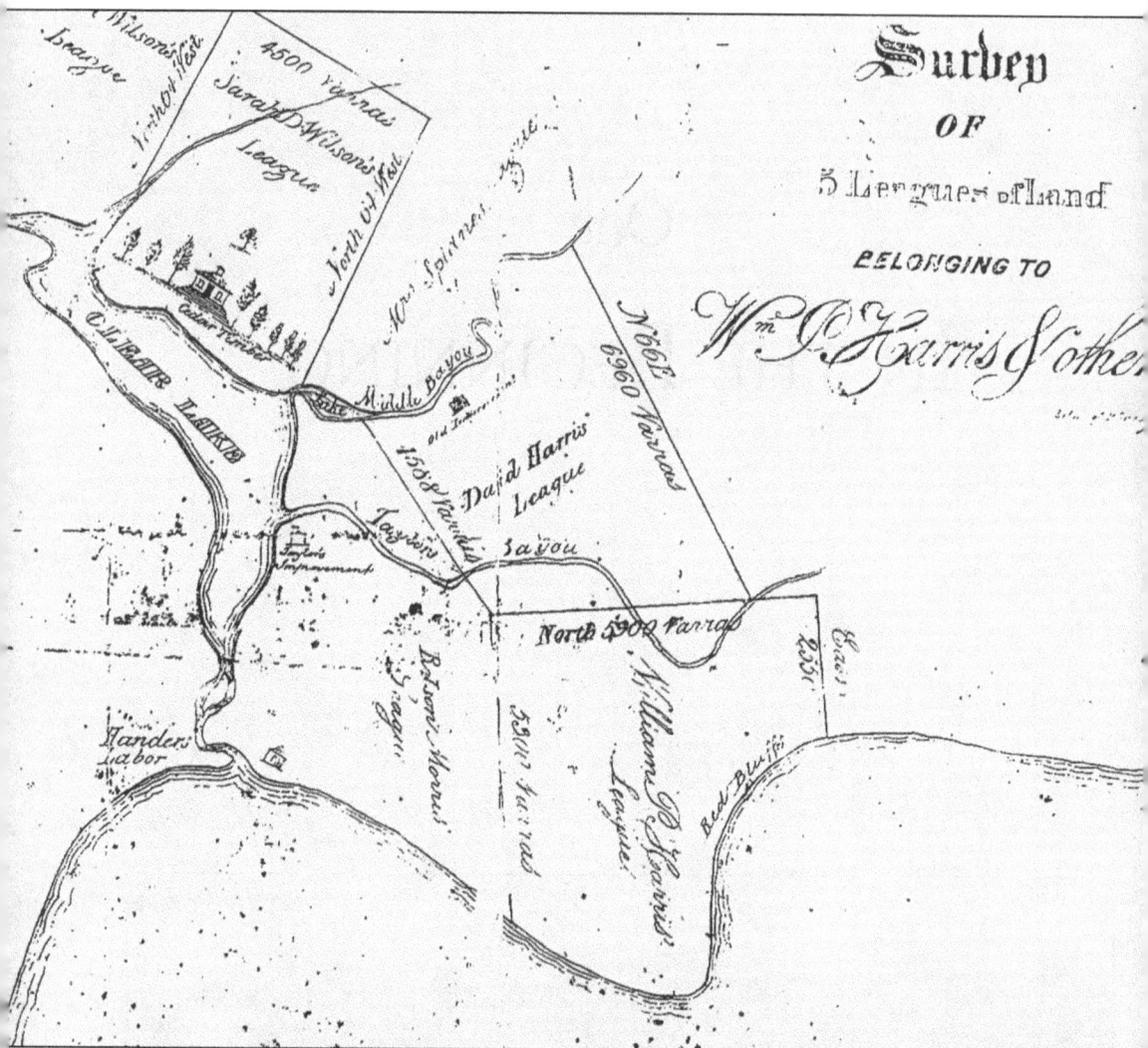

The lay of the land is seen in this early-1800s survey outlining the boundaries of the leagues of land that were part of Stephen F. Austin's Spanish land grant. The owners were early settlers who shaped the future development of the area around Clear Lake. Notable is William P. Harris, the namesake of Harris County and the town of Harrisburg. Ritson Morris was a colorful character who selected his land for the beauty of its shoreline, which included a crescent of bay extending to Red Bluff, which later became known as Morris Cove and is now Seabrook. Flanders Labor, which is in the vicinity of present-day Kemah, is indicated at the mouth of where Clear Lake snakes into Galveston Bay. The area was named after the owner, John Flanders, who was later listed among the dead at the Alamo. (Courtesy of Evelyn Meador Library.)

Human occupation of this area, which was later the site of the Harris County Boys' School, began some 3,500 years ago, around 1500 BC. By this time, the Gulf of Mexico had reached its modern sea level, and the Galveston Bay estuary was in its final phase of development. The estuary became an ideal habitat for oysters and Rangia clams, drawing prehistoric people to its shores. Between about 600 and 950 AD, one area of the site was used as a cemetery, likely by people ancestral to the Akokisa (Orcoquisa) Indians, who were encountered in early historic times in the Galveston Bay area. (Courtesy of Ruth Burke.)

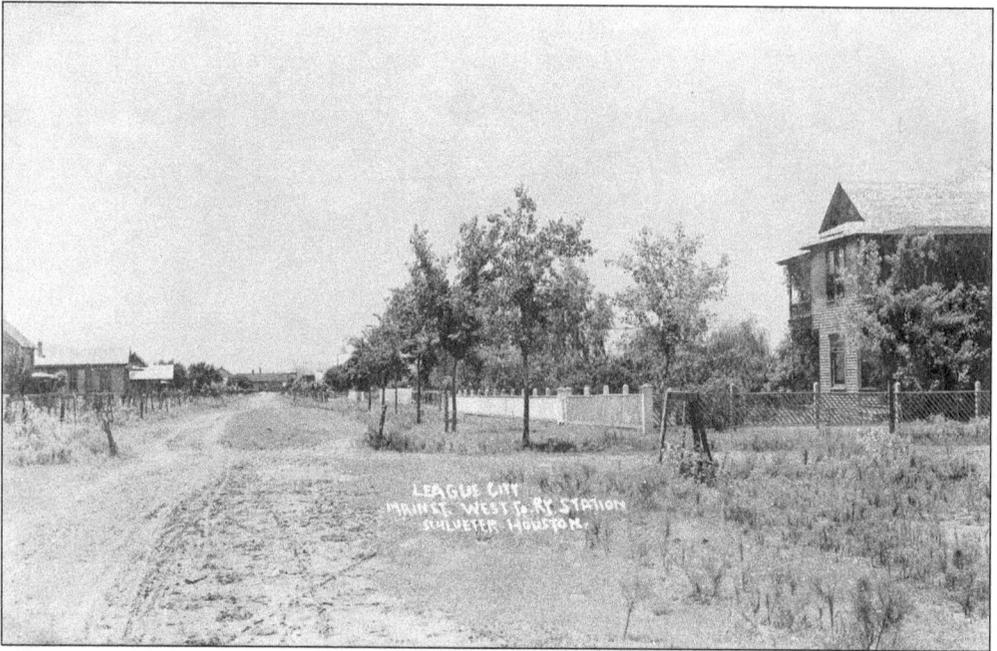

This photograph looks west on Main Street (now Second Street) in League City toward the railroad station in 1901 or 1902. In 1907, John C. League had two railroad flatcars of live oak trees left by the railroad tracks for residents to plant on their property. Many of them line Main Street to this day. (Courtesy of the Caroline D'Etchegoyen Collection, Helen Hall Library Local History Collection.)

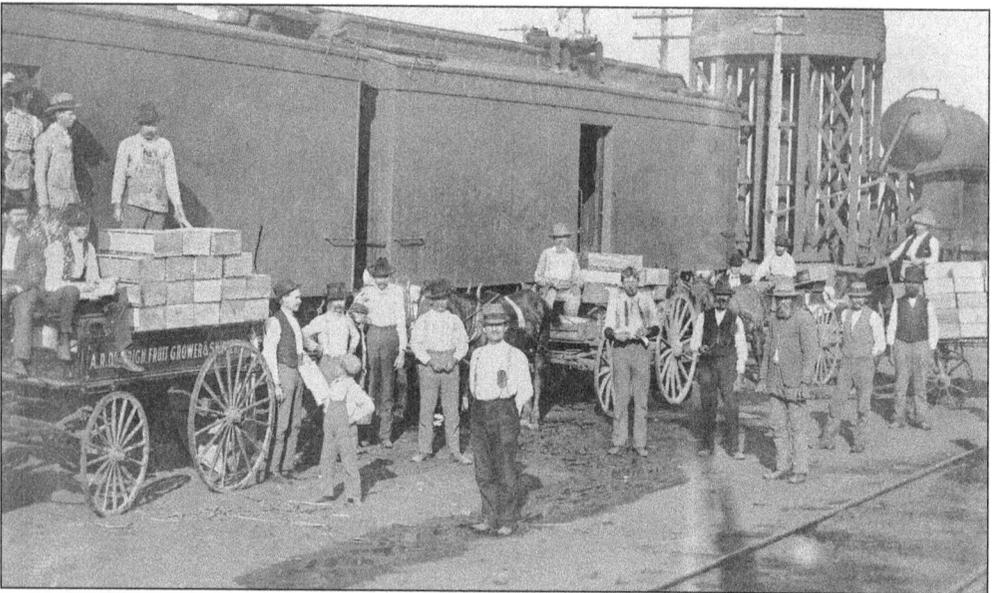

Railroad boxcars are loaded with fruits and vegetables at the railroad station in League City around 1914. Railroads through the town included the Galveston, Houston & Henderson, the International–Great Northern, the Missouri, Kansas & Texas, and the Galveston-Houston Electric Railroad, built in 1911. (Courtesy of the Caroline D'Etchegoyen Collection, Helen Hall Library Local History Collection.)

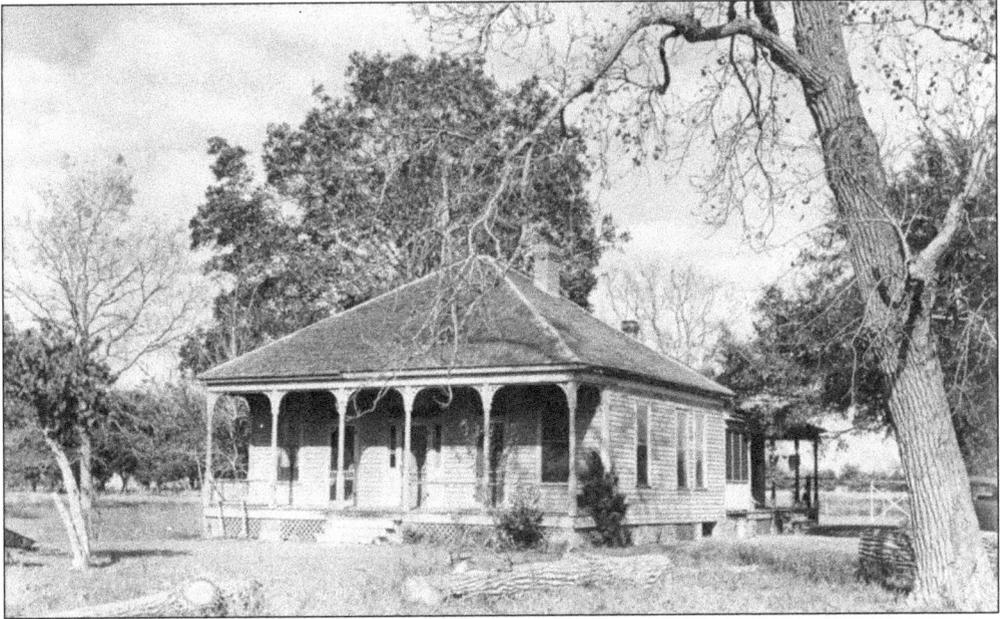

Originally belonging to George Washington Butler, this one-story wooden house features narrow, decorative pillars and a front porch. League City's beautiful live oak trees were first planted in the 1870s, when Butler established his ranch headquarters in town and planted live oak trees around it. (Courtesy of the Caroline D'Etchegoyen Collection, Helen Hall Library Local History Collection.)

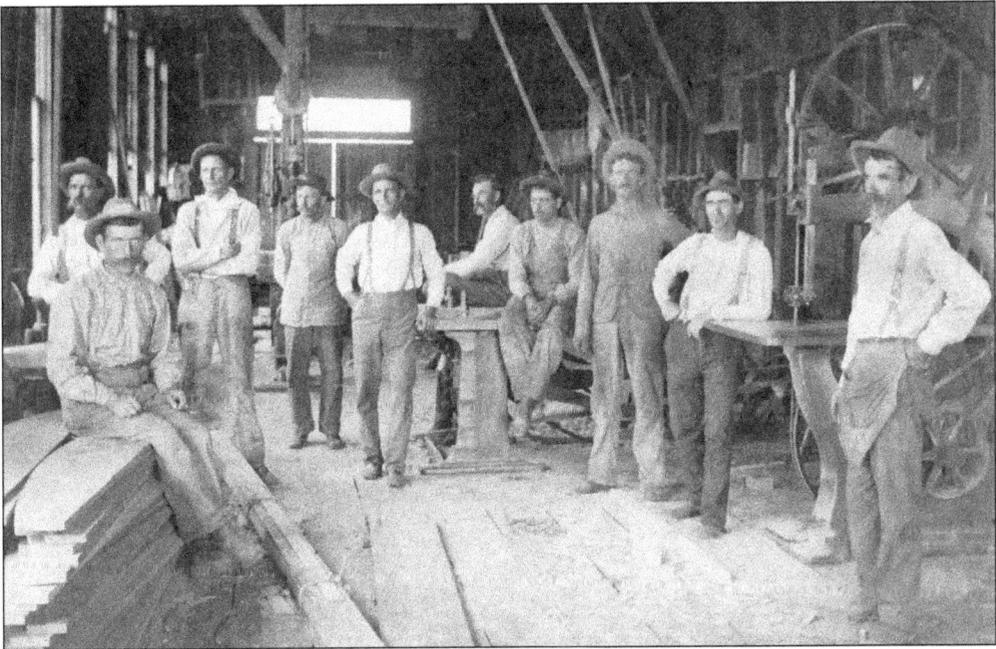

Several workingmen gathered to pose for this photograph inside the League City Railroad Shop in 1918. Among them are, in no particular order, O.V. King, superintendent K.H. Scholes, Perry Johnson, and Percy H. Yoeland. (Photograph by Harry Loraine; courtesy of League City Helen Hall Library.)

15

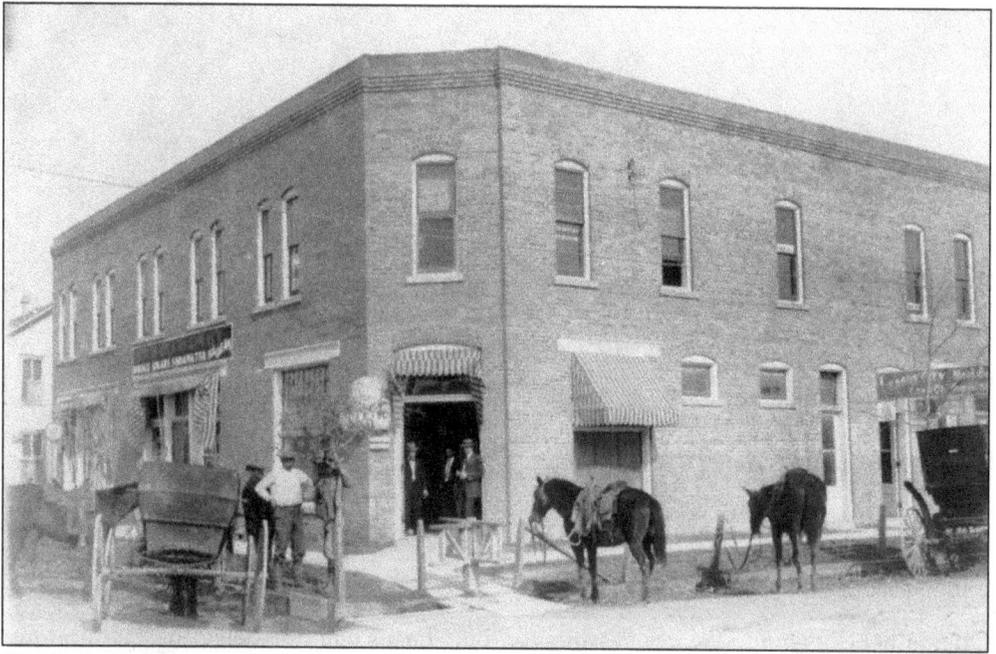

The Butler Building is a historical two-story office building on Second Street, which was originally known as King's Trail. The Citizens State Bank occupied the ground floor. Standing in the doorway with two other men is John P. Atkinson, the cashier of the bank from 1908 to 1917. (Photograph by F.J. Schlueter; courtesy of League City Helen Hall Library.)

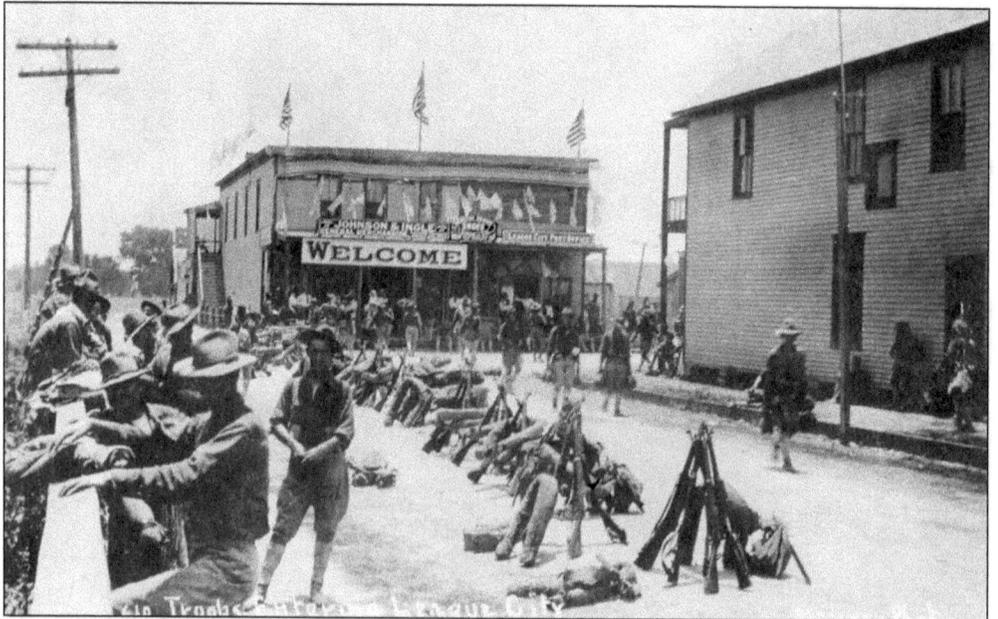

World War I troops entered League City from the city's original thoroughfare between Houston and Galveston. Here, troops are situated on a fence running alongside the road and the railroad tracks, which are not visible. Their arms and weapons are placed in vertical clusters before the troops. The two-story building in the background has a large "Welcome" sign posted in front. (Courtesy of League City Helen Hall Library.)

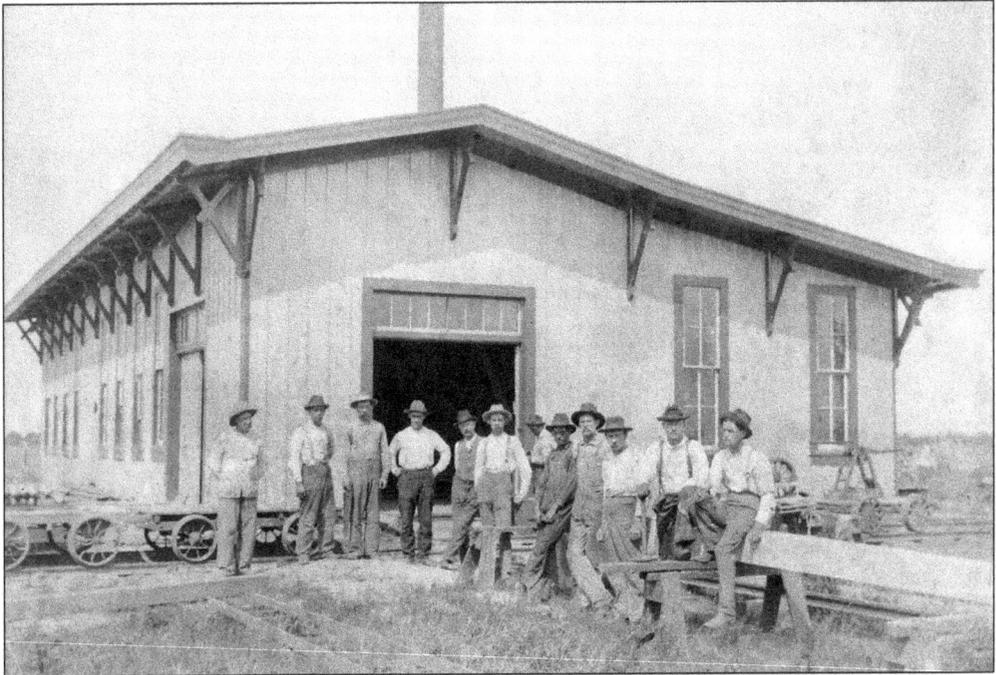

The League City railroad station is seen here in the early 1900s. The men posing in front of the station were loading railroad cars with boxes of produce that had been brought there by wagon. (Courtesy of League City Helen Hall Library.)

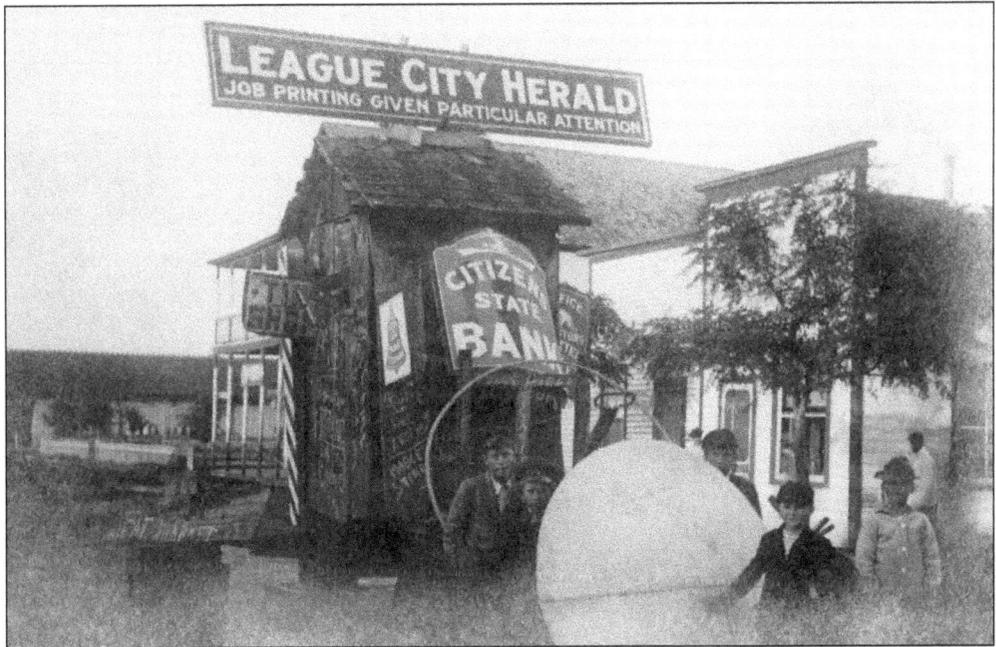

This postcard photograph shows five children in front of a building with multiple signs on Main Street (now Second Street) in League City. The postcard notes that they are looking west toward the railroad station and that this was a Halloween prank of some kind. (Courtesy of League City Helen Hall Library.)

The League City School, known locally as the "big school," was on South Kansas Street. The building was constructed in 1912 or 1915 and housed students from third grade through high school. (Courtesy of League City Helen Hall Library.)

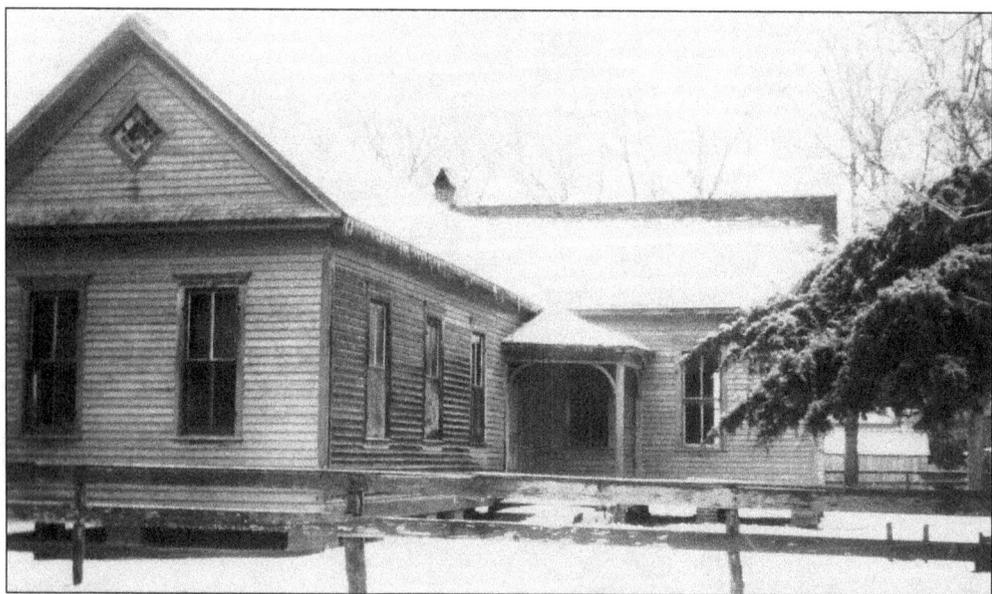

The Little Green School in League City is seen here in 1924. The original wood-frame structure was L-shaped with a small porch in the angle. As late as 1961, it was still used for kindergarten classes. It is now the home of the West Bay Common School Children's Museum, which houses local artifacts. (Courtesy of League City Helen Hall Library.)

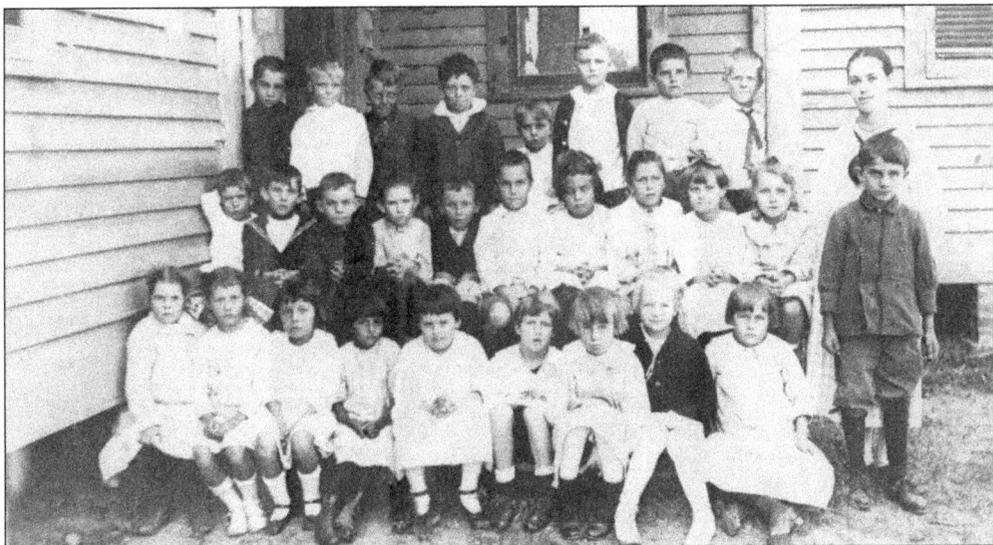

The 1917 first-grade class at the Little Green School in League City poses for a class portrait. John C. League gave this property to the town for a school. Flora Atkinson is second from the right in the first row, wearing the dark sweater. Miss Labuzan (standing, right) was the teacher. (Courtesy of League City Helen Hall Library.)

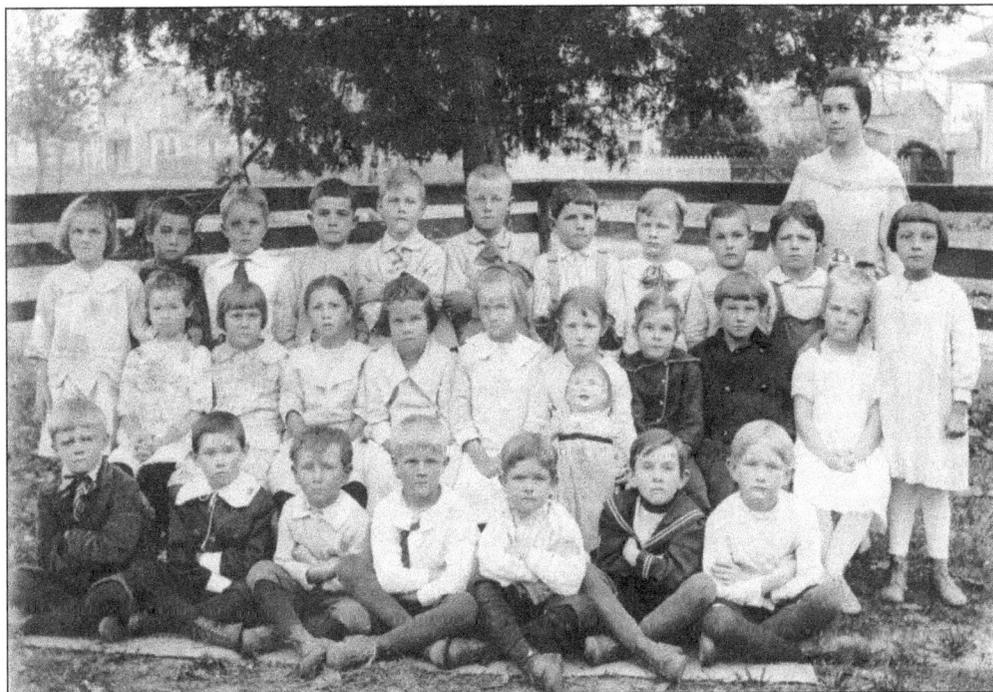

The 1918 first-grade class at the Little Green School poses in the front yard with neighboring homes seen in the background, many of which still stand. A young girl on the right in the second row holds a life-sized doll that likely accompanied her to school each day. (Courtesy of League City Helen Hall Library.)

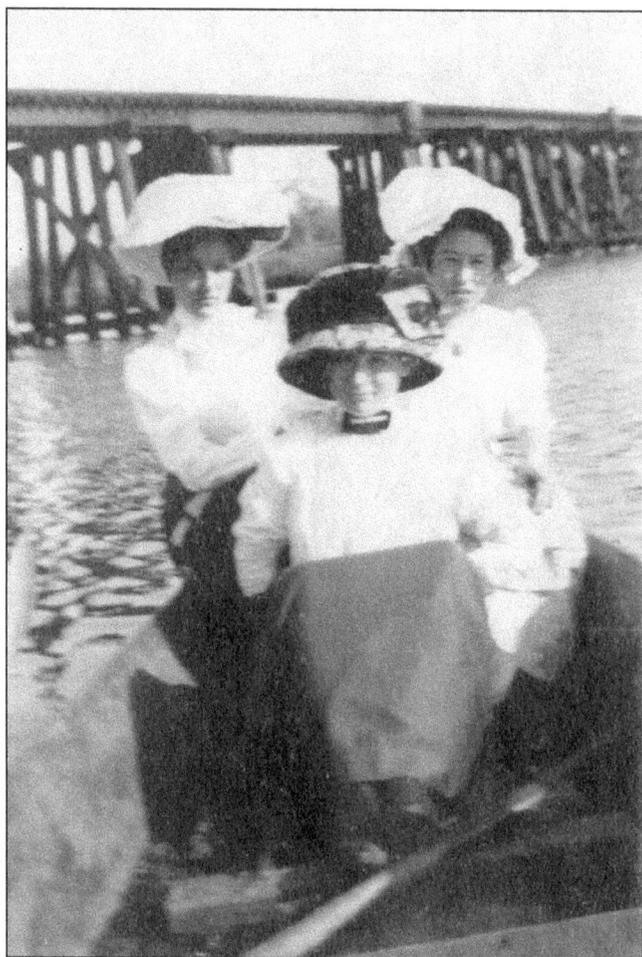

Three women, each wearing Victorian-style attire, sit together in a small rowboat beneath Clear Creek Bridge, which once stood at the end of Kansas Street in League City. The bridge was part of the main road between Houston and Galveston until it was demolished and replaced with Highway 3. (Courtesy of League City Helen Hall Library.)

Walter Hall, a self-made entrepreneur who made his fortune in banking and insurance in the Clear Lake Area, is seen here reclining in an open field with two unidentified young girls. (Courtesy of League City Helen Hall Library.)

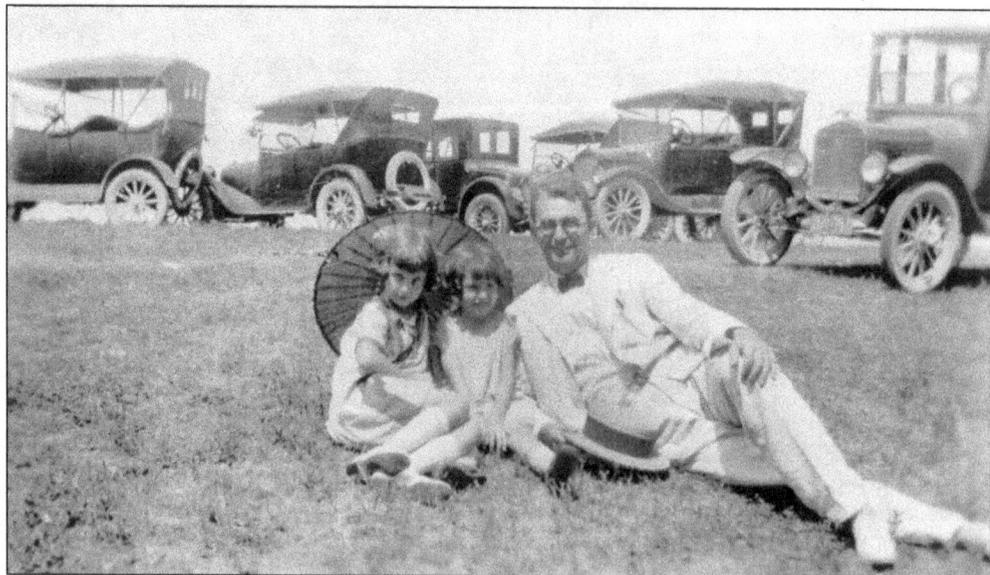

Two

FARMING, RANCHING, FISHING, AND OIL

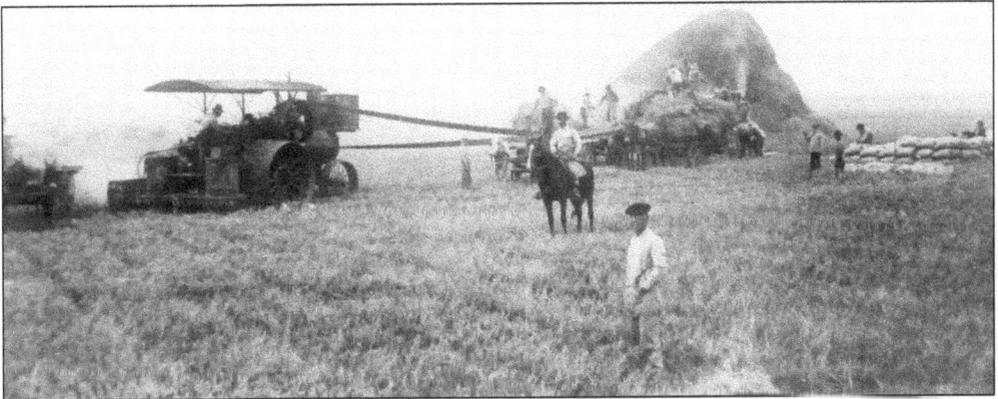

Kiyoaki Saibara (foreground) stands in a rice field owned by his father, Seito Saibara, in the early 1900s. In 1904, Rinei Onishi brought a gift from the Emperor of Japan to the elder Saibara: 300 pounds of *shinriki*, or "God Power," seed rice, which yielded 34 barrels per acre instead of the 18–20 barrels per acre yielded by American rice. Standard Milling Company then purchased seed rice from Saibara to sell to other farmers throughout the Gulf Coast, creating a booming rice industry in Texas and Louisiana. (Courtesy of Webster Presbyterian Church.)

Cattle belonging to George Washington Butler are seen here at the Butler Ranch headquarters in League City. The ranch bordered what are now Farm to Market Road 518 (FM 518), Kansas Street, and Walker Street. The cows are grazing on the grass in front of the ranch house. (Courtesy of League City Helen Hall Library.)

George Washington Butler (far right) poses with fellow cattlemen at the Butler Ranch in League City. The ranch faced the railroad tracks with FM 518 to the north. (Courtesy of League City Helen Hall Library.)

After moving to Webster from Kansas, Henry Waldo Bouton took up farming and became an outspoken leader in the congregation of Webster Presbyterian Church. Bouton's long beard and stern demeanor made him easily identifiable and earned him the nickname "the Prophet." He and his wife, Sarah Jane, prospered by raising vegetables on the gumbo prairie of Webster and raised two children. Around Webster and beyond, Bouton was known as the "Okra King," because he developed a famous strain called O.K. Okra. (Both courtesy of Webster Presbyterian Church.)

Elder Henry Waldo Bouton (1863-1954)

BOUTON

FATHER
HENRY WALDO
JAN. 11, 1863
JUNE 25, 1954

MOTHER
SARA JANE
JULY 5, 1867
SEPT. 22, 1950

DAUGHTER
FANNIE M.
AUG. 21, 1899
NOV. 8, 1991

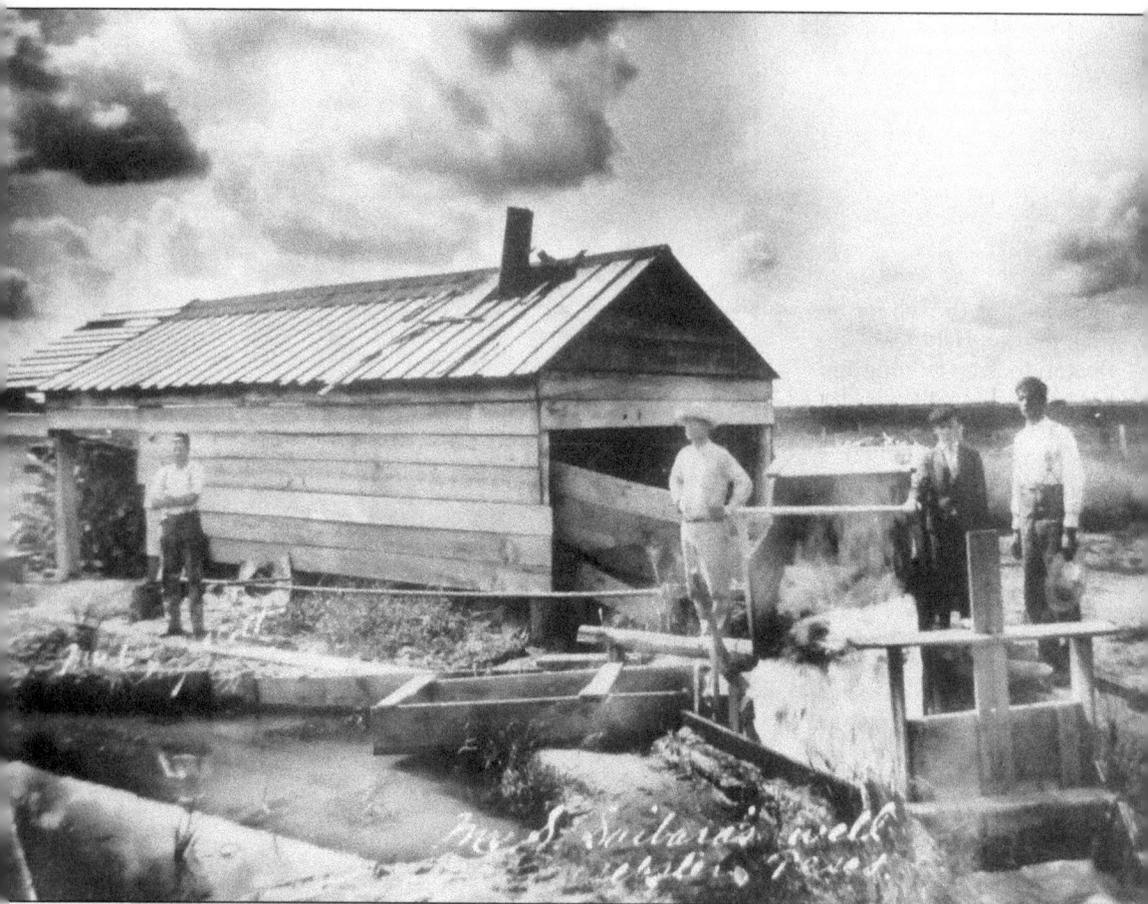

An important event in the development of the Texas Gulf Coast rice industry was the introduction of seed imported from Japan in 1904. Seed rice had previously come from Honduras or from the Carolinas. At the invitation of the Houston Chamber of Commerce and the Southern Pacific Railroad, Japanese farmers were brought to Texas to advise local farmers on rice production, bringing with them seed as a gift from the Emperor of Japan. The first three years' harvest, which produced an average of 34 barrels per acre compared with an average of 18–20 barrels per acre from native rice seed, was sold as seed to Louisiana and Texas farmers. C.J. Knapp, the founder of the US agricultural agent system, helped overcome government regulations to bring seed rice into the country. Japanese rice production began in Webster, in Harris County, under the direction of Seito Saibara, his family, and 30 original colonists. The Saibara family has been credited with establishing the Gulf Coast rice industry. (Courtesy of Webster Presbyterian Church.)

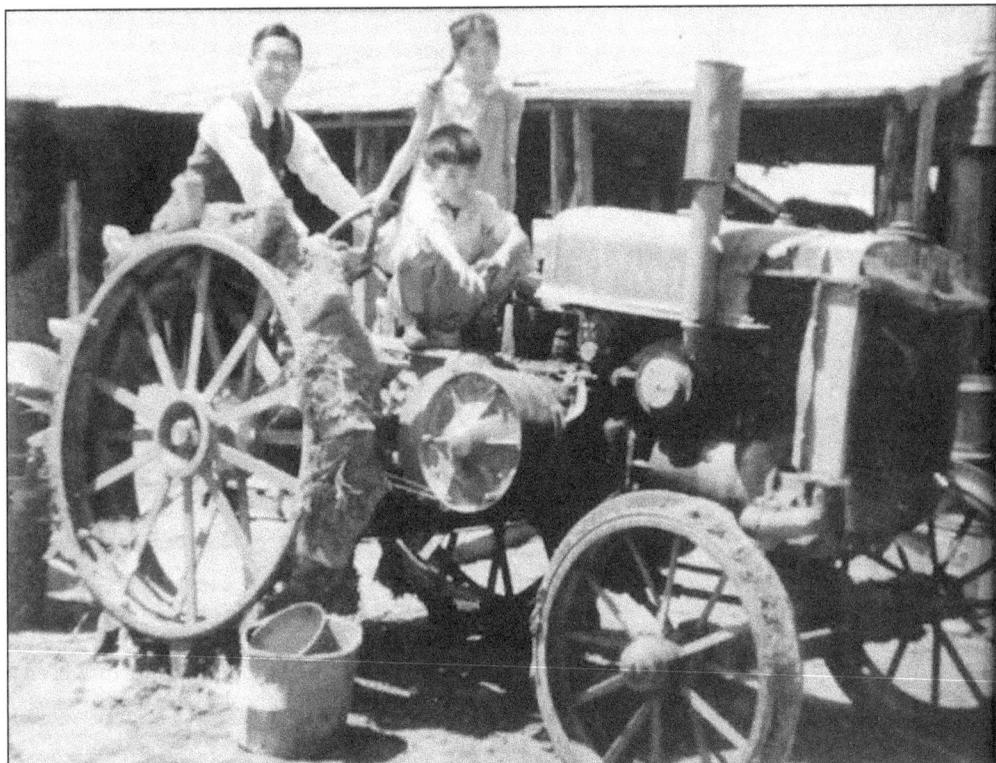

Seito Saibara (1861–1939), the former president of Doshisha University in Kyoto, Japan, and the first Christian member of the Japanese parliament, arrived in the United States in 1901 to study theology. He also wanted to establish a Japanese colony in America. Saibara came to Texas in August 1903 at the invitation of the Houston Chamber of Commerce to advise farmers on the cultivation of rice, which was emerging as a major cash crop. He decided that rice farming was the ideal business for a colony, leased a tract of land, which he later purchased, and sent for his family. (Both courtesy of Webster Presbyterian Church.)

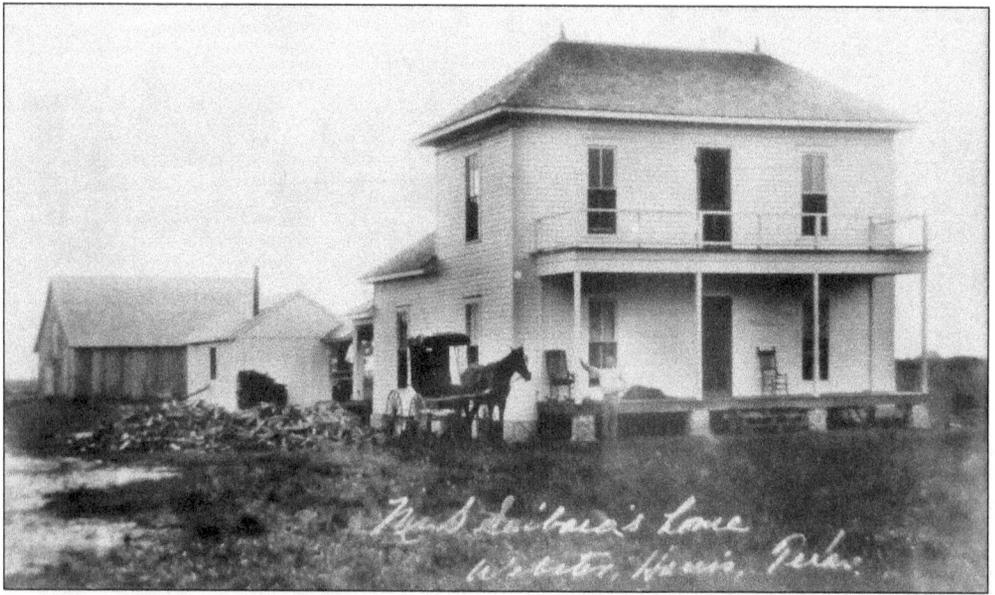

After a friend told him that the Houston Chamber of Commerce was looking for someone with knowledge of rice production, Seito Saibara traveled to Houston on the Southern Pacific Railroad. After investigating the area, he purchased 304 acres of untilled prairie on a railway line in Webster for $5,750. His friends the Onishi brothers and Shataro Nishimura purchased another 600 acres. (Courtesy of Webster Presbyterian Church.)

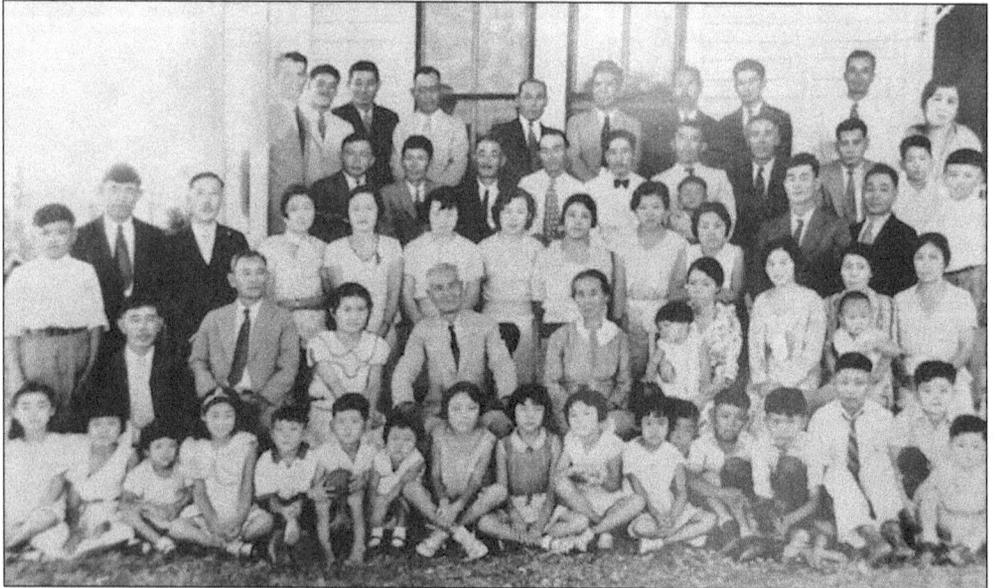

This photograph shows members of the Saibara, Kobayashi, Watanobe, Kagawa, and Sawamura families gathered for a party in honor of Seito Saibara, who was en route from Brazil to Japan. Seito Saibara is in the second row, just left of center. Members of the Kobayashi family in the photograph are: (first row) Lily (second from left), Mitsu (third from left), and Riki (fifth from right); (second row) Tokuye (far left); (third row) Moto (seventh from left), Hope (eighth from left), and Ty (far right); (fourth row) Mitsutaro (sixth from left, with baby Herbert). (Courtesy of Webster Presbyterian Church.)

Seen here is the gravesite of Marie Azuko Matsumoto in Fairview Cemetery in League City. Her parents, Frank Matsumoto and Sino Fujidayash, were Japanese pioneers in the Clear Lake Area. Over 30 Japanese families can be traced back to the pioneer days in Texas. Other pioneer family names are Saibara, Kobayashi, Tanamachi, Onishi, Kagawa, Watanabe, and Okabayashi. (Courtesy of Ruth Burke.)

The Kobayashi farmhouse and outbuildings are seen here in 1910. Mitsutaro Kobayashi settled on this 20-acre tract of land in Webster and eventually purchased additional land formerly owned by the Onishi rice farm. He also expanded his produce farm by hiring Mexican laborers. The Kobayashi farm shipped produce as far as St. Louis, Chicago, and New York. (Courtesy of Webster Presbyterian Church.)

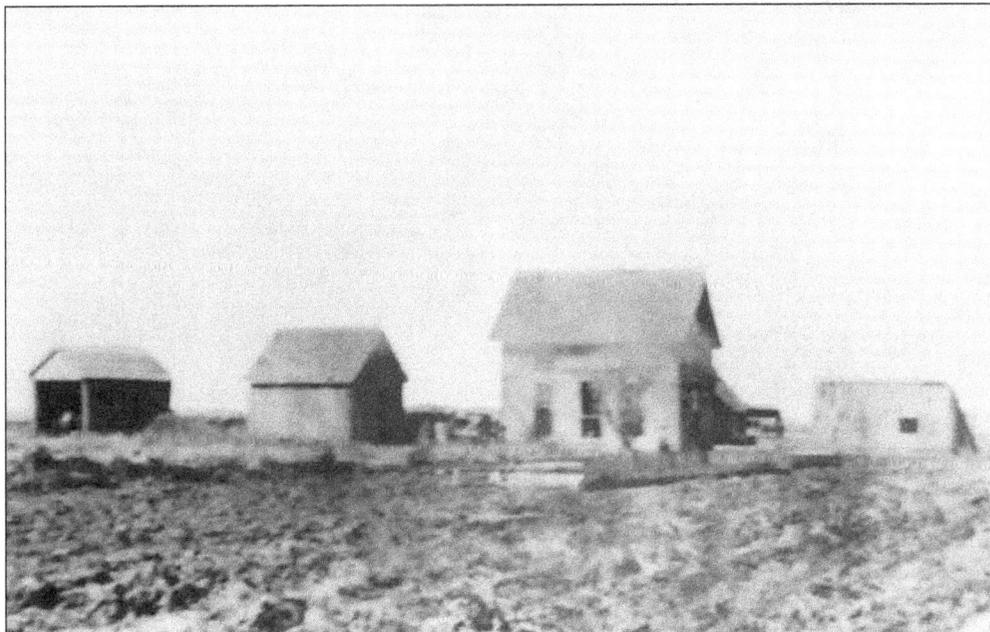

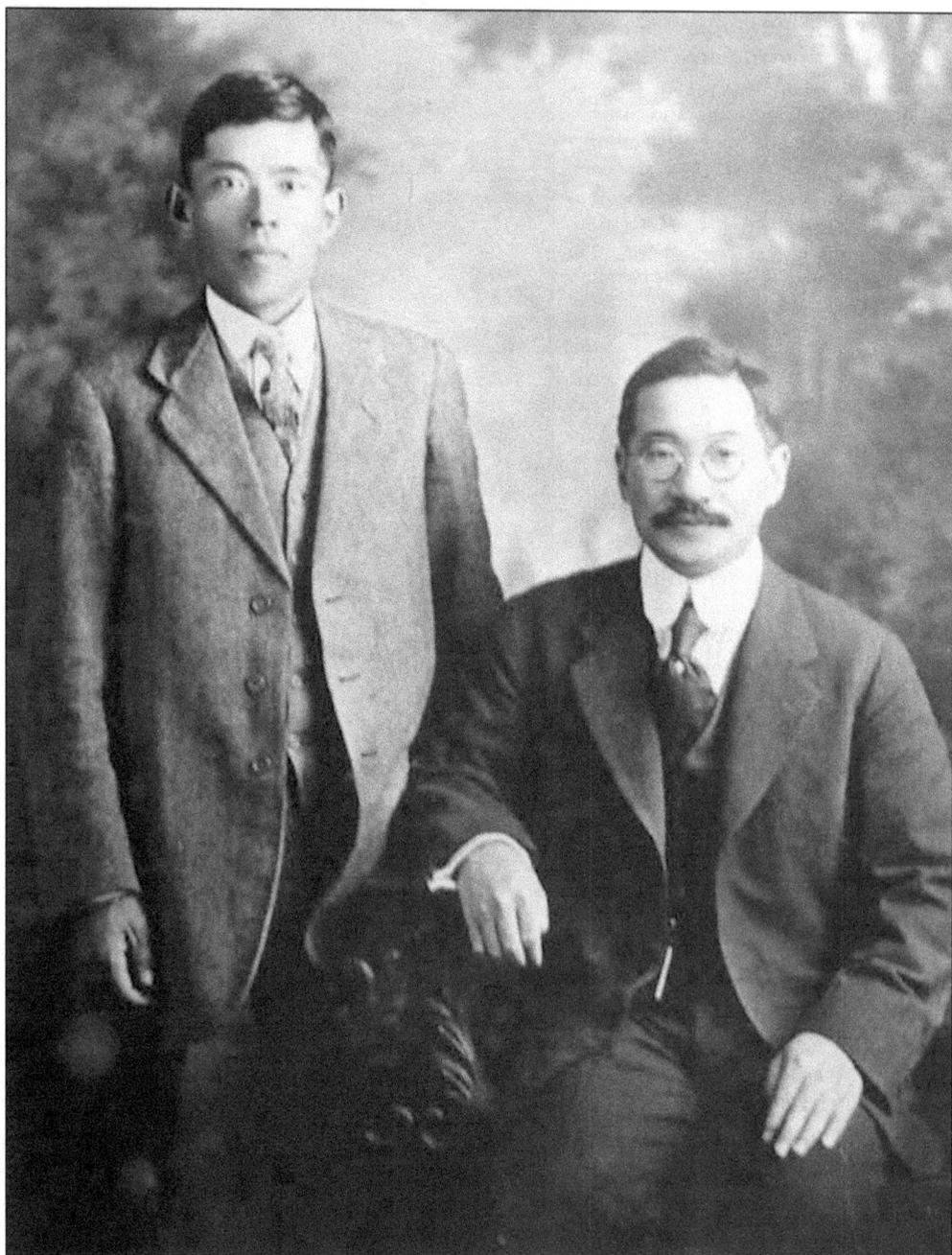

A young Mitsutaro Kobayashi (left) is seen here in a studio photograph with Masakichi Mizuta in 1919. References to Mizuta indicate that he was an engineer and inventor who held the patents for a method of refining cracked oils that was used in the petroleum industry and for a flash-point testing machine. According to Ellis Island records, Masakichi Mizuta arrived in the United States on June 21, 1920. This photograph was probably taken in Japan before either Kobayashi or Mizuta immigrated to the United States. (Courtesy of Webster Presbyterian Church.)

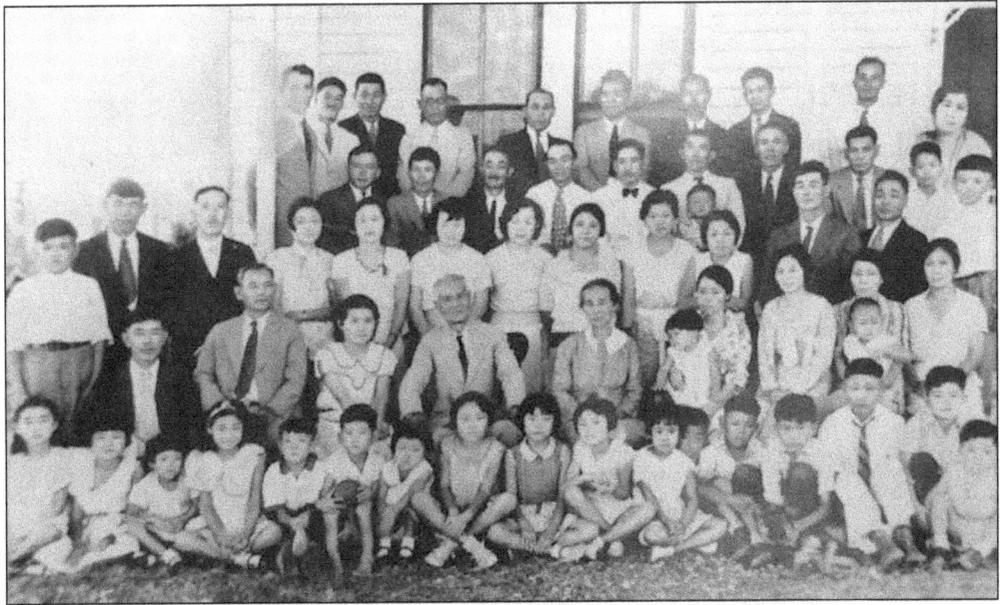

Mitsutaro Kobayashi (right) is seen here in his Satsuma orange grove. Kobayashi was born in 1877 in a settlement called Shinya, a suburb of the city of Fukuyama, in Hiroshima, Japan. He was a mechanical engineering graduate of Kuramae Technical College. He left Japan on a British ship and arrived in San Francisco on August 3, 1904. After the San Francisco earthquake in 1906, he moved to Webster, initially working for Seito Saibara. Kobayashi then purchased 20 acres of land in Webster and planted Satsuma oranges that he ordered from Nagoya, Japan. (Courtesy of Webster Presbyterian Church.)

Moto Kobayashi came to Webster in 1913 as a "picture bride." Although she spent her childhood in a small fishing village on the west coast of Japan, her family was privileged and she was well educated. Mitsutaro Kobayashi's uncle arranged her marriage to Mitsutaro. Moto Kobayashi lived in the house where she married until her death in 1995. (Courtesy of Webster Presbyterian Church.)

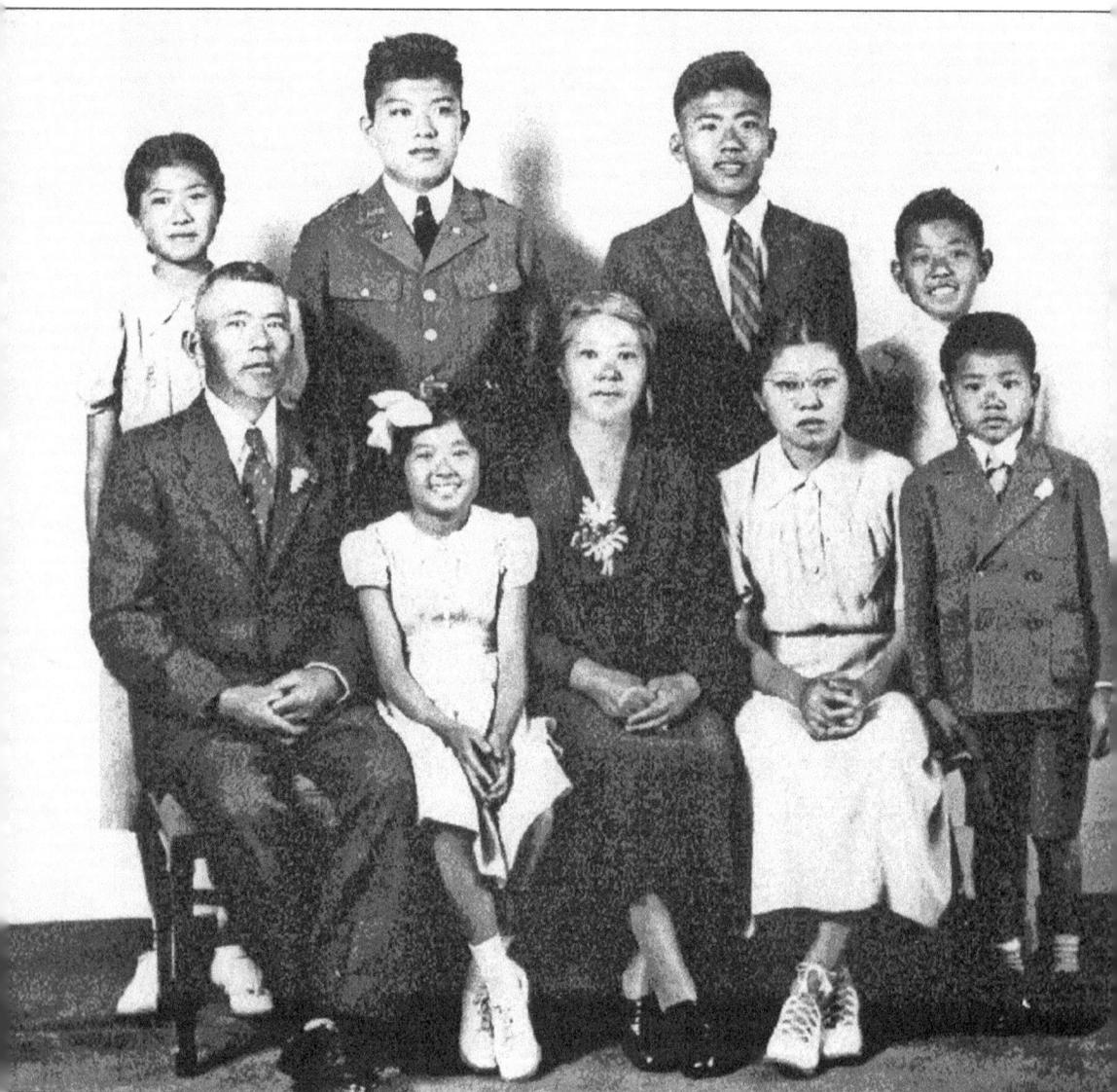

Mitsutaro Kobayashi worked in shipyards and orchards before meeting Seito Saibara and coming to Webster to join the growing Japanese colony. After serving as an engineer for rice farmers, he purchased land and became a successful truck farmer, raising a variety of vegetables and successfully shipping them to several states. He and his wife, Moto, had eight children. Their first child, Thomas, died shortly after birth, and their daughter Hope was born in 1916. The Kobayashis had four more sons and two more daughters. Since Mitsutaro was often busy with marketing produce, Moto took the orders for harvesting and directed the workers until Mitsutaro returned home. Seen here in May 1937 are, from left to right, (first row) Mitsutaro, Mitsu, Moto, Hope, and Herbert; (second row) Lily, Tokuye, Ty, and Riki. (Courtesy of the University of Texas, Institute of Texan Cultures.)

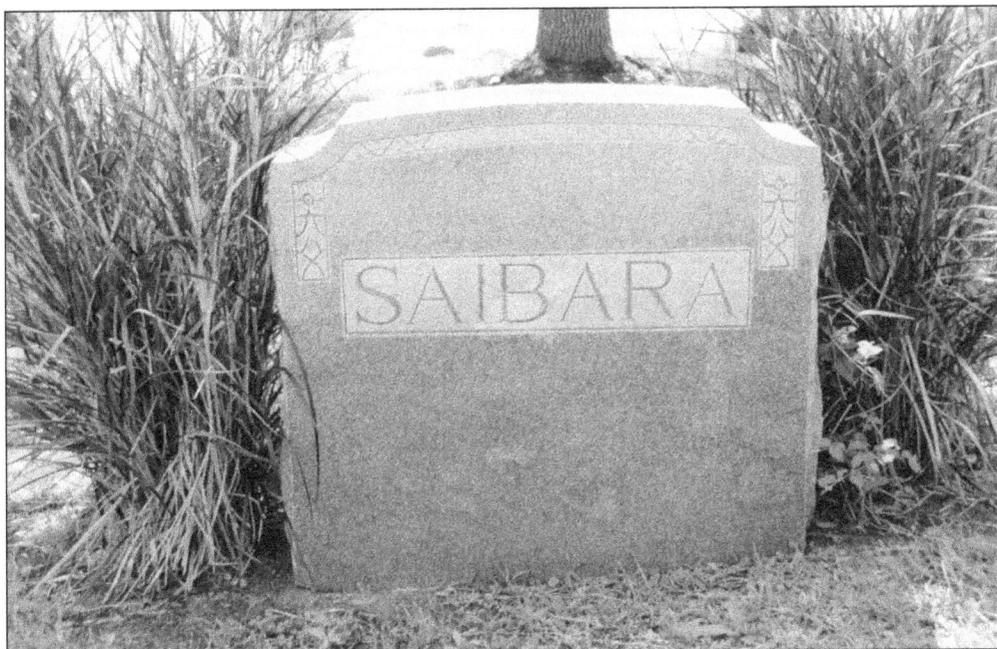

Japanese-born Seito Saibara started the rice-farming industry in Webster by answering an advertisement placed in a Connecticut newspaper by the Houston Chamber of Commerce in 1903. His tombstone, seen here, is in Fairview Cemetery, which was established in 1900 in League City. (Courtesy of Ruth Burke.)

Fairview Cemetery is located on a beautiful spot near Clear Creek in League City, Texas. The location is bound by Kansas Street, Seventh Street, private property, and Clear Creek. The cemetery was established in 1900, and a large number of tombstones are dated between 1900 and 1930. In 1907, A.W. Snider and J.H. Lynch began the Fairview Cemetery Association, and the association continues to maintain the grounds over a century later. (Courtesy of Ruth Burke.)

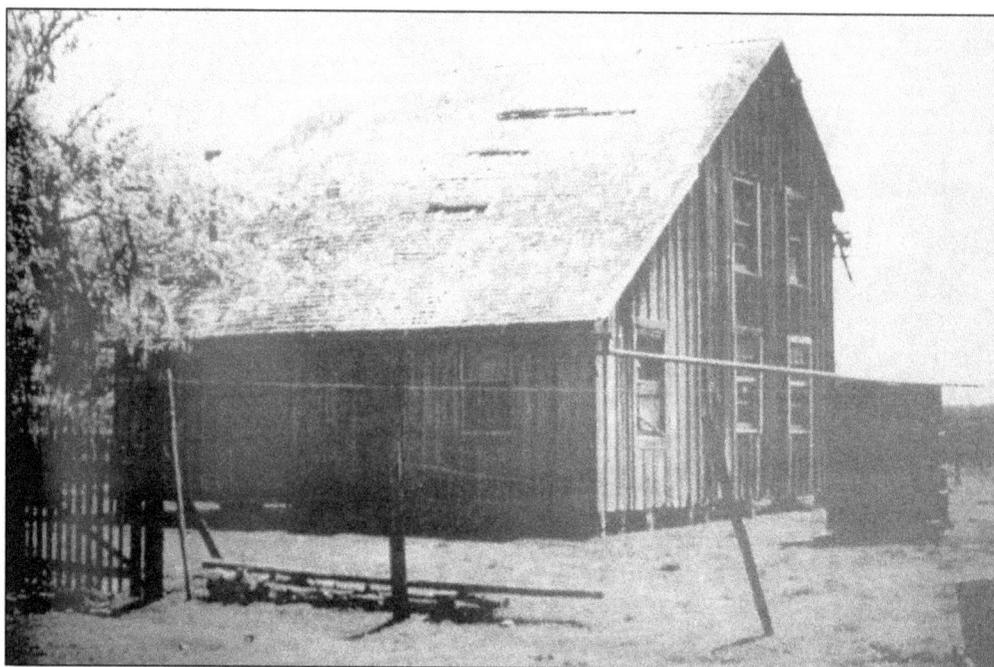

The Martyn farmhouse is seen above in 1894. James Malachi Martyn and his oldest son, Jimmy, built the large two-story home of cypress. The Martyn farm was one of the last operating ranches along the bayou. After James Martyn's death, Jimmy lived alone on the ranch. In the early 1960s, the area began to boom with the planning of the Manned Space Center and the new community of Clear Lake City. Martyn's land doubled and tripled in value, and the Friendswood Development Company offered to buy him out for $500,000, but he refused to sell. (Both courtesy of Jean West, *Catching the Tide on Armand Bayou*.)

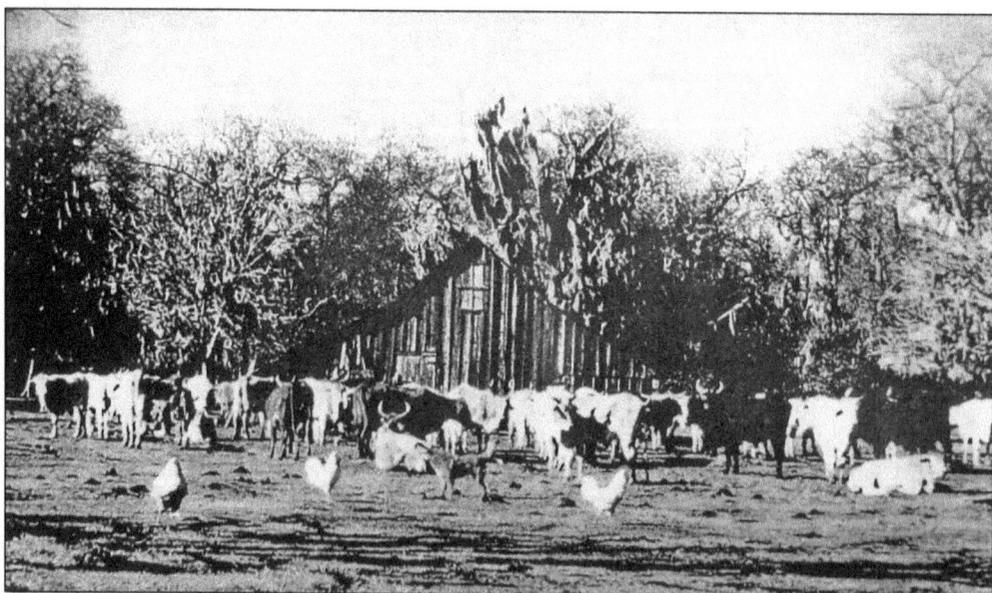

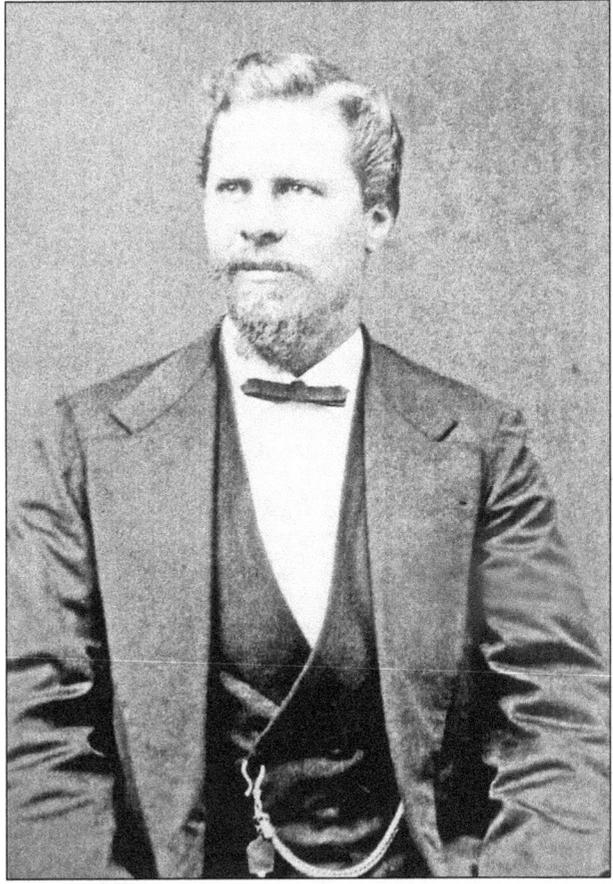

James Malachi Martyn is seen at right in 1877. He left England in the late 1860s for the shores of America. After arriving in the port of Galveston, Martyn leased a few acres of land. The area, then known as Middle Bayou, contained forest for timber, a prairie for grazing cattle and crop production, and a bayou for transportation. All of these characteristics made it an appealing place to live. Below, the Martyn family and their neighbors make syrup from sugar cane. (Both courtesy of Jean West, *Catching the Tide on Armand Bayou*.)

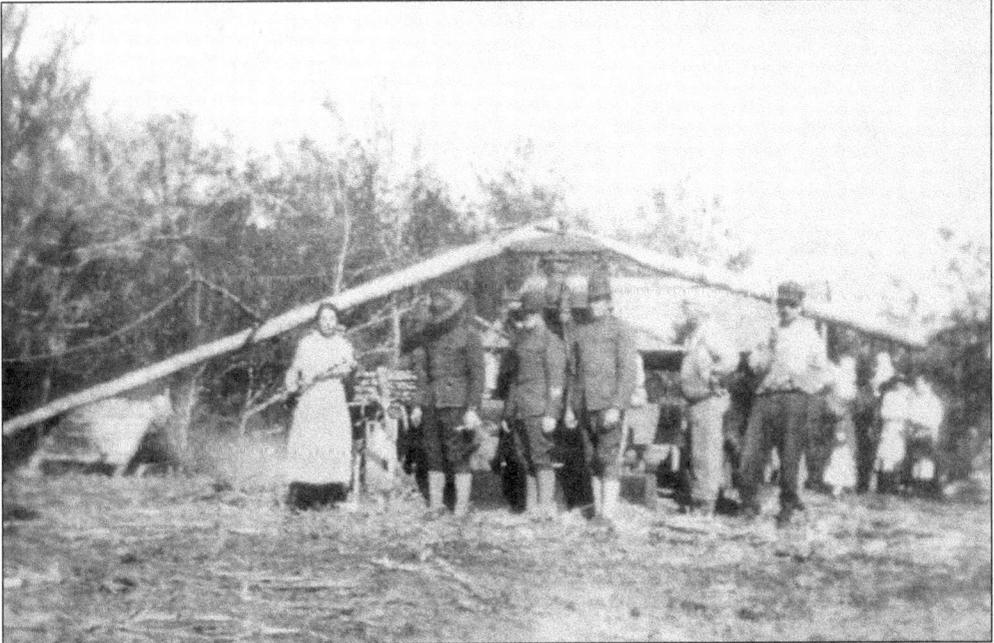

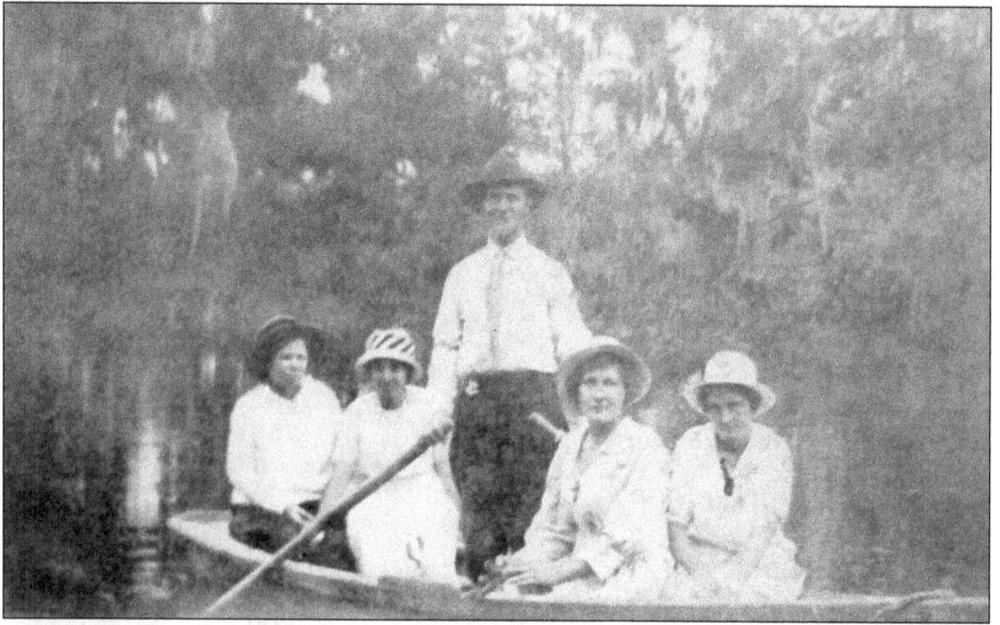

Families in the Middle Bayou settlement lived by hunting, fishing, and growing produce, which they floated in barges down the bayou to market. The settlement had a post office and a school. In the early 1900s, residents along Middle Bayou raised cattle and harvested cedar from the surrounding forests. Here, Jimmy Martyn and a group of ladies float down the bayou in a rowboat in a leisurely outing. (Courtesy of Jean West, *Catching the Tide on Armand Bayou*.)

Elizabeth Margaret Williams and James Malachi Martyn were married in 1875. The couple settled in Harrisburg (now Houston). After saving his money, James was able to purchase 83 acres on Middle Bayou for 50¢ per acre. Of the Martyns' seven children, only four survived to adulthood. (Courtesy of Jean West, *Catching the Tide on Armand Bayou*.)

Students at the Middle Bayou school posed for this photograph by a woodpile during recess in 1908. (Courtesy of Jean West, *Catching the Tide on Armand Bayou*.)

James Malachi Martyn is seen here in his older years near his original homestead, which is now the Armand Bayou Nature Center. A longtime resident of the Middle Bayou settlement, Martyn lived in a modest house near the banks of Middle Bayou from 1894 until his death in 1964. Like many area residents, the Martyns raised cattle, grew produce, and harvested cedar from the surrounding forest. The Armand Bayou Nature Center re-created a typical farm from the 1800s, naming it Martyn Farm in honor of Jimmy Martyn. (Courtesy of Jean West, *Catching the Tide on Armand Bayou*.)

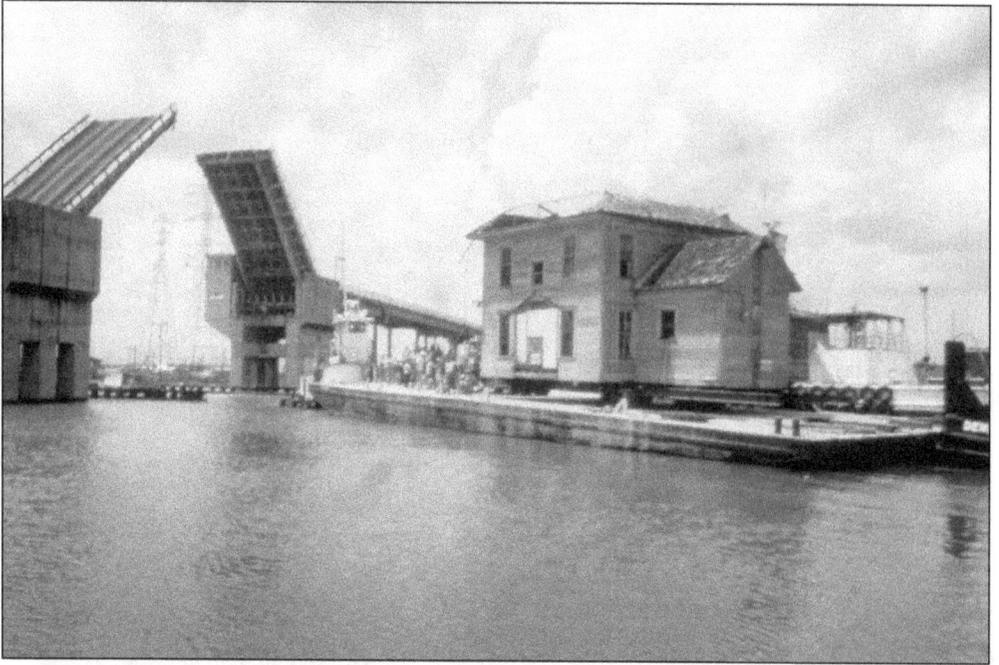

This photograph shows the Hanson house being moved by barge through Clear Creek Channel and under the Kemah drawbridge. The two-story, nine-room house was moved by truck and barge from its location near the intersection of Highway 146 and FM 518 and placed on the grounds of the Armand Bayou Nature Center. It was restored with a heritage garden surrounding it. It now serves as an educational center for those interested in 1890s farm life and is central to the annual Martyn Farm Harvest Celebration. Below, crews begin the restoration project on the house. (Both courtesy of the Armand Bayou Nature Center.)

The Hanson house was built about 1895 on Galveston Bay in Kemah by Clarence Roberts and his mother, Susan Lamb Roberts, both of whom had moved to Texas from Minnesota. The 1900 storm blew the house off its foundation, after which it was moved about a mile northwest, near the intersection of Highway 146 and FM 518, using logs and mules. Susan Roberts's daughter and son-in-law, Addie Roberts Weekes and John Ellsworth Weekes, moved into the house at its new location. John Weekes died in 1916, and Addie Weekes died in 1919. Addie willed the house to her daughter Isabel Natalie Weekes Hanson, the wife of Everett Andrew Hanson Sr. Susan Roberts's great-grandson Everett Andrew Hanson Jr. inherited the house when his mother died in 1978. He and his wife, Ruth Yeager Hanson, donated it to Armand Bayou Nature Center in 1982 to replace the original farmhouse on the Martyn farm, which had been destroyed by vandals. The house was then moved by truck and barge from Kemah to the Armand Bayou Nature Center. (Courtesy of Armand Bayou Nature Center.)

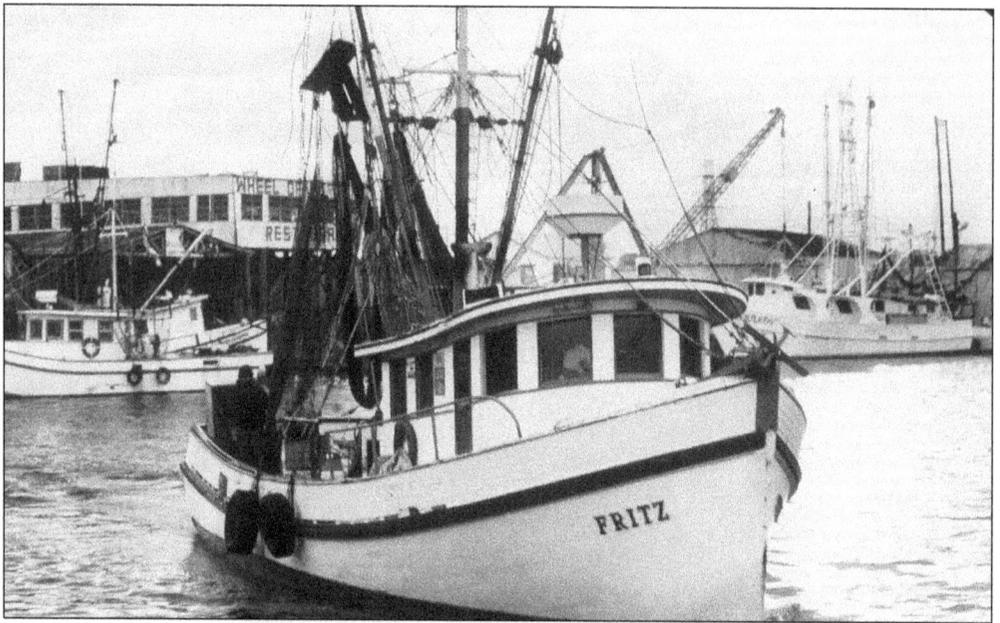

This photograph was taken in 1978, when fishing boats lined the waterfronts of Seabrook and Kemah. The *Fritz*, a working shrimp boat owned by shrimper Bobby Weldon, heads into dock. Shrimp have been exported from Galveston Bay since the 1920s, when frozen transport became possible. By 1930, shrimp had become the most important fishery in the bay, above finfish and mollusks. (Courtesy of Ruth Burke.)

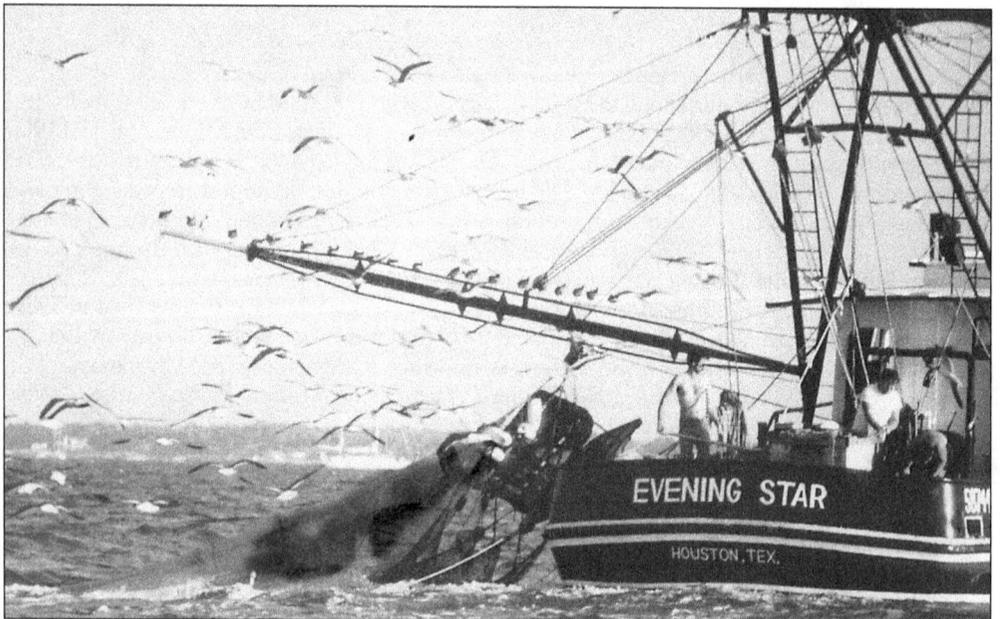

Seagulls hover for a snack as a shrimper on Captain Wick's boat the *Evening Star* pulls in a catch in the early 1980s in Galveston Bay, near Seabrook. According to data from the National Marine Fisheries Service, commercial shrimping in Galveston Bay has been on a generally steady rise since 1956. In that year, 106,000 pounds of shrimp were taken from the bay. In 1998, after years of gradual increase, nearly 4.5 million pounds of shrimp were caught. (Courtesy of Ruth Burke.)

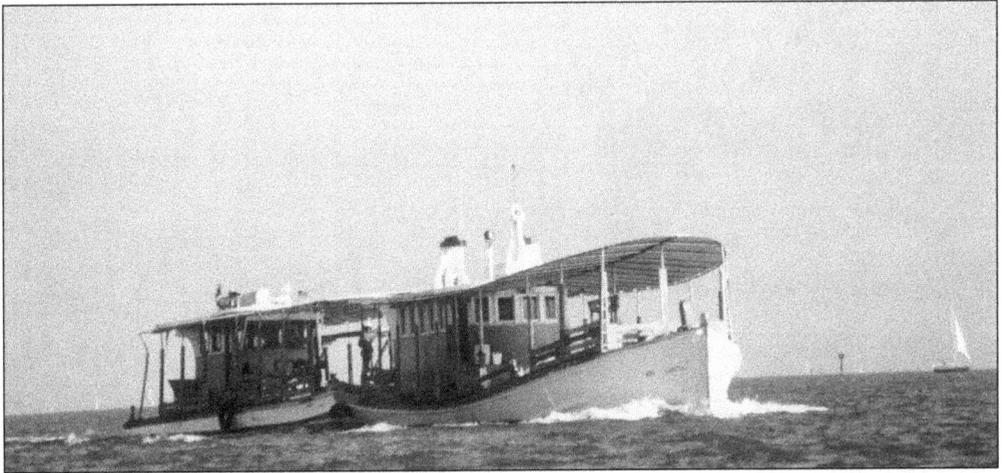

A commercial oyster-fishing boat is seen here near the shoreline of Kemah in 1980. Currently, oyster fisheries in Galveston Bay produce more oysters than any other single body of water in the United States. In addition, oysters serve an important ecological role as filter feeders in the estuary, influencing conditions such as water clarity and phytoplankton abundance. Oysters create reef habitats utilized by many other species and serve as an important indicator of the overall health of a bay ecosystem. (Courtesy of Ruth Burke.)

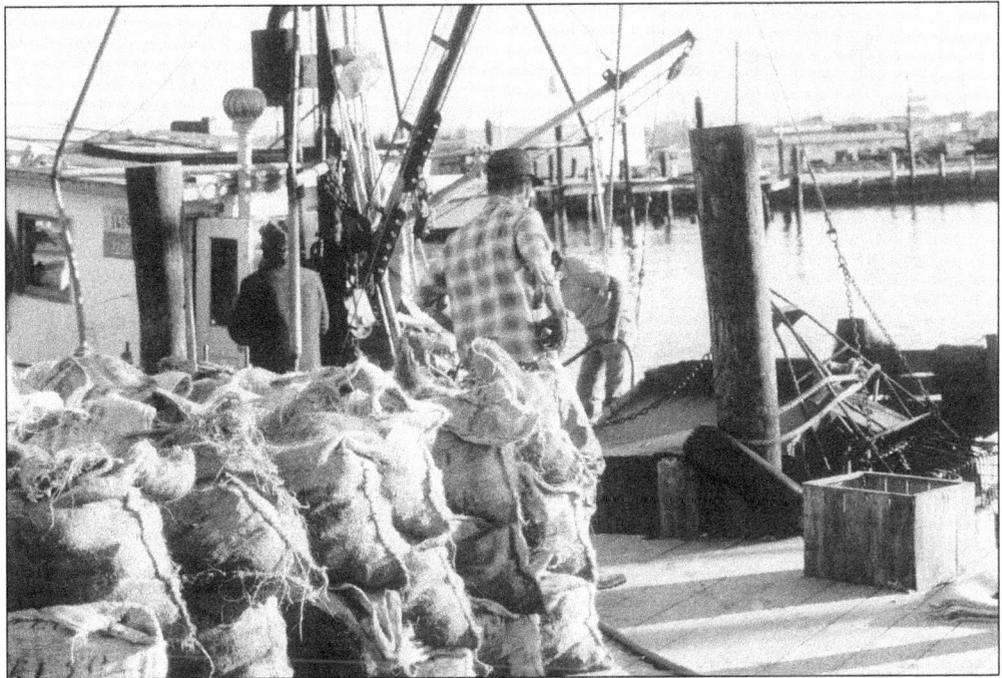

Pier 5 on the Seabrook waterfront, owned by the Forman family when this photograph was taken in 1982, played an important role in the oyster-fishing industry of the Clear Lake Area. Sacks loaded with oysters in their shells are seen here ready for sale on the dock. Early settlers discovered mounds of these oyster shells, called shell middens, all along the bay shore of what are now Seabrook and Kemah, indicating that Indians feasted on oysters as a source of protein in their diet. (Courtesy of Ruth Burke.)

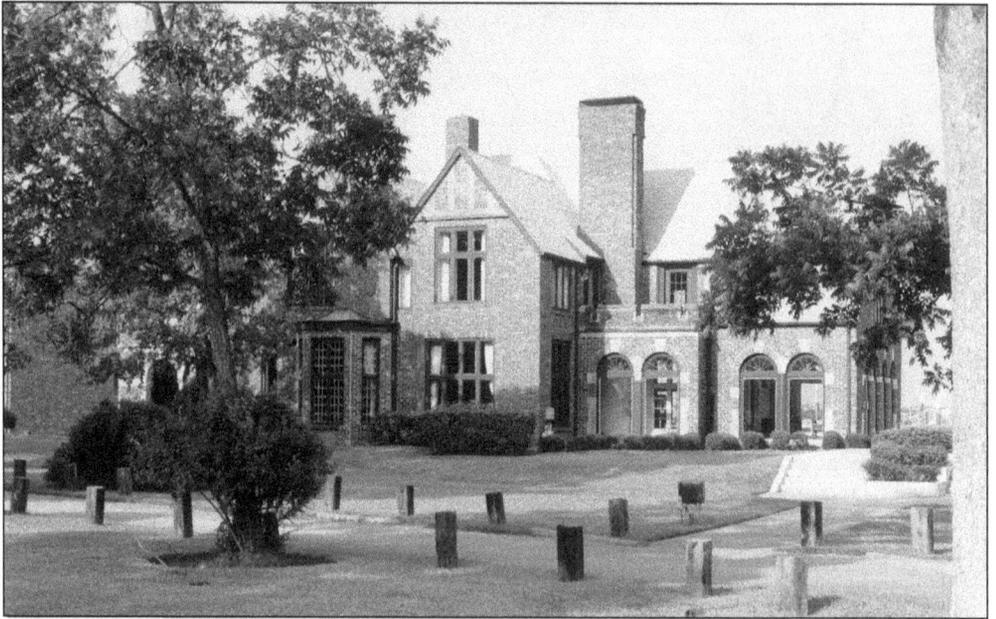

The Windemere Mansion, situated on a crescent of Clear Lake's north shore, was once the home of Harold W. Fletcher, the chief engineer of the Hughes Tool Company. He eventually became the vice president and general manager of the company. Built in 1929, the house was the permanent residence of the Fletcher family for several years. In the 1970s, the house and its surrounding property became part of the Bal Harbour Association. (Courtesy of Ruth Burke.)

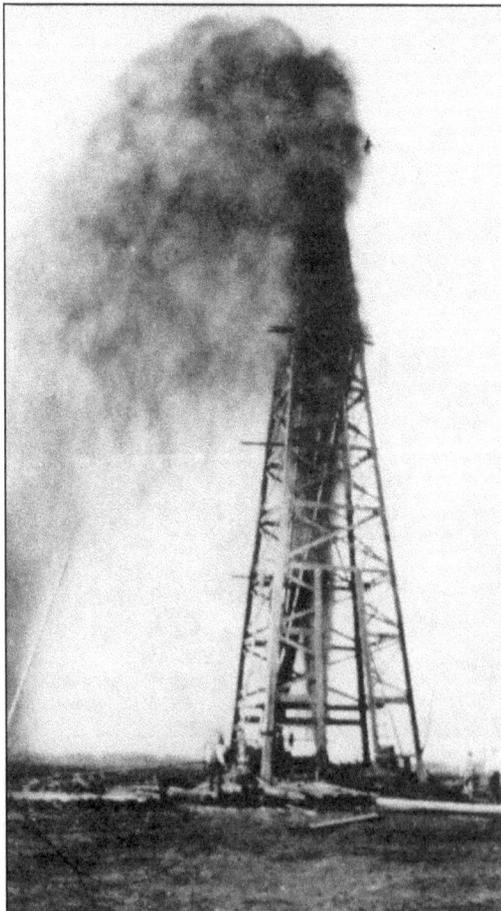

Oil was discovered in Webster in the 1930s, and the find was named Webster Field. Oil was also discovered in League City, but that discovery did not compare to Webster Field. In 1938, Humble Oil Company purchased the West Ranch for gas and oil exploration. (Courtesy of Ruth Burke.)

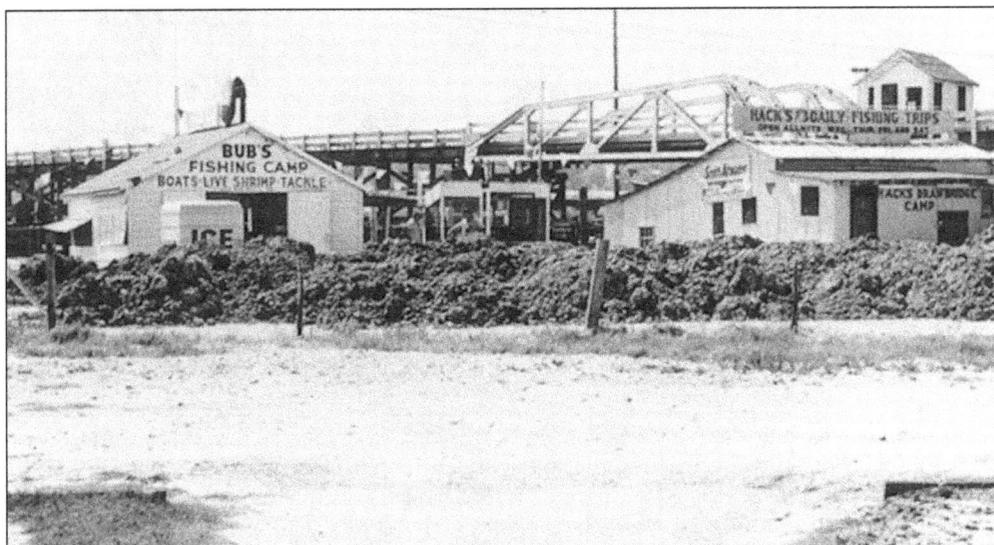

The first bridge built across the Clear Creek Channel between Kemah and Seabrook was the one-arm drawbridge seen above in the mid-1950s. Bub's Fishing Camp was located on the Seabrook side. In an article by Keith Ozmore in *Texas Outdoors* magazine, Bub recalled that "skiffs rented for $1 a day and live shrimp sold for 50 cents a pound." "Outboards were really scarce," he continued, "why if a man had an outboard, he was a big shot." He said about shrimping, "We used to catch our shrimp right here off the pier . . . shrimp trawls are new—they just started using them in the last few years." Part of his business also included rowing tarpon fishermen up and down Clear Creek for 50¢ an hour. At right, a local fisherman shows off his catch in front of Bub's. (Both courtesy of Dr. Ed Staggs.)

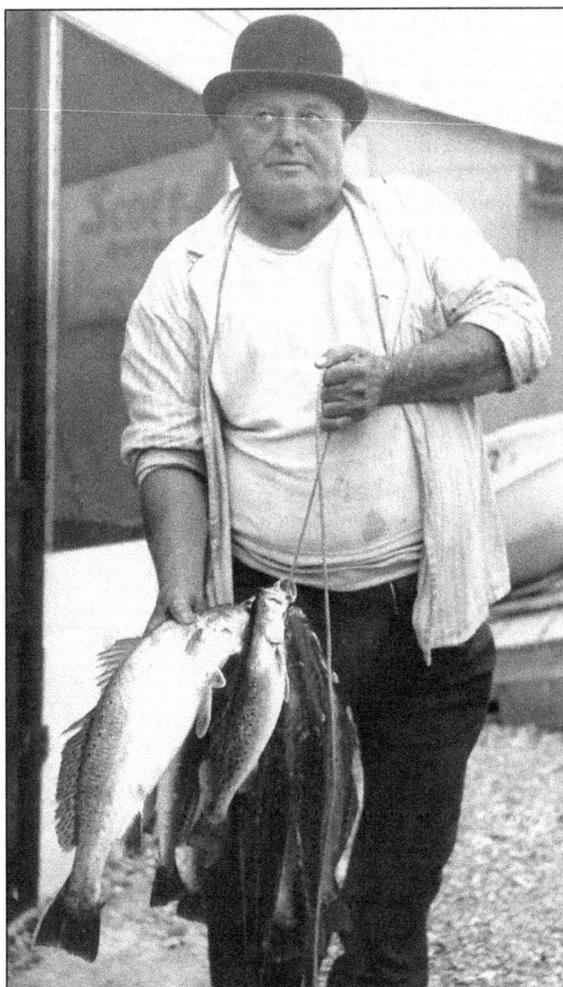

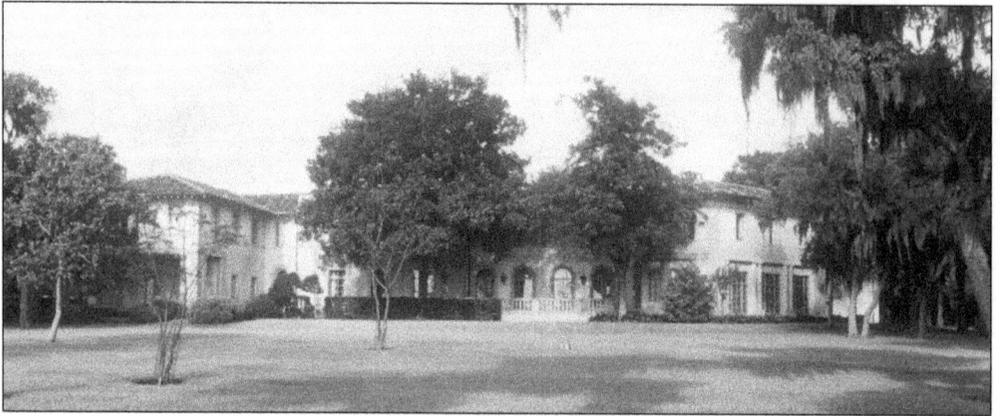

These photographs show the West Mansion, on NASA Parkway in Nassau Bay. James Marion West Sr. began planning and constructing the stately Italian Renaissance mansion after a European family vacation in 1924. Designed by architect Joseph Finger, the 17,000-square-foot structure was completed in 1930. It took three years to complete, at a cost of $250,000. The mansion boasted six bedrooms, 12 bathrooms, a sleeping porch, a solarium, a mahogany-paneled study, a ballroom, a huge dining room, a music room, a two-story living room, and a private barber's room. Rare Dresden work decorated some of the mantels. It stood on a 30,000-acre ranch that stretched from what is now Ellington Field to what is now Todville Road. The West family sold the property to Humble Oil in 1939, and it was later given to Rice University. The empty building, used at one time by the Lunar Science Institute, was then sold to the Pappas family, Houston restaurant owners who put it back on the market in 2003. Hall of Fame Houston Rockets basketball player Hakeem Olajuwon purchased the property in 2006 and then sold it to a developer, sparking fears in the Clear Lake community that the historic building would be torn down and inspiring a campaign to save the mansion. The developer went bankrupt, however, and, in 2009, ownership of the property reverted back to Olajuwon, who still owns it today. After his playing career, Olajuwon created a luxury clothing line that sells menswear, leather bags, suits, basketball shoes, and other products. (Both courtesy of Ruth Burke.)

Three

RECREATION HOT SPOT FOR CITY DWELLERS

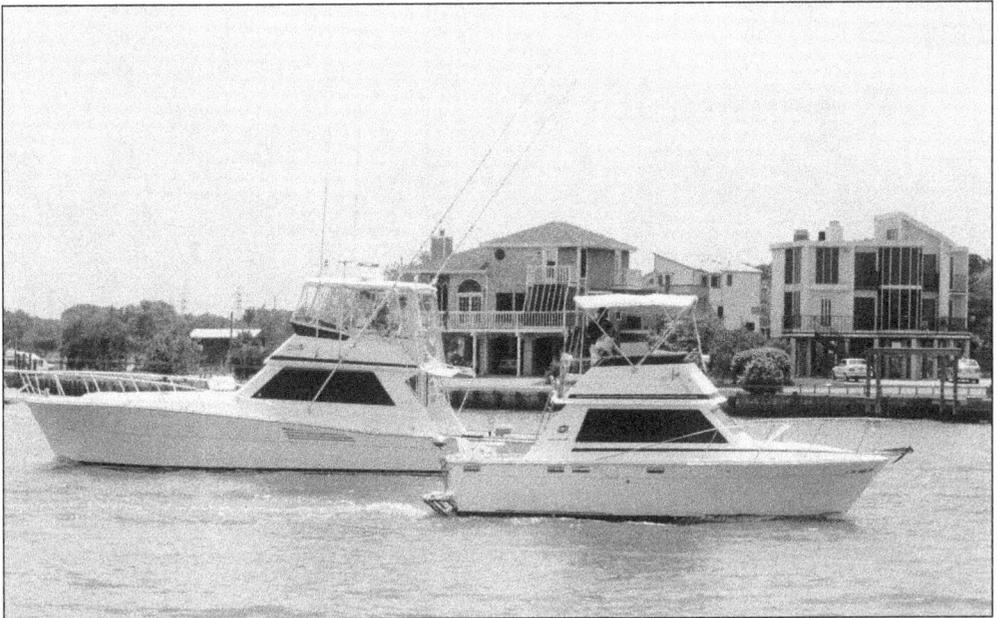

Two yachts pass each other on Clear Lake in the no-wake zone in front of waterfront homes in the south shore community of Clear Lake Shores. The development of marinas with floating docks in the 1980s created a home for larger pleasure boats like these in protected harbors. (Courtesy of Ruth Burke.)

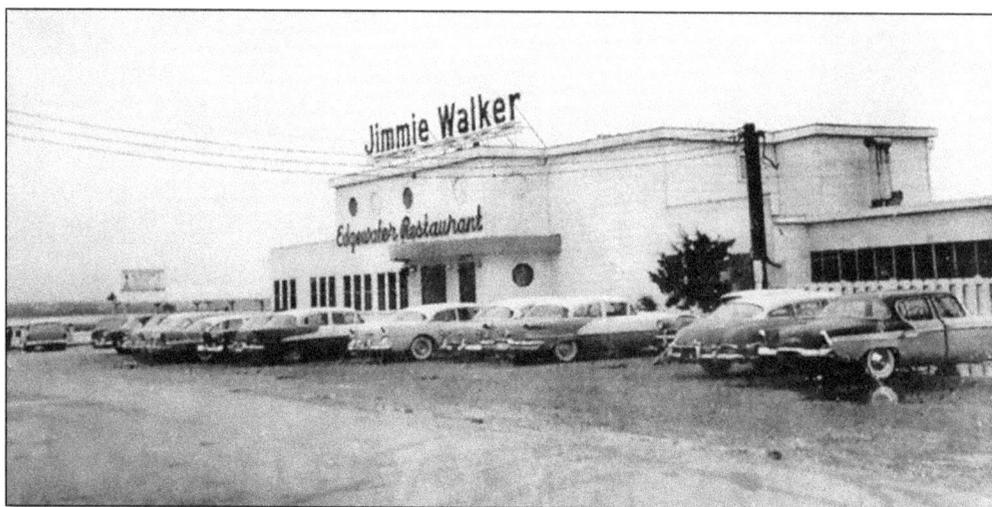

Edgewater Restaurant was located on the waterfront in Kemah. This photograph was taken in the 1950s, when Jimmie and Lorae Walker operated the restaurant on the first floor. The second floor was for gambling and was operated by Italian families from Galveston. When Hurricane Carla struck in 1961, the building was demolished. (Courtesy of Ruth Burke.)

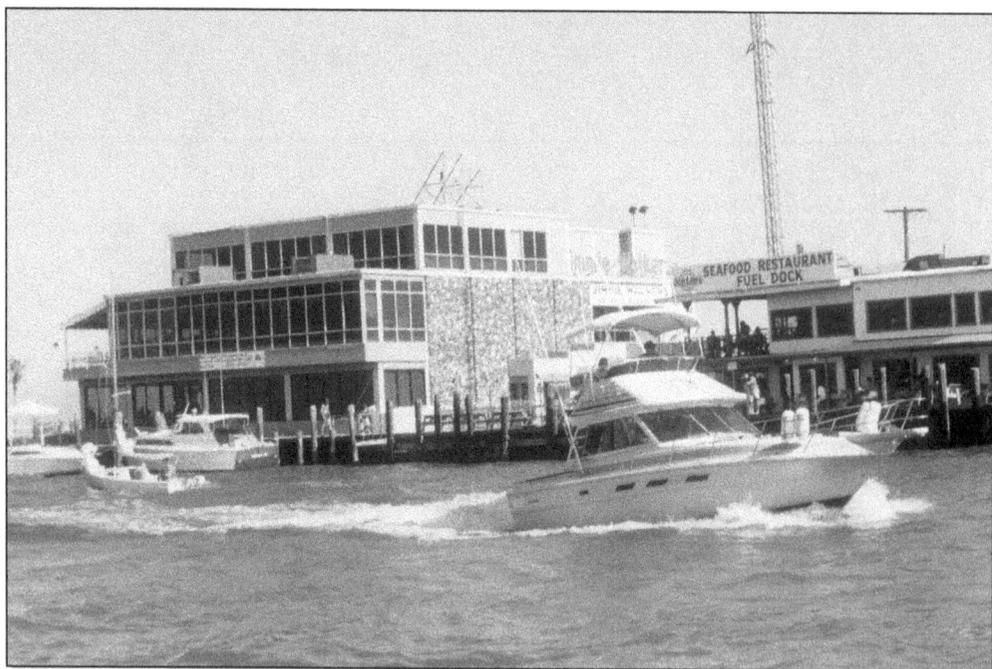

This 1981 photograph shows the three-story building the Walkers replaced their former building with, which still stands today. After gambling was stopped in the late 1950s, the upstairs became the famous, elegant Supper Club. Its million-dollar view and fresh seafood made it one of the most popular spots in the Clear Lake Area for visitors from Houston to watch the boats go by. In the 1980s, the Supper Club became UP's, a club popular with boaters. In the late 1990s, the Landry's Corporation took control of the restaurant and changed the name to Landry's, leaving the Jimmie Walker sign as part of the exterior decor. (Courtesy of Ruth Burke.)

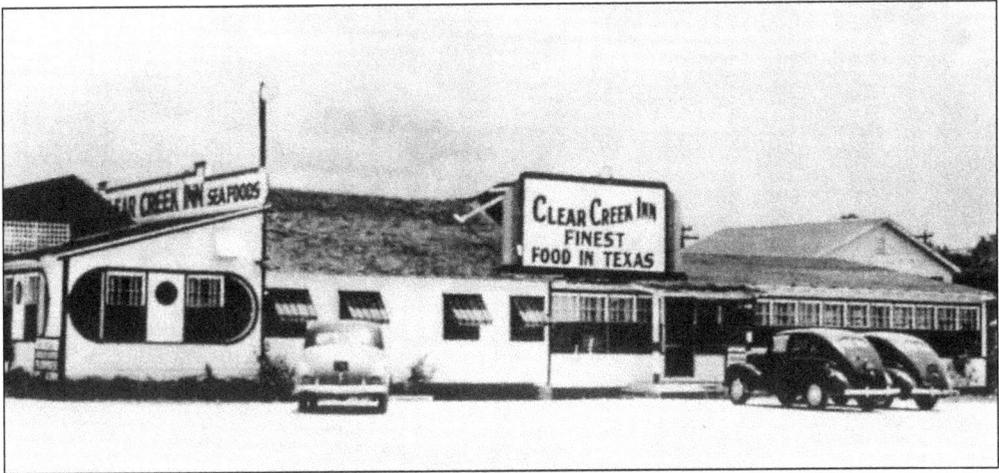

The Clear Creek Inn was opened in Kemah in the late 1940s by Lewis and Winifred Thompson. It was located behind the waterfront restaurants and earned a reputation for having the finest seafood in town. The successful family-owned business was in operation for 44 years. For many Clear Lake residents, it was a loss when the family decided not to rebuild after the building was damaged by Hurricane Alicia in 1983. (Above courtesy of Seaside Gallery; below courtesy of Ruth Burke.)

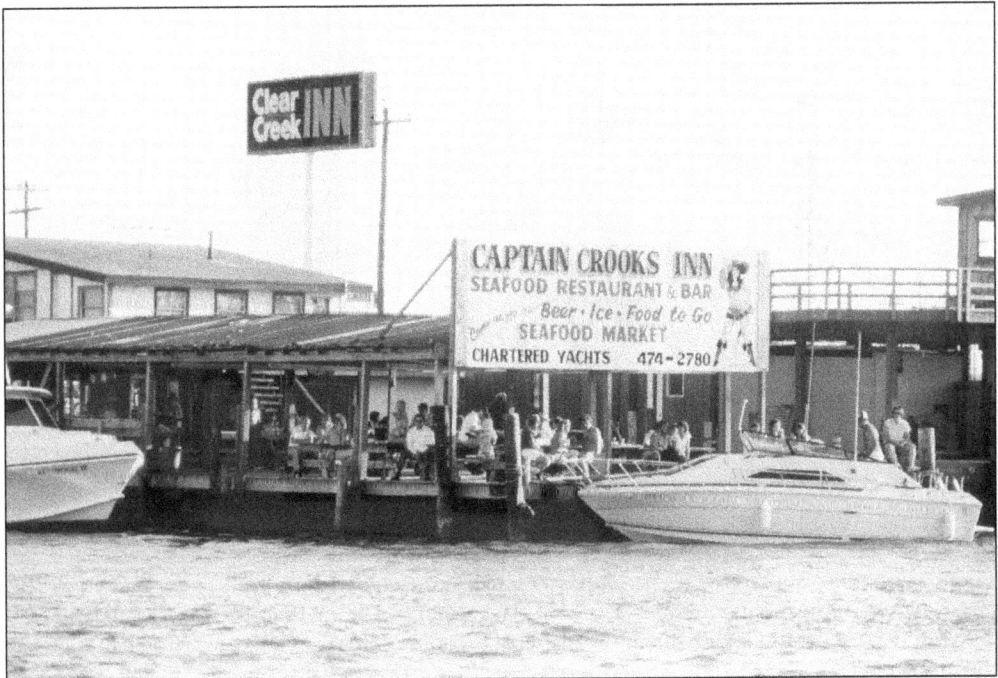

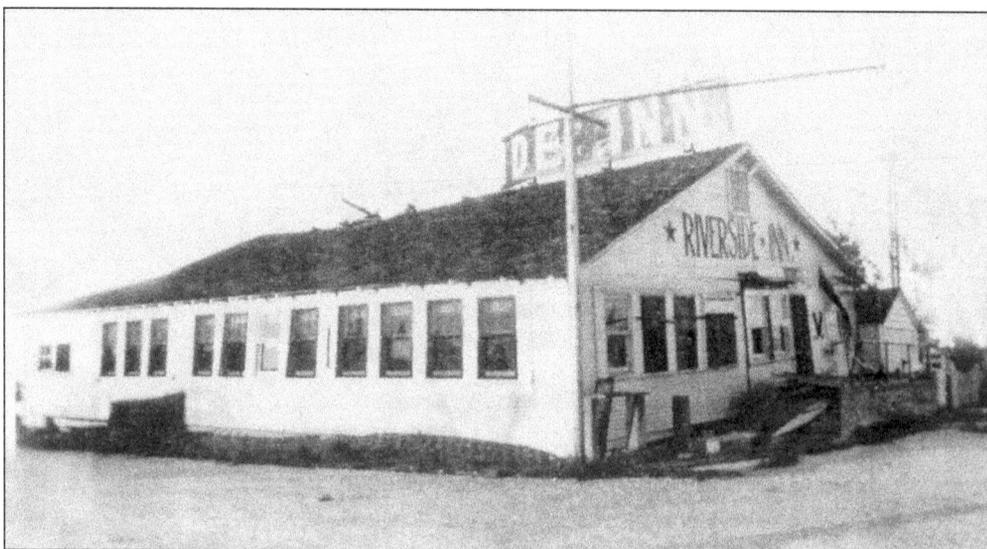

The Riverside Inn was located on the Kemah waterfront, near Edgewater Restaurant. In the beginning, gambling was on the second floor and the dining room was on the first floor. This photograph shows damage from Hurricane Carla in 1961. The location later became Fishbones Restaurant, which burned in the 1990s. Currently, the Landry's Corporation maintains a franchise at this location. (Courtesy of Seaside Gallery.)

The most popular sport fish in the Galveston area is the spotted sea trout, also known as the speckled trout. Other common catches include black drum, red drum, flounder, croaker, sheepshead, sand sea trout, gafftopsail catfish, and whiting. It is common to see people enjoying fishing from the many banks and piers in the Clear Lake Area. (Courtesy of Ruth Burke.)

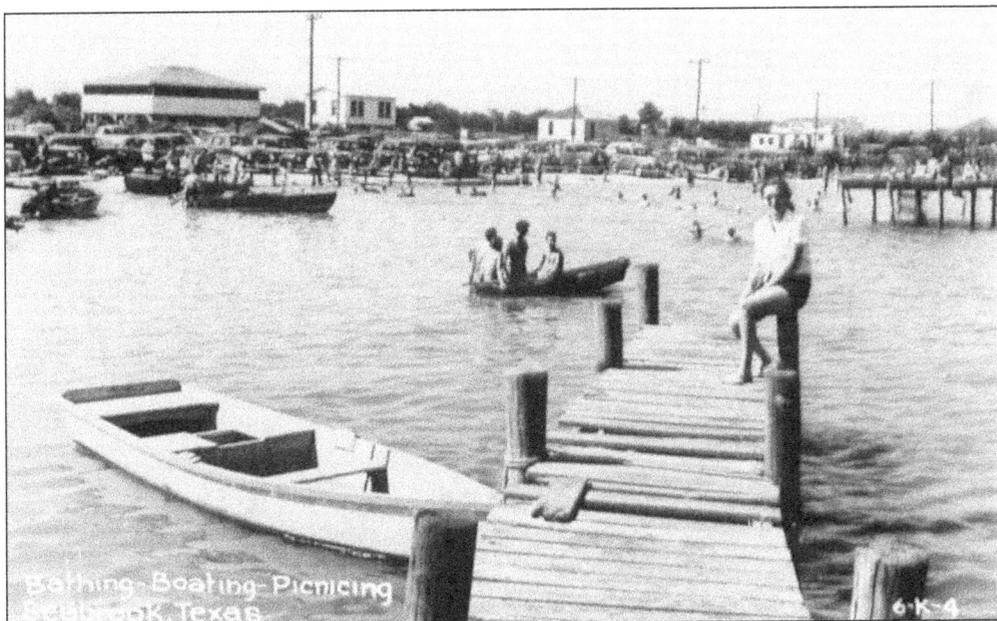

Before subsidence that began in the late 1960s, the coastal areas of Seabrook and Kemah had beaches for bathers to enjoy. This photograph shows the swimming hole area in Seabrook, near Todville Road. Muecke's, a popular restaurant and hangout place, was nearby, and summer homes on stilts are seen in the distance. (Courtesy of Evelyn Meador Library.)

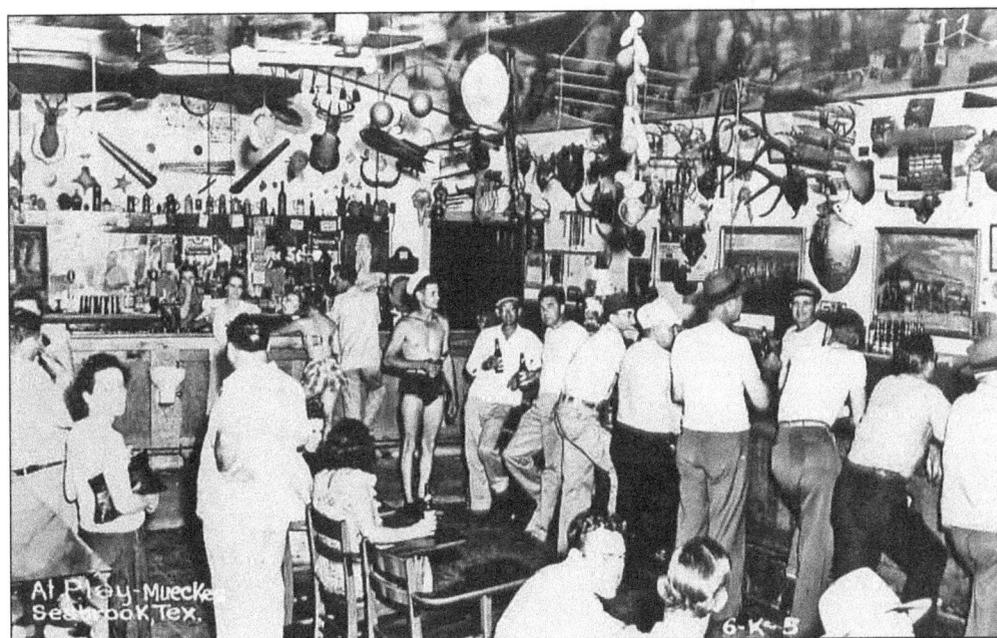

From the 1940s into the 1950s, Muecke's was the hot spot for hanging out by the water. Owner Wes Muecke decorated the place with anything he could find that was interesting to him. After subsidence and storms, the place officially closed in the late 1970s, marking the passing of an era of coastal activity. (Courtesy of Evelyn Meador Library.)

Once part of William Plunkett Harris's Red Bluff Ranch, El Jardin was one of the early developments on the water near Clear Lake. This land plot advertises the advantages of having a home on Red Bluff Point. Because it was before air-conditioning, sea breeze was a selling point, and the advertisement describes the location as having a broad, 245-degree angle for sea breeze. (Courtesy of Seaside Gallery.)

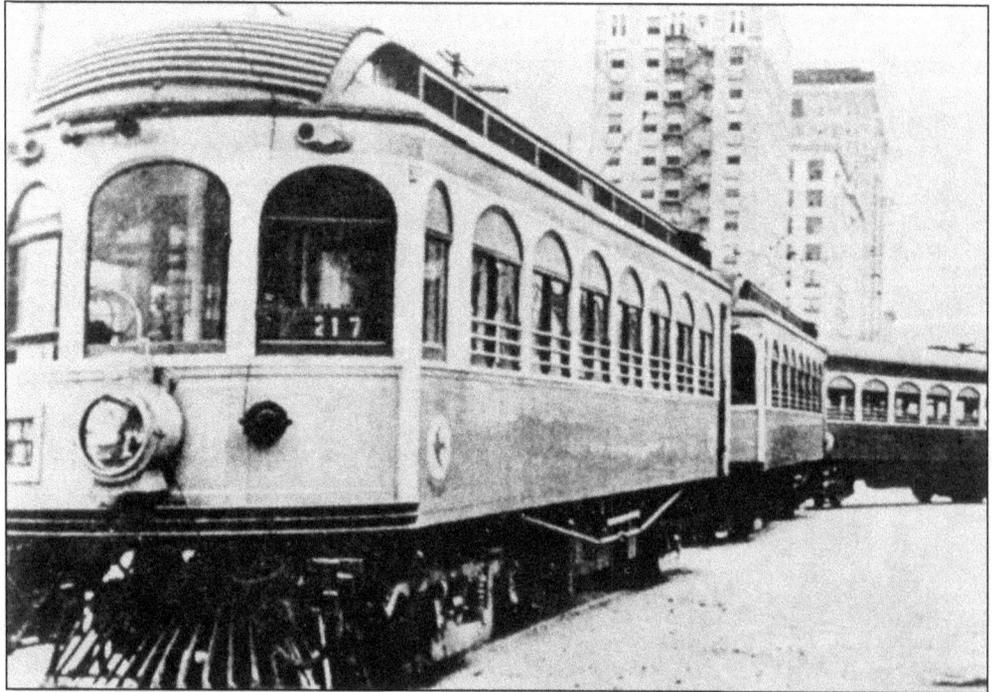

The area around Clear Lake benefited greatly from the Galveston-Houston Interurban Electric Railroad, which began service in 1911 and ceased operation in 1936. The area quickly became a popular spot for Houstonians, who flocked to the coastal areas of Clear Lake for recreational activities, creating a developers' paradise. (Courtesy of Evelyn Meador Library.)

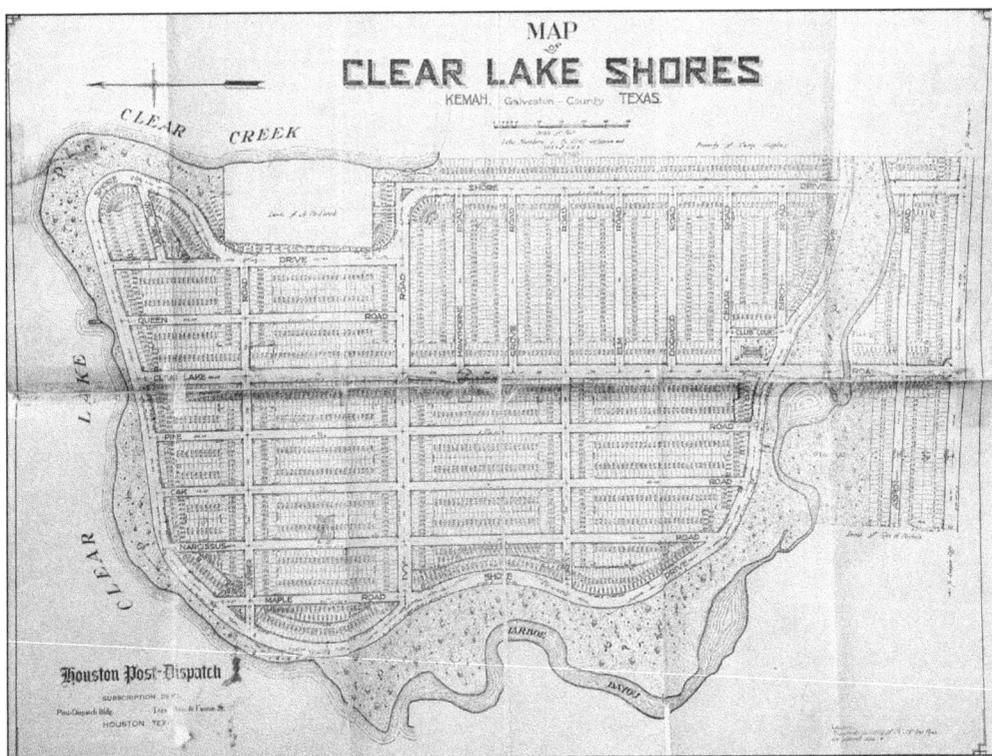

MAP
of
CLEAR LAKE SHORES
KEMAH, Galveston County TEXAS.

During the oil boom years of the 1920s, developers began to sell properties around the Clear Lake estuary as recreational waterfront retreats. The new development was named Clear Lake Shores. Though the development was initially successful, the Great Depression halted most of the area's growth. On April 6, 1927, the *Houston Post Dispatch* advertised that readers who signed up for a subscription were eligible to buy 20-foot-by-100-foot lots in Clear Lake Shores for $69.50 each. Buyers could pay $9.50 down and $3 per month. (Courtesy of Sue Harral.)

Thousands of people came to Clear Lake Shores on the interurban from Houston and by automobile. In 1987, Mary Williams recalled coming to Clear Lake Shores accompanied by her late husband in a Ford Model T. The Civic Club House, built in 1927, was where potential buyers gathered to purchase the 2,400 lots. It is currently in use for residents. Clear Lake Shores was incorporated in 1962, and the city hall and police station are located in the building in this photograph, taken from Jarbo Bayou. (Courtesy of Ruth Burke.)

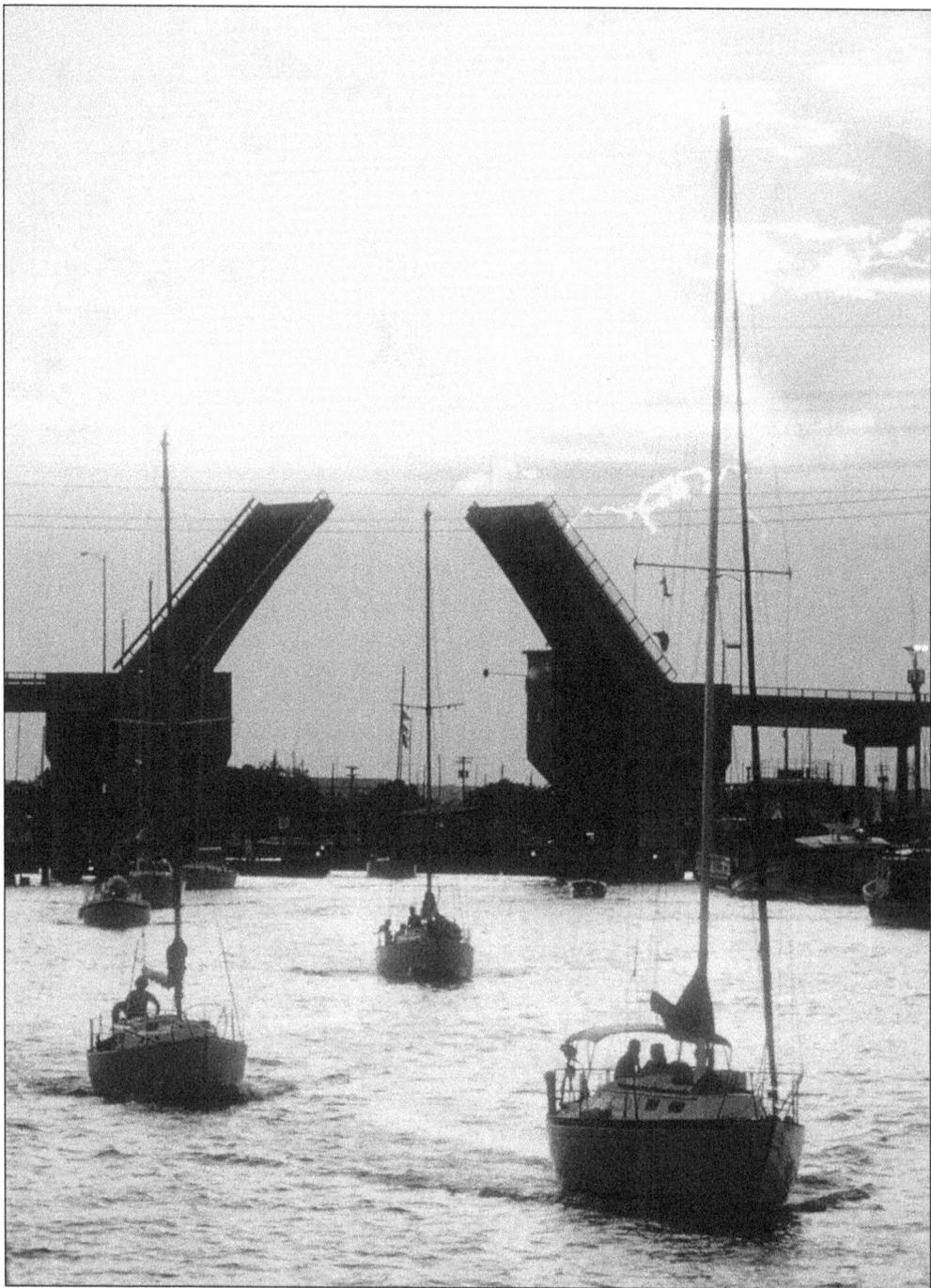

Construction of a two-arm drawbridge to replace the one-arm drawbridge between Kemah and Seabrook began in 1959 and was completed in 1961. In 1980, when this photograph was taken, the drawbridge was often open on the weekends to allow sailboats to pass. Since this became an inconvenience for motorists and boaters alike, a fixed-span bridge opened in 1986. This drawbridge was dismantled and moved to Louisiana, where it was reassembled and used as a drawbridge again. (Courtesy of Ruth Burke.)

50

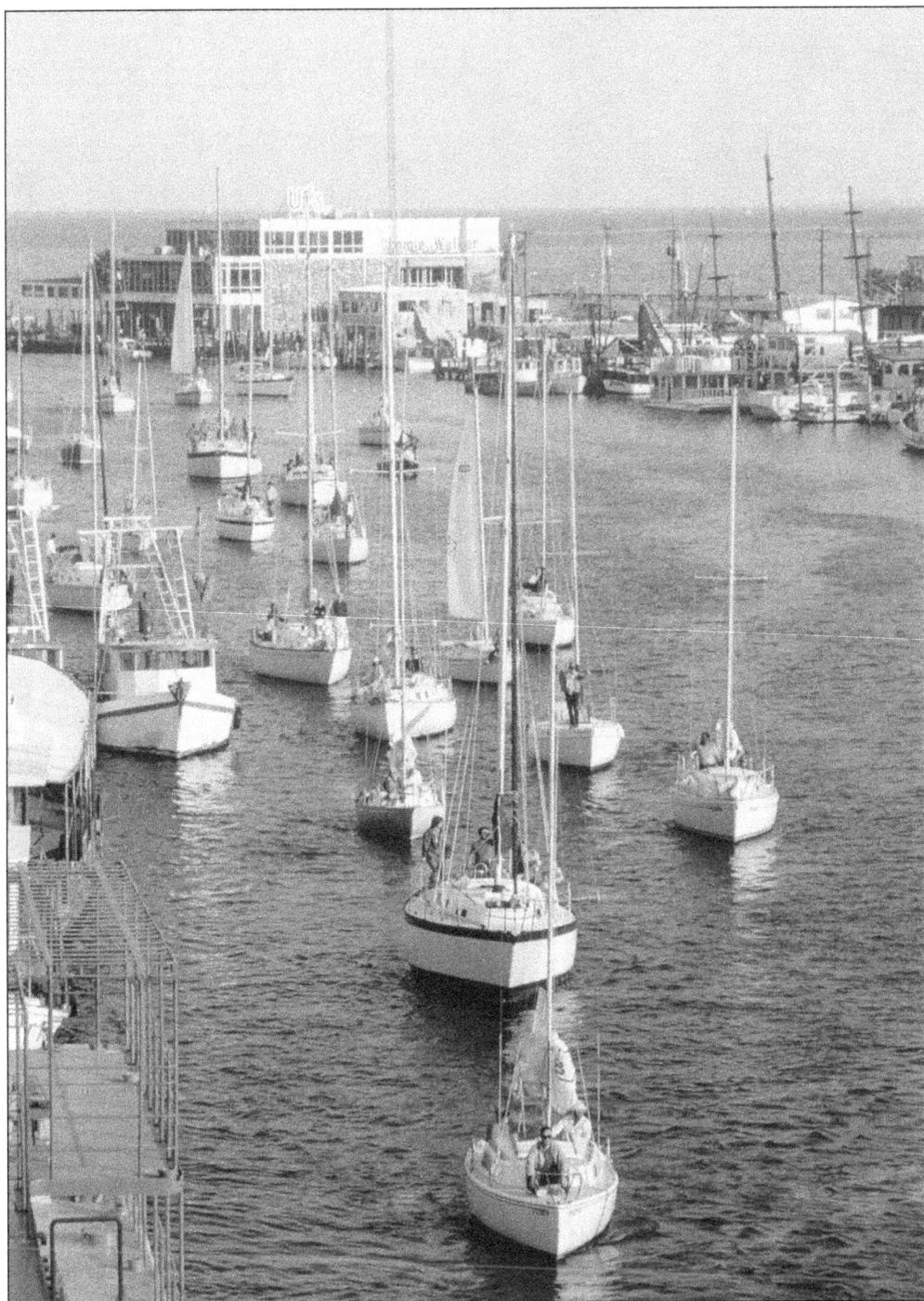

Looking towards Galveston Bay from atop the Seabrook-Kemah drawbridge in 1980, this photograph shows boat traffic in the Clear Creek Channel on a busy weekend. Boaters had to circle in the channel, and with sailboats being 30 feet or more long, this was a tricky maneuver to do without hitting other boats. Once the bridge opened, boats went under single file. (Courtesy of Ruth Burke.)

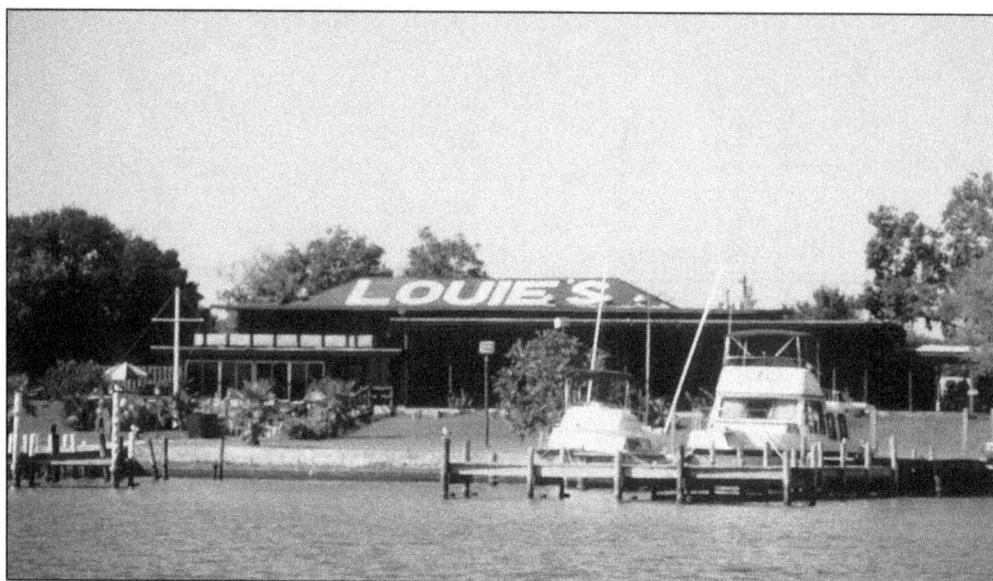

Louie's on the Lake was a popular restaurant from the 1970s into the 1980s. Located on the north shore of Clear Lake, it was frequented by astronauts and locals alike, who dined on the freshest seafood in a lakefront, party atmosphere. The building was originally a beautiful summer estate built in the 1920s by E.A. Peden on property linked to legends of buried treasure from Jean Lafitte. (Courtesy of Ruth Burke.)

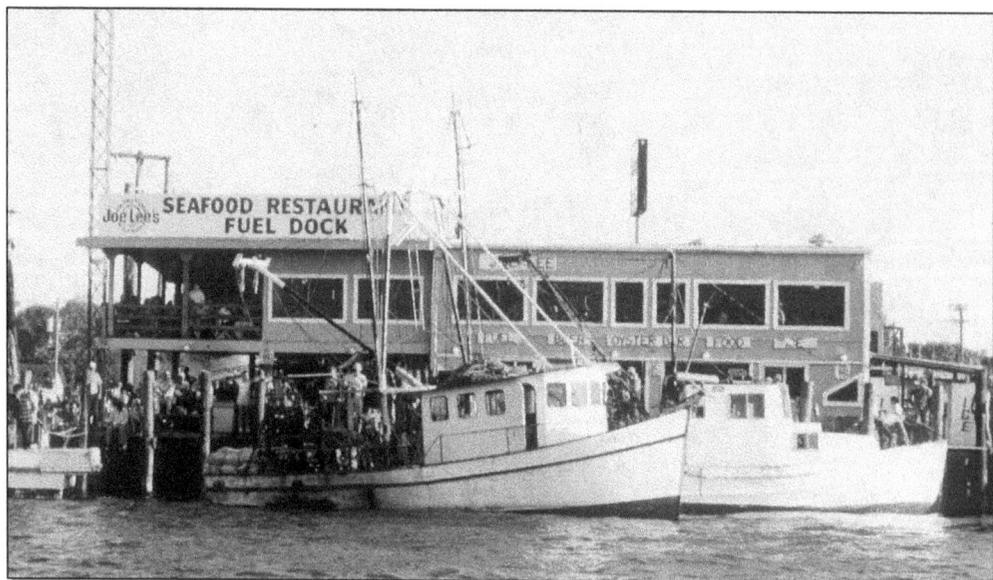

In 1979, Joe and Suzanne Lee bought an abandoned building on the channel in Kemah and opened Joe Lee's Seafood Restaurant. It was a casual place where patrons could dock their boats and go inside to eat or eat outside overlooking the channel. On weekends, the upper deck was packed with people eating and watching the sailboats circle in the channel as they waited for the drawbridge to open. In 1997, Tilman Fertitta purchased the property and changed its name. (Courtesy of Ruth Burke.)

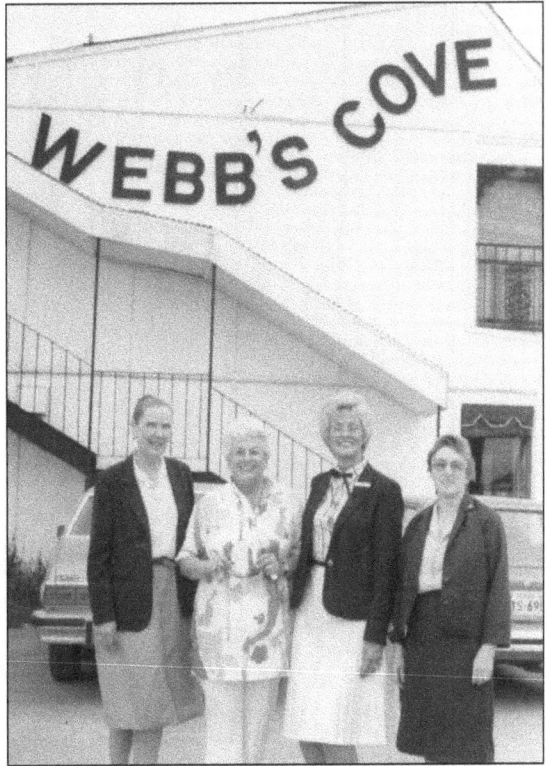

Lois Webb was a well-known local restaurateur who developed signature seafood dishes for her restaurant, Webb's Cove, which was on NASA Road 1 in Seabrook in the 1970s and 1980s. Her place was popular with locals and frequented at lunch by NASA employees. There was always something creative cooking, with Webb perfecting shrimp fried with coconut in the batter and oysters on the half shell grilled with seasonings. Webb is seen below showing off fresh seafood. She later expanded into catering and was sought after for her creative displays of food. She catered events at landmark locations such as the San Jacinto Monument, where she filled a wooden boat with raw oysters and carved bread displays in the shapes of alligators. (Both courtesy of Ruth Burke.)

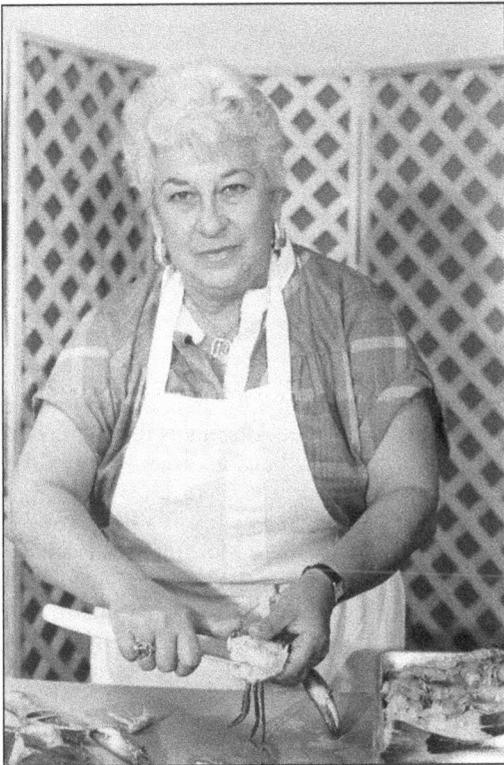

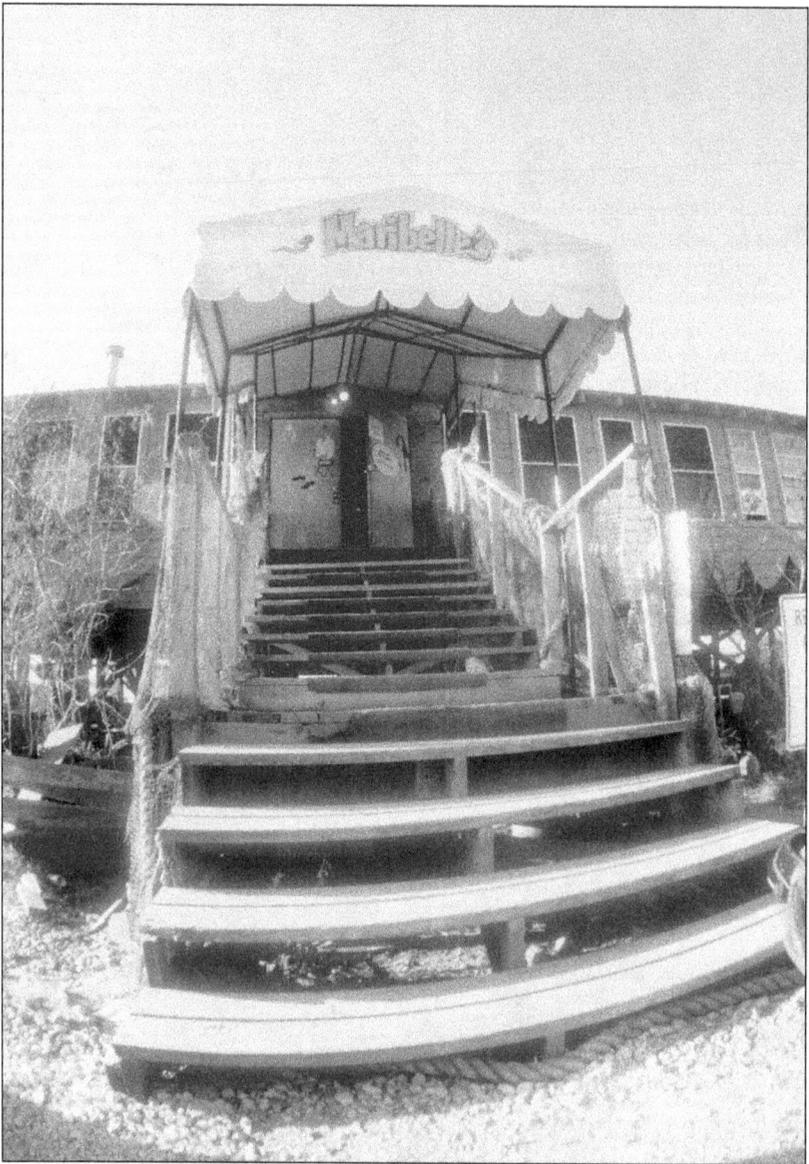

Maribelle's shocking pink restaurant and bar opened in Seabrook in 1969 in a former summer home on the waterfront. It made history as a hangout place where astronauts ducked out of the spotlight of the space program. Maribelle Easter was an "army brat" and met many of the astronauts through her father, who was involved in the Guided Surface-to-Air Missile Program at White Sands Missile Range. In 1961, she first opened Castaways, which was a hideaway for many famous people, including Willie Nelson, who wrote "Bloody Mary Morning" while sitting on the floor in the bar one morning. A freak storm came up Galveston Bay during a Valentine's Day party in 1969 and blew the place down while the band continued playing "How High's The Water, Momma?" She reopened with the name Maribelle's in the building seen here in 1969. It was rumored that she gave 500 hippies $1 to decorate the place. Tattered shrimp nets hang from the corners, and business cards and photographs of patrons and friends are plastered to everything. Its bright pink color was a landmark on the Seabrook waterfront until Hurricane Ike swept the building away in 2008. (Courtesy of Ruth Burke.)

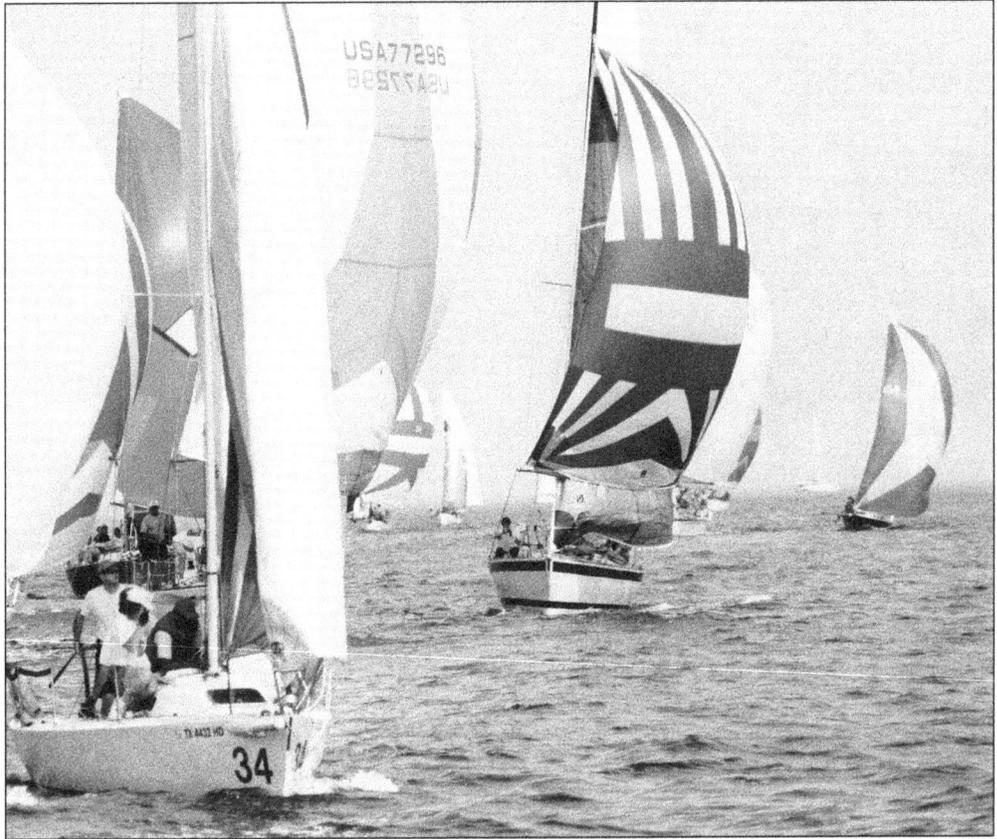

Sailing regattas became a common sight on Galveston Bay in the 1980s. The Lakewood Yacht Club sponsored many races, including the Walters National Offshore One-Design (NOOD) race seen here. The brightly colored spinnakers could often be seen from shore. (Courtesy of Lakewood Yacht Club.)

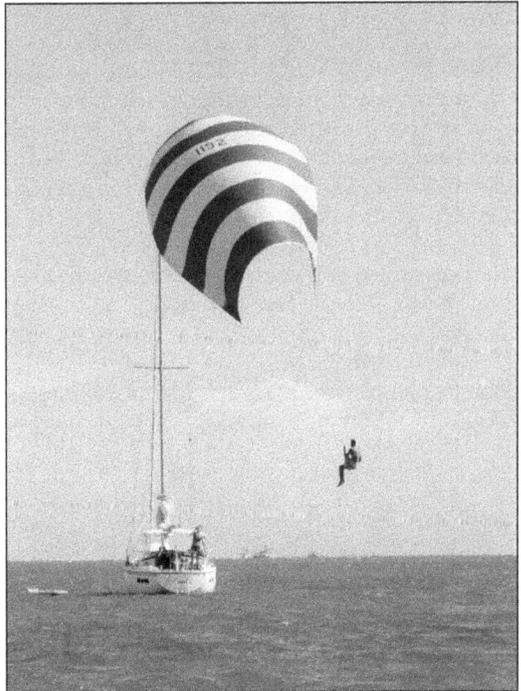

When this photograph was taken in the 1980s, it was common to see people riding their spinnaker sails while their boats were anchored in Galveston Bay. Usually, boats would anchor near Red Fish Island, which formed a naturally smooth water section in the bay. (Courtesy of Ruth Burke.)

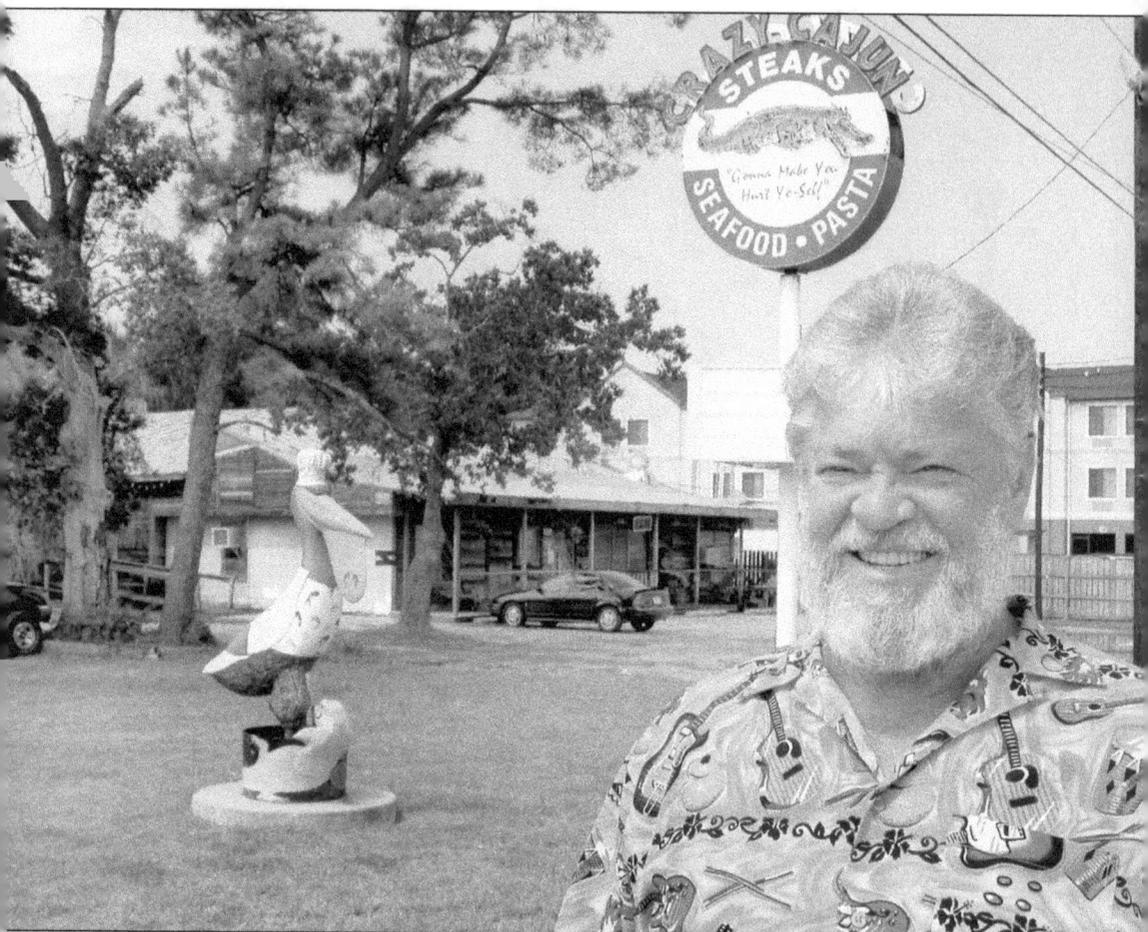

One of the most popular restaurants and hot spots in the Clear Lake Area was the Crazy Cajun Food Factory, located on NASA Road 1 in Seabrook. It was opened on October 28, 1982, by proprietor Sonny Payne, who is seen here in front of the restaurant. In January 1984, it was selected as the best restaurant in Houston after one year in business. It was also selected as having the best Cajun food in the Houston-Galveston area by *Houston Monthly* magazine. The Crazy Cajun was host to many celebrities, including country and western musicians, actors, attorneys, and sports stars. Musicians Willie Nelson, Kenny Rodgers, and Dolly Parton, film and television stars Melissa Gilbert, Tom Hanks, Kevin Bacon, and Ron Howard, sports figures Earl "The Pearl" Cambell and Bum Phillips, and attorneys Richard "Racehorse" Haynes and Joe Jamail were just a handful of famous faces who walked through the doors of the Crazy Cajun. Payne closed the doors of the Crazy Cajun in 2005 but still caters events and sells Crazy Cajun–brand spices. (Courtesy of Sonny Payne.)

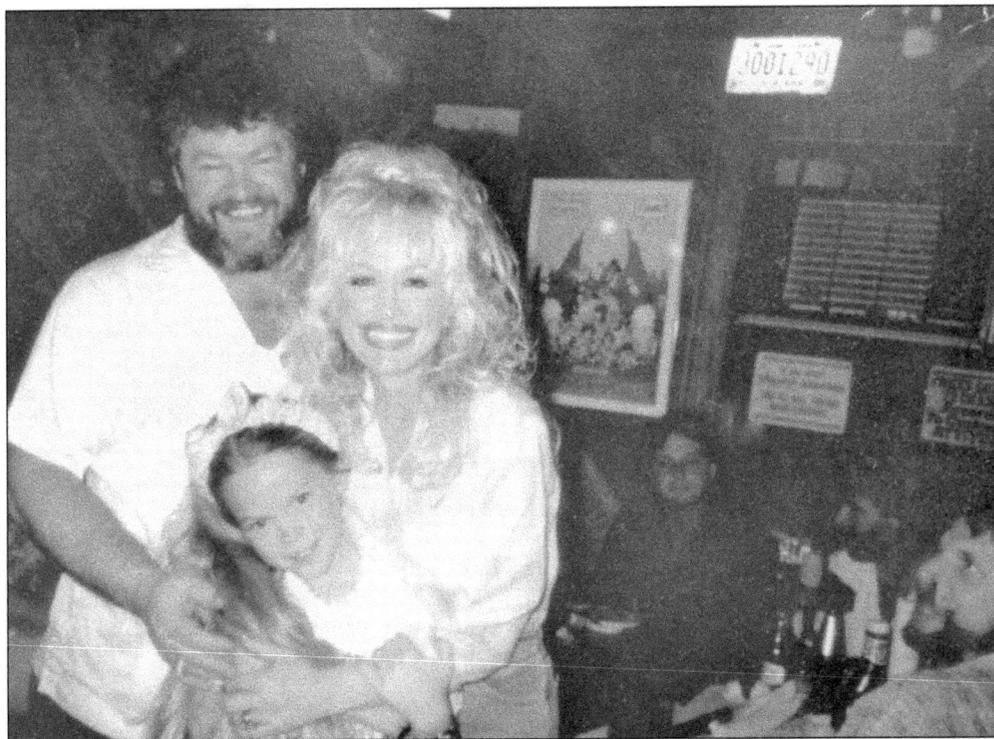

Crazy Cajun Food Factory owner Sonny Payne welcomed country music legend Dolly Parton to his restaurant. Parton was a frequent visitor to the Crazy Cajun when she visited the Clear Lake Area. She is seen here with Payne and his daughter Sondra. (Courtesy of Sonny Payne.)

One of Payne's favorite visitors to the Crazy Cajun was evangelical minister James Robison, seen here with Payne in the 1980s. Robison is the founder and president of Life Outreach International and cohosts the daily television program *LIFE Today* with his wife, Betty, which is still on the air today. (Courtesy of Sonny Payne.)

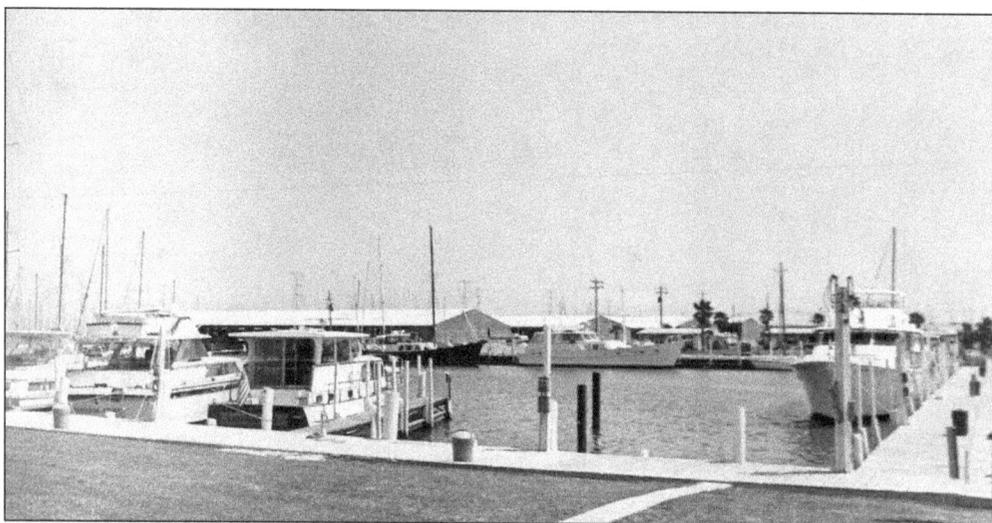

This photograph shows the early construction of the inner harbor at Lakewood Yacht Club, which opened in 1955 on the northeast corner of Clear Lake in Seabrook. When Pres. Lyndon Johnson moved NASA to the Clear Lake Area at the request of several influential Texas Democrats, Lakewood Yacht Club offered its cabanas to house the astronauts until facilities could be built at NASA. The first astronauts lived at Lakewood in 1964 and 1965. (Courtesy of Lakewood Yacht Club.)

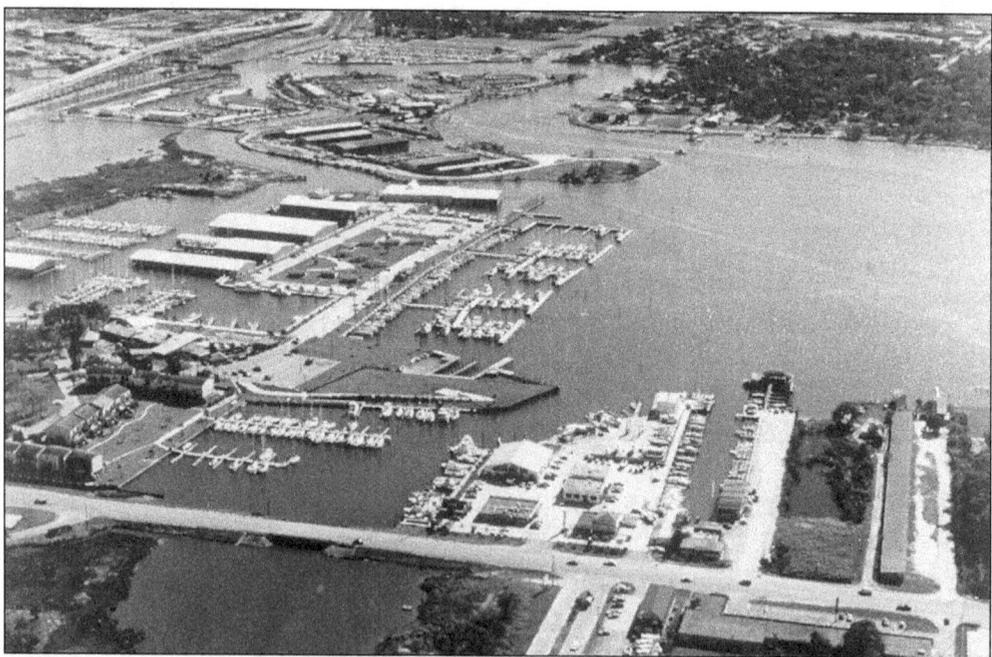

Lakewood Yacht Club is located on 38 beautifully landscaped acres with over 300 covered and open boat slips. In 1977, the club allowed sailboats to be docked there. A ballroom was added in 1985, and piers F and G were rebuilt in 1988, when this photograph was taken. (Courtesy of Lakewood Yacht Club.)

Francesco (Frankie), left, and Giuseppe Camera are pictured in the family's first restaurant, Frenchie's, which opened in 1979 at the corner of NASA Road 1 and El Camino Real. They were born on the isle of Capri in Italy. The space center brought them to Texas when their sister Olga and her husband, a NASA engineer were asked to relocate from Virginia. Frankie says, "I came to America in 1973, then my brother and his family came and then my sister, Anne. In 1979 we decided to live here for the rest of our life so we open a small restaurant called Frenchie's. . . . The sign was there [on the building], that is why we call the Italian Restaurant, Frenchie's. Soon after we open, NASA astronauts flock in, so we had to enlarge twice. Business was incredible, so we decide to open a restaurant on the lake." In 1988, Villa Capri opened in a beautiful spot overlooking Clear Lake in Seabrook. The *Houston Chronicle* in May 1996 said, "At Villa Capri . . . Italian is the specialty of the house. That and the view enjoyed by everyone from Presidents on down. Splashdown parties for returning astronauts were held there." At Frenchie's, the walls are lined with signed astronaut photographs and memorabilia thanking the Camera family for being there, a decision that brought a bit of Italy to the Moon. (Courtesy of Ruth Burke.)

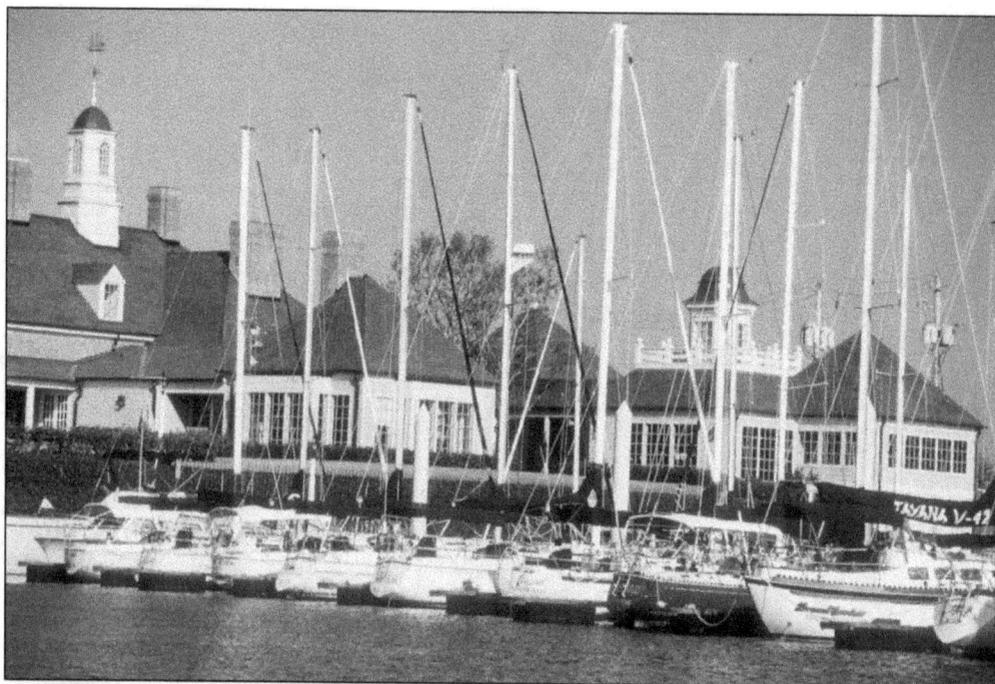

The Waterford Harbor Yacht Club, on the north side of Clear Lake in League City, was formed in 1999 by a group of charter members led by Bob Trask and Lewis Cade, who wanted to create an active club with social activities and boating programs for sailors and power-boaters alike. It is currently the fastest-growing yacht club on the Gulf Coast. (Courtesy of Ruth Burke.)

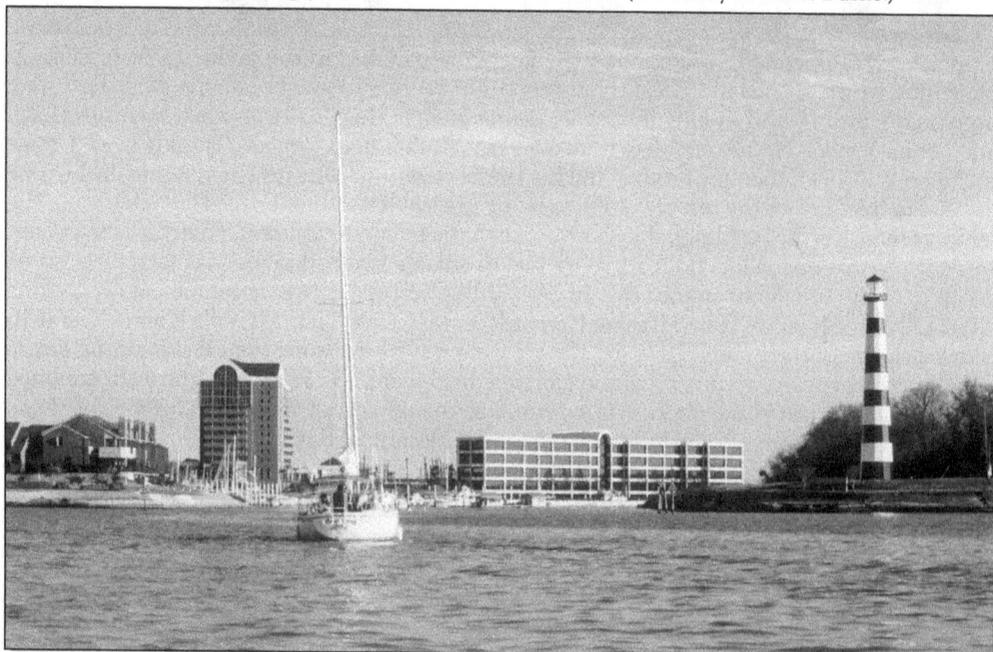

On July 1, 1983, South Shore Harbour Marina opened its doors to the boating community on the south shore of Clear Lake. With its landmark lighthouse guiding boaters home, the 855-slip marina is known as one of the best marinas on the Gulf Coast. (Courtesy of Ruth Burke.)

Taylor Lake, which is fed from Clear Lake, provides calm water for waterskiing. When this photograph was taken in the 1980s, the banks of Taylor Lake were mostly wooded forest. This area was heavily developed in the 1990s into subdivisions featuring massive waterfront homes. (Courtesy of Ruth Burke.)

Armand Bayou, near the bridge on NASA Parkway, is a common place to view windsurfing. There is a launching area in the adjacent Clear Lake Park, and the waters are calm for easy surfing. (Courtesy of Ruth Burke.)

This recent photograph of the Kemah boardwalk shows one of the fast boats frequently seen from the waterfront. The boardwalk features restaurants, hotels, shopping, and amusement rides. (Courtesy of Ruth Burke.)

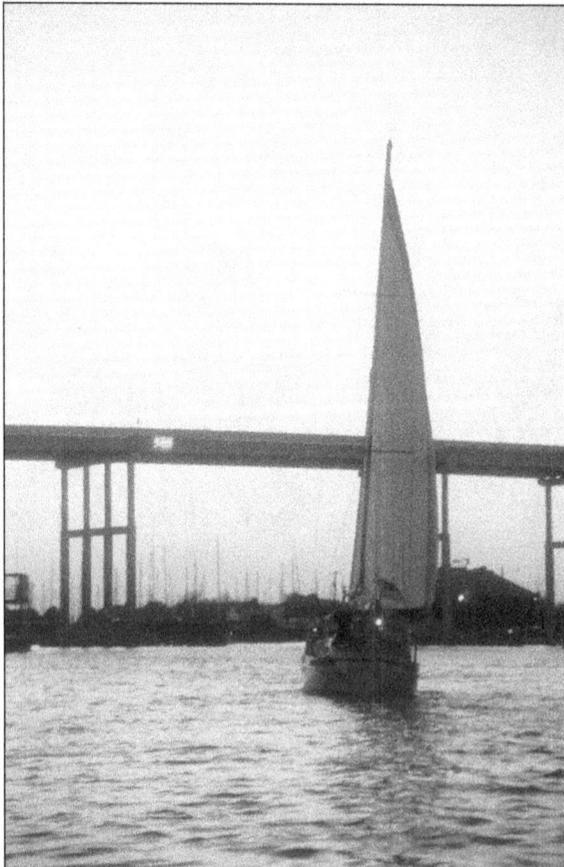

On June 10, 1983, ground was broken on a four-lane, fixed-span bridge crossing the Clear Creek Channel inlet, which separates Harris and Galveston Counties. The bridge opened in 1986, allowing for tall-masted sailboats to pass under the bridge. The Clear Lake Area Chamber of Commerce was instrumental in installing the Texas flag in neon on the bridge. (Courtesy of Ruth Burke.)

Four

THE SPACE AGE AND TECHNOLOGY

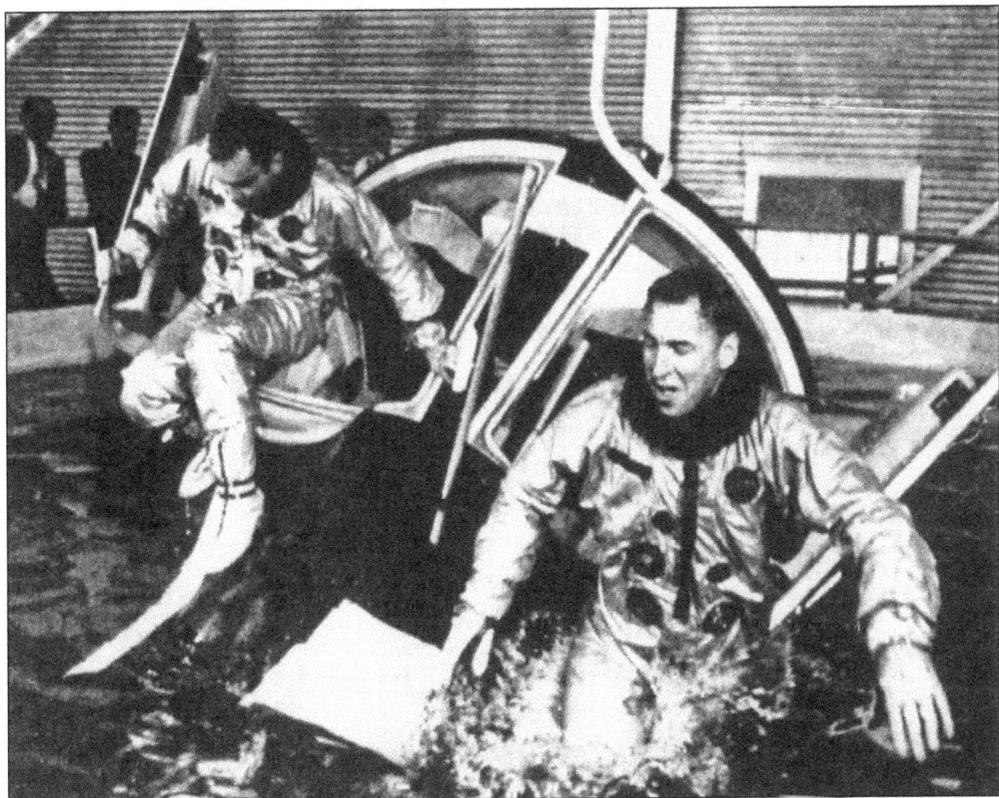

From the moment astronauts stepped into the Gemini spacecraft, they had to be prepared to abort in an emergency. In case the spacecraft sprang a leak or became swamped with seawater through an open hatch, egress methods were developed to remove astronauts from the sinking craft. Here, astronaut trainer Gordon Harvey (left) and astronaut Jim Lovell experience a watery exit from an egress-training tank for Gemini. The training tank was housed at Ellington Air Force Base's Hangar 135. (Courtesy of CLACC.)

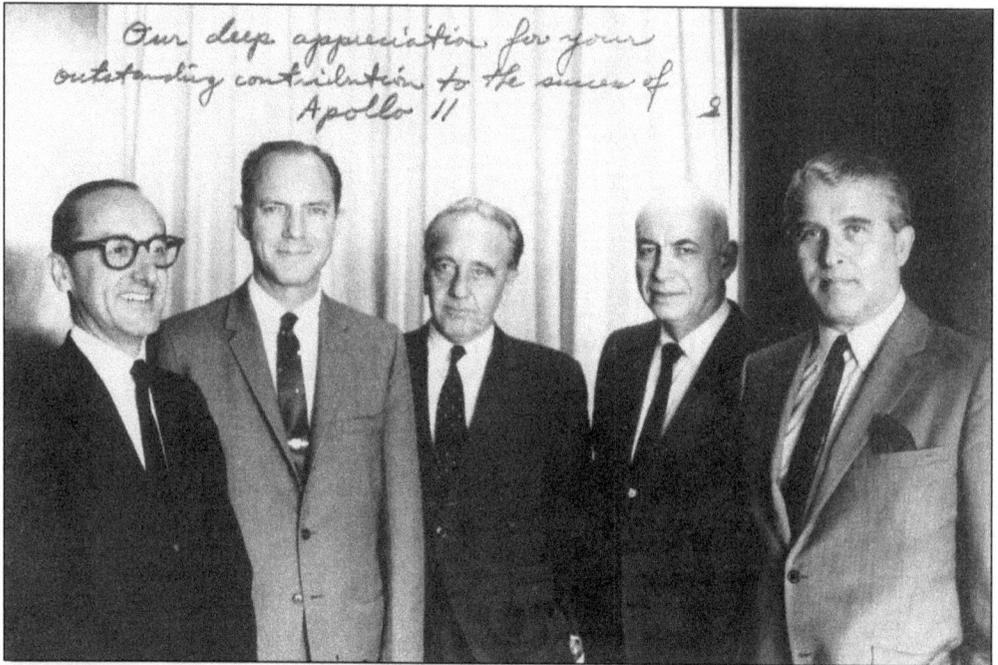

Our deep appreciation for your outstanding contribution to the success of Apollo 11

The historical photograph above shows the leaders of the Apollo space program. The inscription at the top of the image says, "Our deep appreciation for your outstanding contribution to the success of Apollo 11." It is signed "S," indicating that it was originally signed by Apollo program director Gen. Sam Phillips (second from left). From left to right are NASA associate administrator George Mueller; General Phillips; Kurt Debus, the director of the Kennedy Space Center; Robert Gilruth, the director of the Manned Spacecraft Center (now the Johnson Space Center); and Wernher von Braun, the director of the Marshall Space Flight Center. The photograph below is an aerial view of the Johnson Space Center in the 1970s. (Above courtesy of Rose Zarcaro; below courtesy of CLACC.)

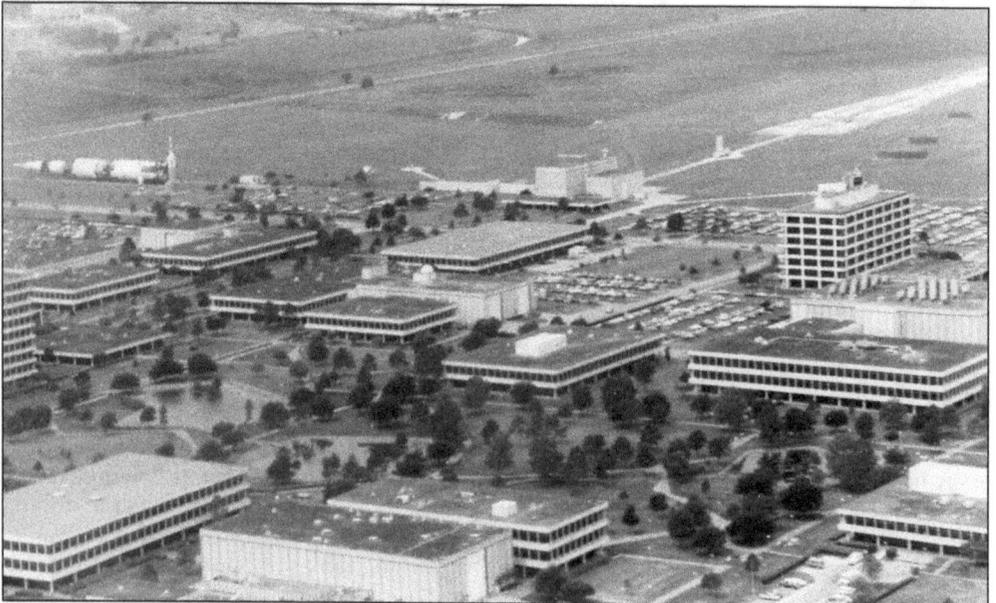

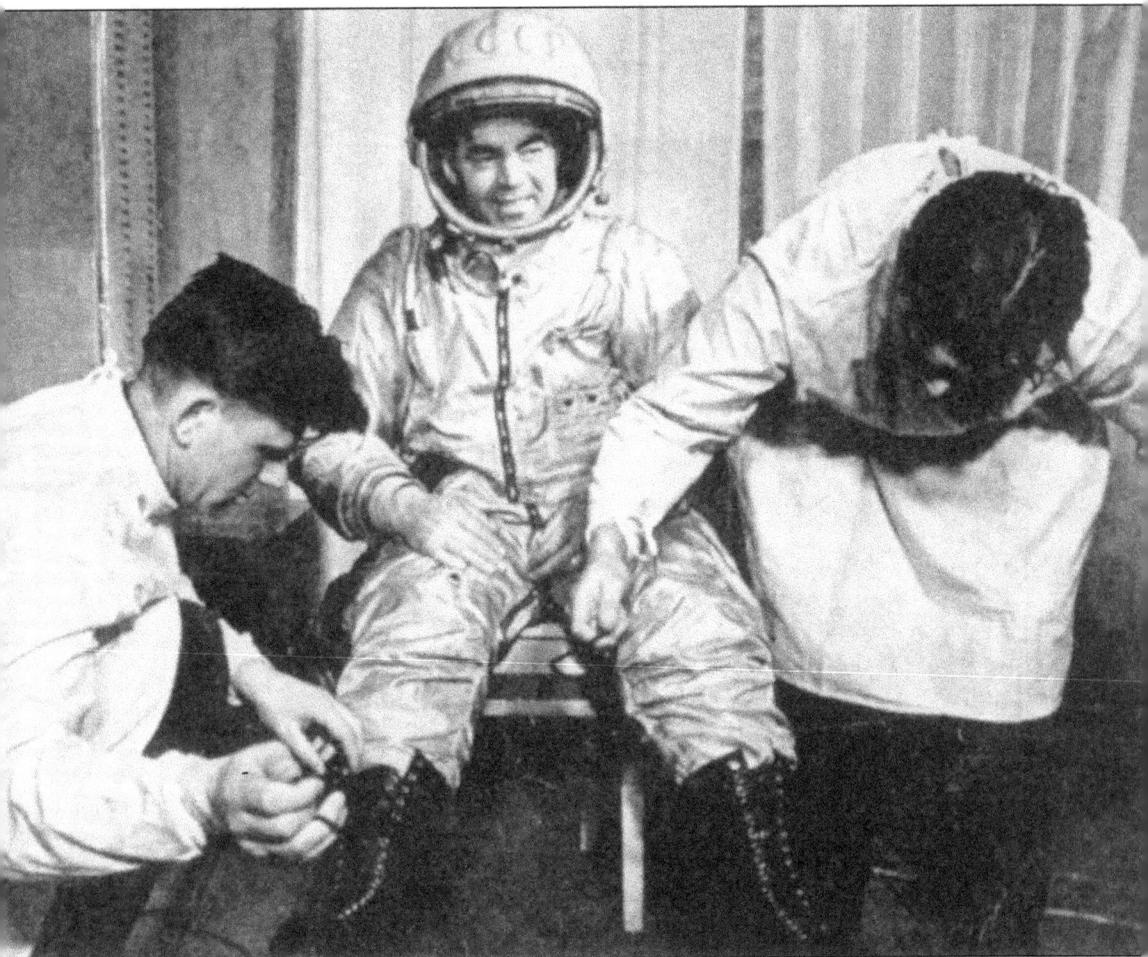

Andrian Nikolayev (1929–2004), a Soviet cosmonaut, is seen here before flying on Vostok 3 on August 11, 1962. Vostok 3, along with Vostok 4, was the first mission in which two manned spacecraft were working in orbit simultaneously. It orbited the earth 65 times, with a mission length of around four days. Nikolayev set new endurance records for the longest time a human being had remained in orbit. He also served as backup for the Vostok 2 and Soyuz 8 missions and flew on Soyuz 9. Nikolayev was the first person to make a television broadcast from space, in August 1962, and he married the first woman in space, Valentina Tereshkova. On January 22, 1969, Nikolayev survived an assassination attempt on Leonid Brezhnev by Soviet army deserter Viktor Ilyin. He left the cosmonaut corps on January 26, 1982. (Courtesy of CLACC.)

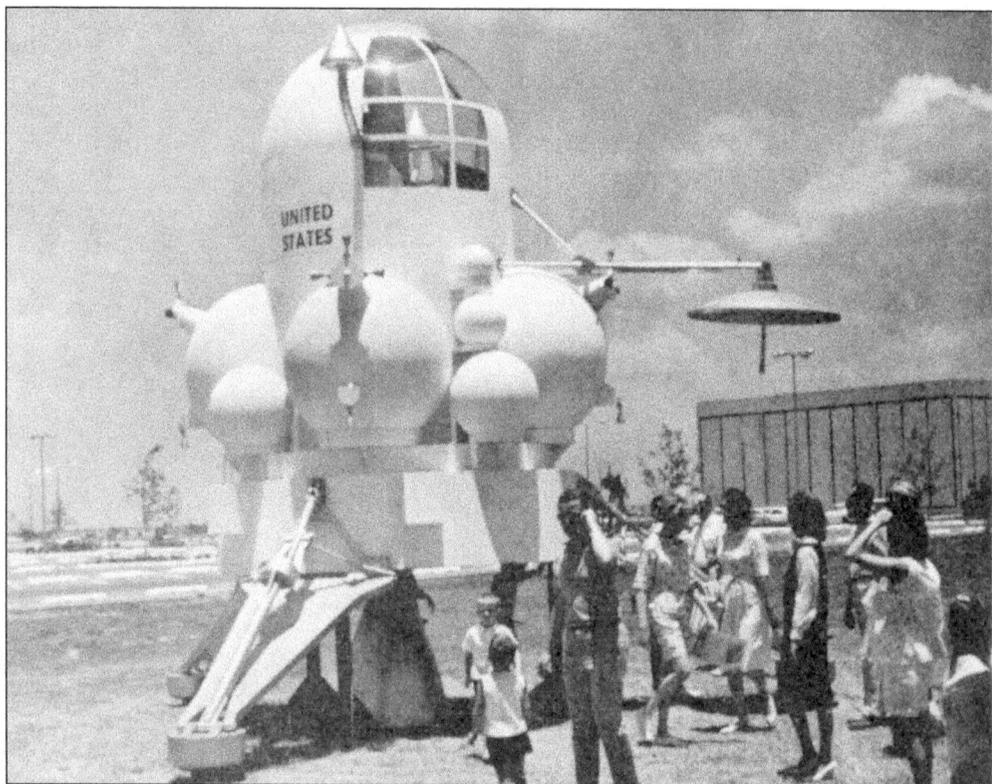

Above, the Lunar Excursion Module, a spacecraft designed to carry astronauts from the Command Module to the surface of the Moon and back, is displayed at the opening of NASA's Manned Spacecraft Center in 1963. Thousands of people poured through the main gates at the Manned Spacecraft Center for a tour of the new facilities. Various exhibits included astronaut Scott Carpenter's pressure suit and survival gear, a mock-up of the Mercury environment control system, a scale model of the Saturn V launch vehicle, and other Gemini and Apollo items. (Both courtesy of CLACC.)

Lt. Col. Edward Higgins White II (November 14, 1930–January 27, 1967) was an engineer, an Air Force officer, and a NASA astronaut. On June 3, 1965, he became the first American to "walk" in space. White died along with fellow astronauts Virgil "Gus" Grissom and Roger B. Chaffee during prelaunch testing for the first manned Apollo mission at Cape Canaveral. He was awarded the NASA Distinguished Service Medal for his flight in Gemini 4 and then was posthumously awarded the Congressional Space Medal of Honor. White also has many schools and hospitals named in his honor, including Ed White Elementary School in El Lago. (Courtesy of CLACC.)

Who Flew When

YURI A. GAGARIN, U.S.S.R.
April 12, 1961—Vostok I
1 orbit—108 minutes

ALAN B. SHEPARD JR., U.S.A.
May 5, 1961—Freedom 7
Suborbital—15 minutes

VIRGIL I. GRISSOM, U.S.A.
July 21, 1961—Liberty Bell 7
Suborbital—15 minutes

GHERMAN S. TITOV, U.S.S.R.
Aug. 6, 1961—Vostok II
17 orbits—25 hours, 18 minutes

JOHN H. GLENN JR., U.S.A.
Feb. 20, 1962—Friendship 7
3 orbits—4 hours, 56 minutes

M. SCOTT CARPENTER, U.S.A.
May 24, 1962—Aurora 7
3 orbits—4 hours, 56 minutes

ANDRIAN G. NIKOLAYEV, U.S.S.R.
Aug. 11, 1962—Vostok III
64-plus orbits
94 hours, 25 minutes

PAVEL R. POPOVICH, U.S.S.R.
Aug. 12, 1962—Vostok IV
48-plus orbits—71 hours

WALTER M. SHIRRA JR., U.S.A.
Oct. 3, 1962—Sigma 7
6 orbits—9 hours, 13 minutes

L. GORDON COOPER, U.S.A.
May 15, 1963—Faith 7
22 orbits
34 hours, 20 minutes

VALERY BYKOVSKY, U.S.S.R.
June 14, 1963—Vostok V
81 orbits—119 hours, 6 minutes

VALENTINA TERESHKOVA, U.S.S.R.
(Mrs. Andrian Nikolayev)
June 16, 1963—Vostok VI
48 orbits—70 hours, 50 minutes

Russia: 259 orbits—382 hours, 27 minutes
America: 34 orbits—53 hours, 55 minutes

John Herschel Glenn Jr. was born on July 18, 1921, and went on to be a US Marine Corps pilot, an astronaut, and a US senator. He was the first American to orbit the earth and the fifth person in space, after cosmonauts Yuri Gagarin and Gherman Titov and fellow Mercury Seven astronauts Alan Shepard and Gus Grissom. Glenn was a combat aviator in the Marine Corps and one of the Mercury Seven, who were the elite US military test pilots selected by NASA to operate the experimental Mercury spacecraft and become the first American astronauts. He flew the *Friendship 7* mission on February 20, 1962. In 1965, Glenn retired from the military and resigned from NASA in order to be eligible to run for public office. A Democrat, Glenn represented Ohio in the US senate from 1974 to 1999. (Both courtesy of CLACC.)

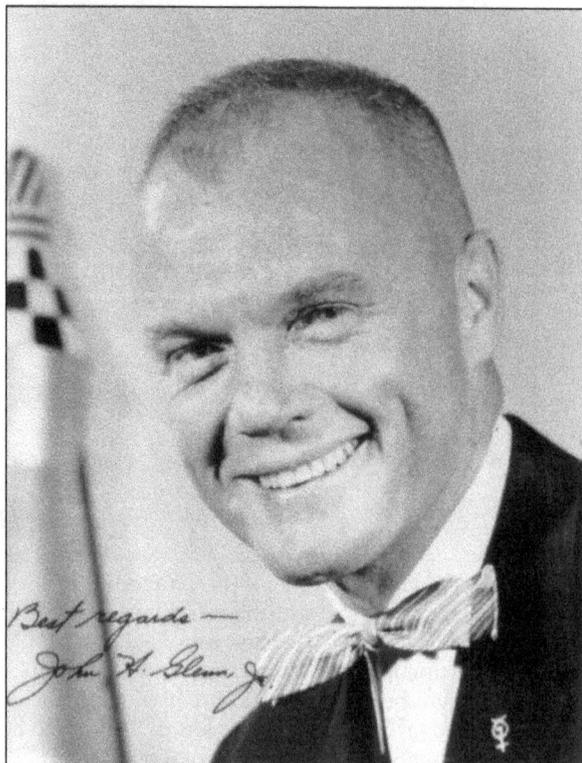

Best regards —
John H. Glenn Jr.

Charlie Duke was born in Charlotte, North Carolina, in 1935, and attended the US Naval Academy in Annapolis, Maryland. Following graduation, he was commissioned into the US Air Force. After being a fighter pilot and a test pilot, he was encouraged by his commandant, Chuck Yeager, to become an Apollo astronaut. His love of adventure took him to the pinnacle of achievement when, on April 20, 1972, he and John Young landed on the surface of the Moon. Their stay on the Moon was a record-setting 71 hours and 14 minutes. Duke and Young spent more than 20 hours exploring. This involved emplacement and activation of scientific equipment and experiments, the collection of nearly 213 pounds of rock and soil samples, and the evaluation and use of Rover-2, their lunar car, over the roughest and blockiest surface yet encountered on the Moon. Duke took the only photographs of the rover in action. (Courtesy of CLACC.)

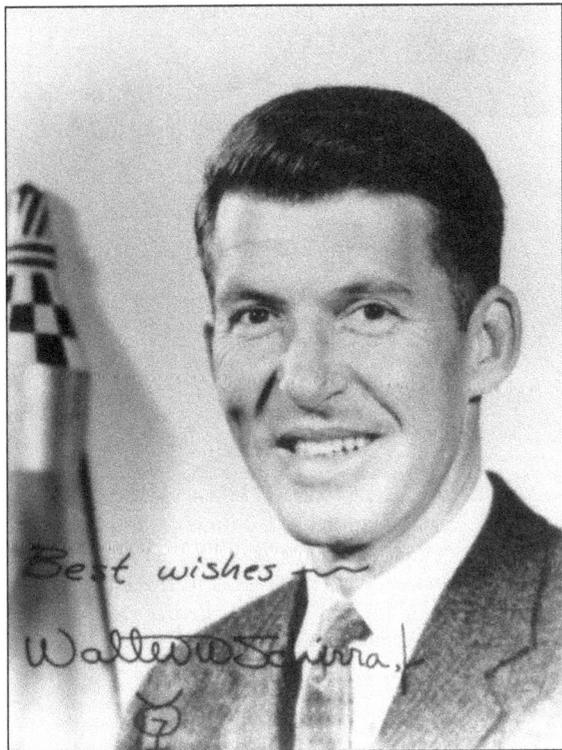

Walter Marty Schirra Jr. (March 12, 1923–May 3, 2007) was an American test pilot, a Navy officer, and one of the original seven astronauts chosen for Project Mercury, America's effort to put humans in space. He is the only person to fly in all of America's first three space programs, Mercury, Gemini, and Apollo. He logged a total of 295 hours and 15 minutes in space. Schirra was the fifth American and the ninth human to ride a rocket into space and the first person to go into space three times. (Courtesy of CLACC.)

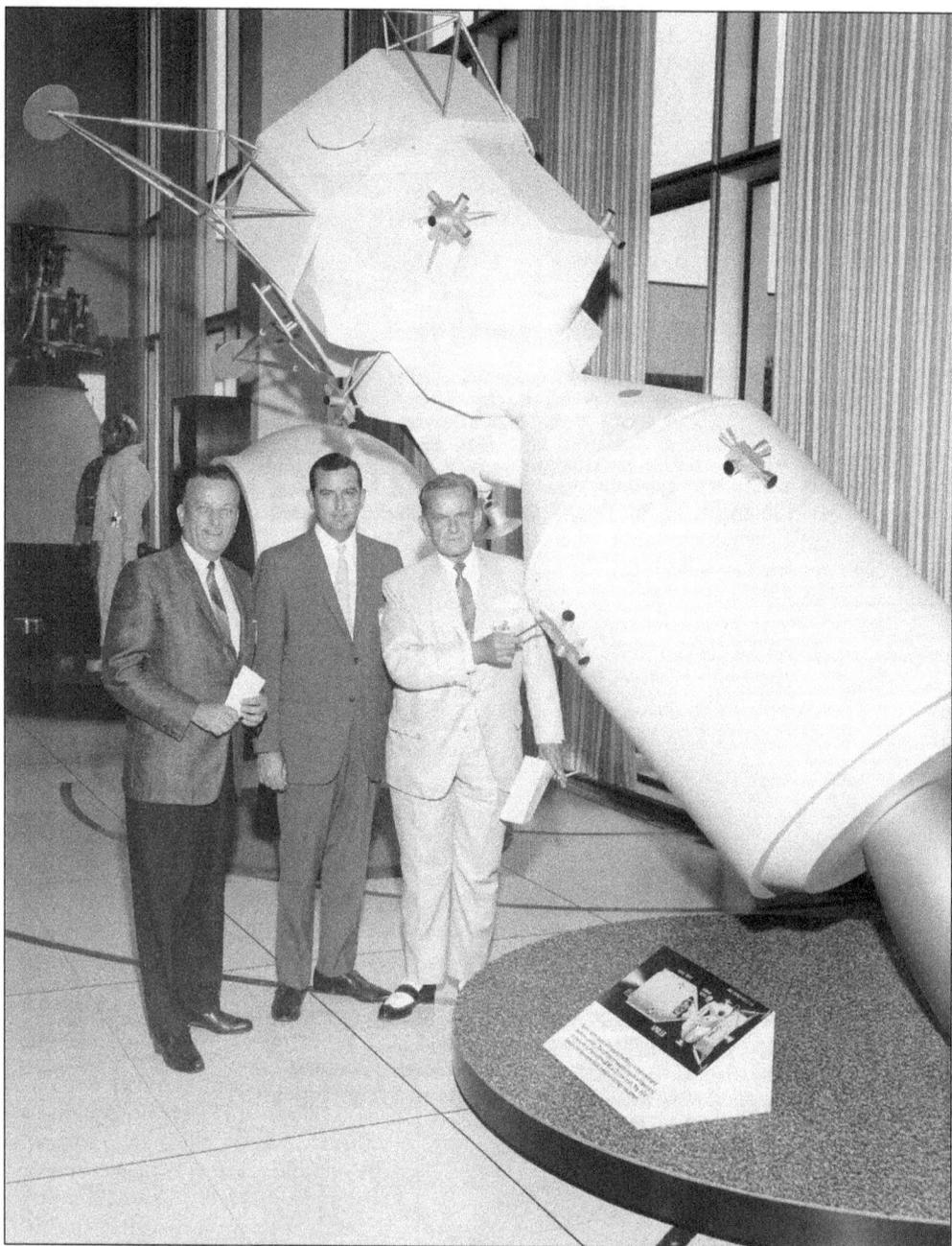

Eugene Lindquist (left), president of the Clear Lake Area Chamber of Commerce, and Dr. Lloyd Ferguson (center), superintendent of the Clear Creek Independent School District and director of the Clear Lake Area Chamber of Commerce, discuss exhibits on display in the lobby of the Manned Spacecraft Center auditorium with Philip T. Hamburger (right), the center's assistant for Congressional relations, during a visit to the center on August 30, 1967. (Courtesy of NASA.)

Eugene Lindquist gives a speech at NASA's Teague Auditorium. Lindquist was instrumental in organizing committees that addressed the four major objectives of the different communities around Clear Lake: business development, community development, public affairs, and organization improvement. (Courtesy of CLACC.)

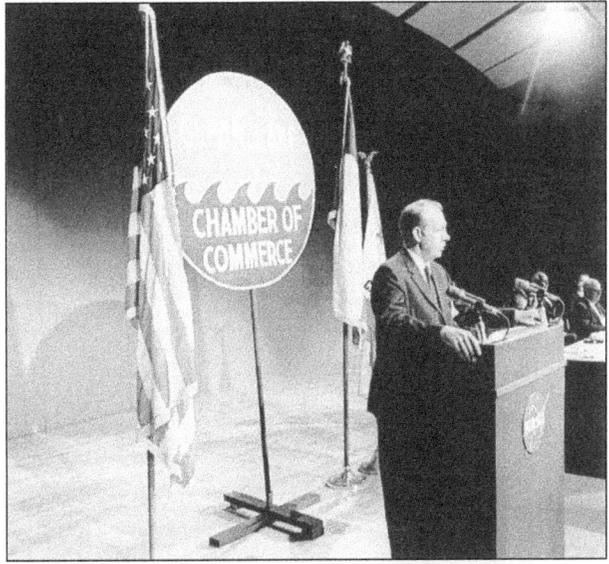

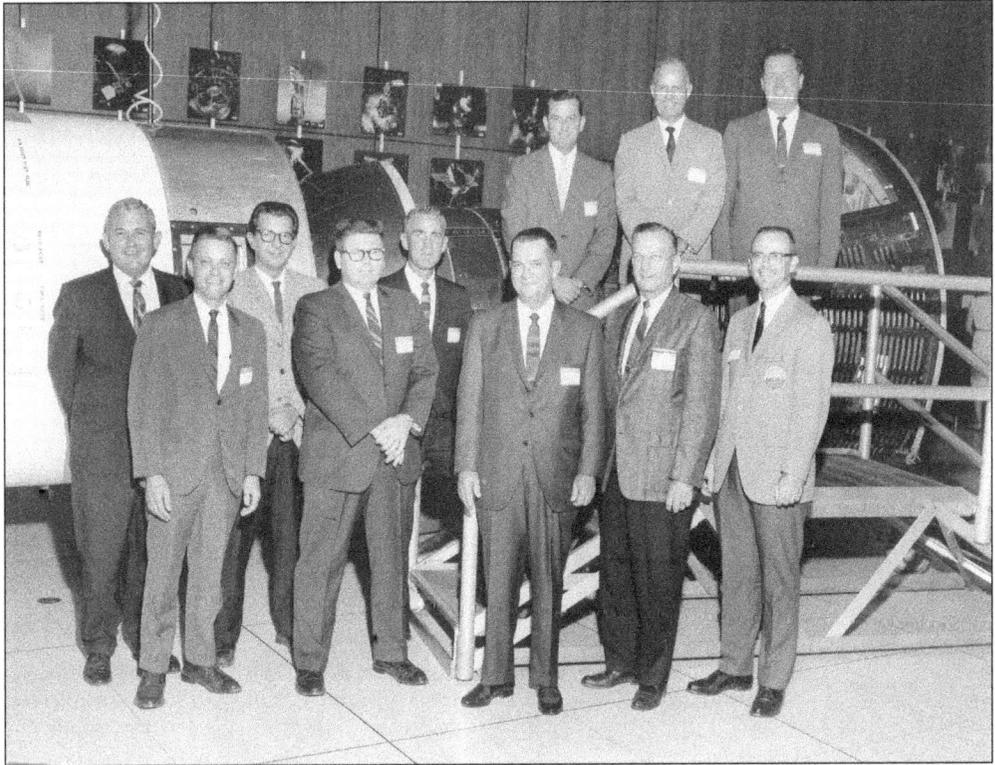

This group of 11 officers of the Clear Lake Area Chamber of Commerce stands beside an Agena Target Docking Vehicle (left) and the Gemini V spacecraft, on display in the lobby of the auditorium of the Manned Spacecraft Center, during a reception and welcome honoring approximately 200 Clear Creek teachers on August 30, 1967. They are, from left to right, (first row) Darwin Gilmore, Dr. Jack Bridwell, Norm Shirley, Eugene Lindquist, and Webb Sharp; (second row) Dave Stewart, James Hummer, Norm Hartwell, Dr. Lloyd Ferguson, John Turner, and Dick Chandler. (Courtesy of NASA.)

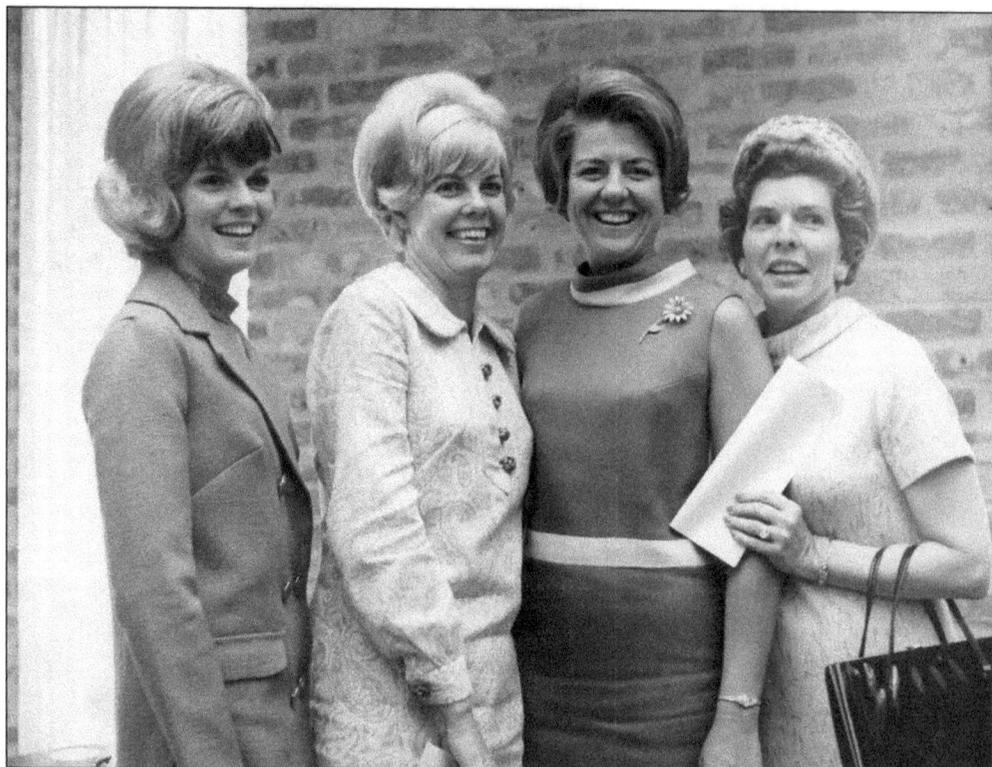

In the 1960s, astronauts' wives were constantly being pursued by the media. Seen here from left to right are Martha Chaffee, the wife of astronaut Roger Chaffee; Norma Lang, the wife of NASA executive Dave Lang; Mary Deck, the wife of NASA executive Art Deck; and Adelin Hammack, the wife of NASA executive Jerry Hammack. Roger Chaffee was killed aboard the Apollo 1 spacecraft. (Courtesy of CLACC.)

Seen here at a March of Dimes benefit in the 1980s are, from left to right, Claudette Alderman, the Clear Lake Area Chamber of Commerce president from 1986 to 2008; Mike Hozelrigs; Donna Birdwell; and NASA astronaut Gordon Cooper, who was an American aeronautical engineer, a test pilot, and one of the seven original astronauts in Project Mercury, the first manned space program in the United States. (Courtesy of CLACC.)

The city rocketed to international prominence when the space center opened for business 50 years ago in Houston, Texas. As Melissa Kean, Rice University's historian, noted in the September 15, 2013, issue of the *Houston Chronicle*, "All of a sudden we went from a sleepy little place to being potentially the most important city in the South. It was like someone flung open a window and the whole way the city felt about itself changed from that moment on." Businesses of all types benefited with the influx of prominent residents. They eagerly touted their support, as shown in these advertisements from May 31, 1964, in the *Houston Chronicle*. Foley's was a prominent department store in Houston with several locations. On September 22, 2013, the original Foley's building in downtown Houston on Main Street was demolished in an implosion. (Both courtesy of CLACC.)

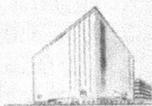

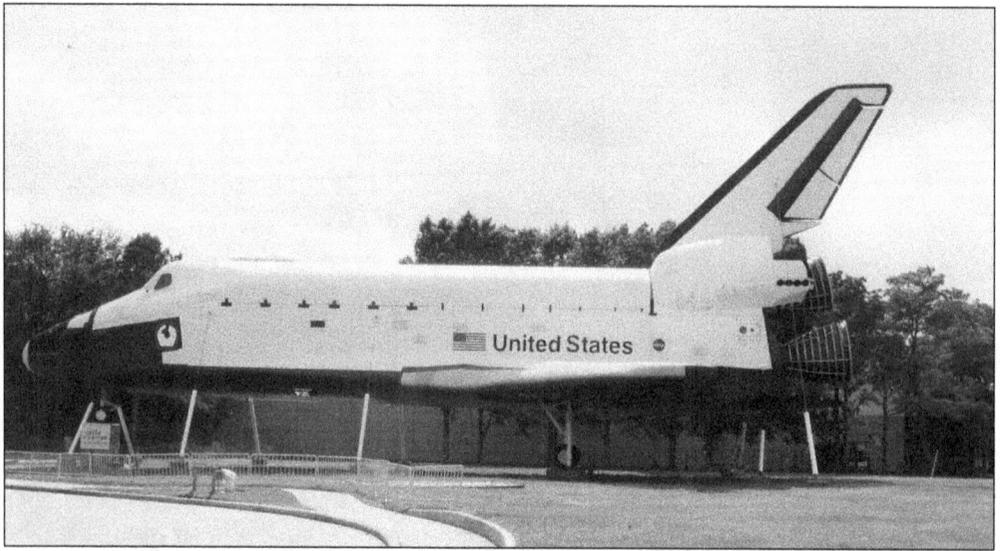

In the spring of 2012, the full-scale Space Shuttle replica *Explorer* was moved onto the grounds of Space Center Houston. The replica was moved by barge on Galveston Bay and through Clear Creek Channel into Clear Lake, where it was loaded onto a truck before reaching its final destination. Built using blueprints and archival documents from NASA, the *Explorer* measures 122 feet in length and 78 feet in height with a 54-foot wingspan. Many of the *Explorer*'s features have been re-created, giving visitors an inside look at an actual space orbiter. NASA's Johnson Space Center hosted a community celebration called "Shuttlebration" on June 1, 2012, for the arrival of the *Explorer*. (Courtesy of CLACC.)

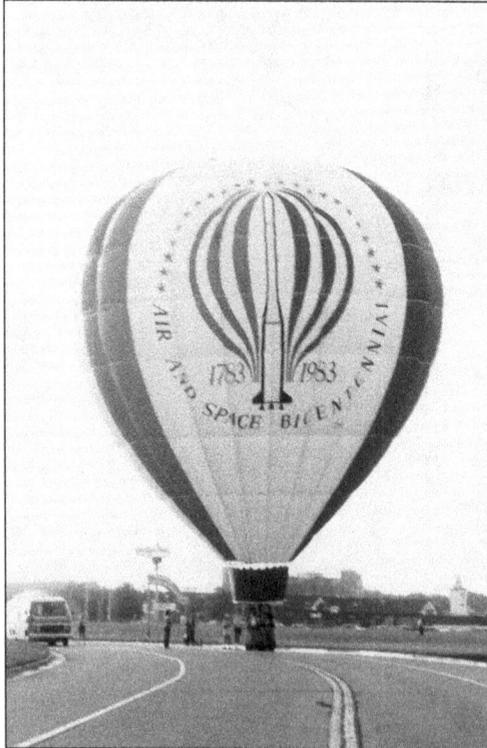

In recognition of 200 years of progress around the globe in manned flight, the US Congress designated the year 1983 as the bicentennial of air and space flight. Pres. Ronald Reagan delivered a proclamation marking the bicentennial and, in a speech, said, "I call upon all government agencies and the American people to observe this year with appropriate ceremonies and activities." Seen here is a hot air balloon used in the celebration of the bicentennial on January 3, 1983. (Courtesy of CLACC.)

Space Center Houston opened on October 16, 1992, and is the official visitor center of the Lyndon B. Johnson Space Center—the National Aeronautics and Space Administration's (NASA) center for human spaceflight activities—in Houston. The facility is operated by the nonprofit Manned Spaceflight Educational Foundation, Inc., with design input from Walt Disney Imagineering. A restored Saturn V, on loan from the Smithsonian Museum, is on display after it sat exposed to outdoor elements from 1977 through 2004, leading to exterior weather damage and plants, mold, and small animals inside the stages. In 2004, the Smithsonian took over and began efforts to restore the vehicle through a grant from the National Park Service's Save America's Treasures program and the National Trust for Historic Preservation, along with a private contribution. The space center is the new home of the Space Shuttle *Explorer* mock-up. (Both courtesy of CLACC.)

Theodore "Ted" Cordy Freeman was born on February 18, 1930, in Haverford, Pennsylvania. He graduated with a bachelor of science degree from the US Naval Academy and married Faith D. Clark on the same day in 1953. A second lieutenant at the time, Freeman opted to get his commission in the Air Force rather than continue in the Navy. In 1960, he received a master of science degree in aeronautical engineering from the University of Michigan. Freeman was assigned to Edwards Air Force Base in California as a flight-test aeronautical engineer. When chosen for the Aerospace Research Pilot Course, a distinctive honor, the possibility of Freeman becoming an astronaut was made public. When he was tapped for the new astronaut team, he moved to Texas for his training at the Manned Spacecraft Center in Houston. On October 31, 1964, Freeman was killed during a routine training flight as he turned to land his plane at Ellington Air Force Base. He was buried at Arlington National Cemetery. Had he not been killed, he may have flown a Gemini mission before moving on to Apollo. The Clear Lake City Library was renamed in honor of Captain Freeman in 1964. When the library became a part of the Harris County Public Library system for the second time in 1972, it became the Freeman Memorial Branch Library. (Courtesy of Ruth Burke.)

Five

CLEAR LAKE
CITY DEVELOPMENT

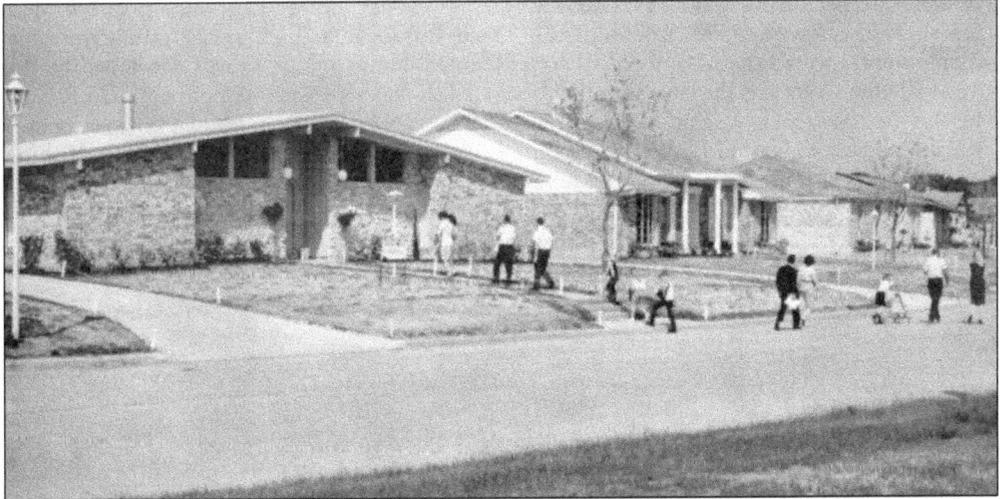

In 1964, Nassau Bay's Galaxy of Homes drew thousands of visitors when 11 beautiful homes, one erected by each contractor building homes in Nassau Bay, were shown. An additional 227 homes were planned and built in the scenic, $100-million residential-commercial development directly across from NASA's Manned Spacecraft Center. One of the strict rules in the Nassau Bay building code called for no two homes to be built alike. (Courtesy of CLACC.)

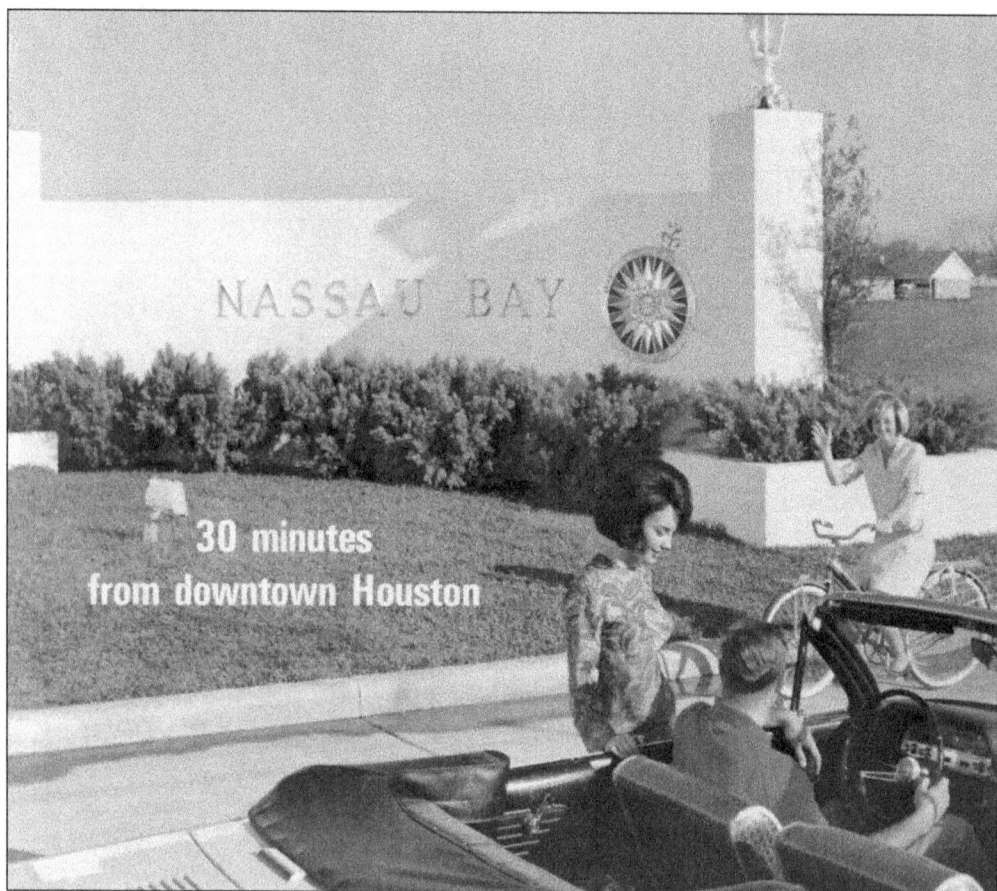

The advertisement above was for Nassau Bay, the prestigious subdivision developed in 1962, just a few short months after NASA put a man in space. It is located directly across the street from the main entrance to the Manned Spacecraft Center. The community was developed by the Ernest W. Roe Company on land that had been Col. Raymond Pearson's Spirit of 1776 Ranch. The site was bounded by Clear Lake, Carlton Bayou, and Swan Lagoon. Many of the astronauts lived and played in Nassau Bay. The brochure below boasted, "Boating, sailing, skiing, fishing and swimming become everyday part of luxurious living." (Both courtesy of CLACC.)

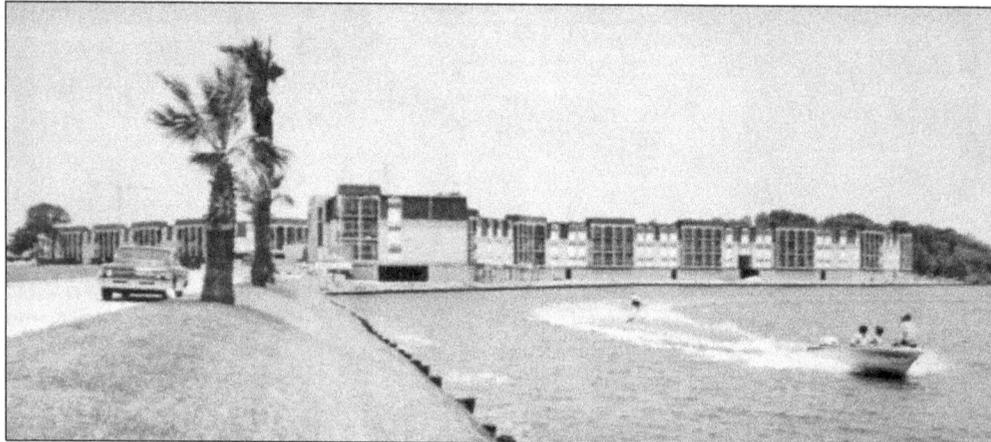

incomparable *living* Surrounded by navigable waterways, incomparable Nassau Bay provides the finest features of both city and resort living. Careful planning takes full advantage of all its natural beauty and combines it with a modern . . . yet gracious way of life.

incomparable

NASSAU BAY

FM 528 Across from the Main Entrance to the Manned Spacecraft Center

Developers aimed to satisfy every possible need with homes built in the Clear Lake Area, which included Nassau Bay, seen here. Other new developments at the time included Timber Cove, El Lago, Bayou Brea, Clear Lake City, Miramar, Seascape, El Cary, and Swan Lagoon. (Courtesy of CLACC.)

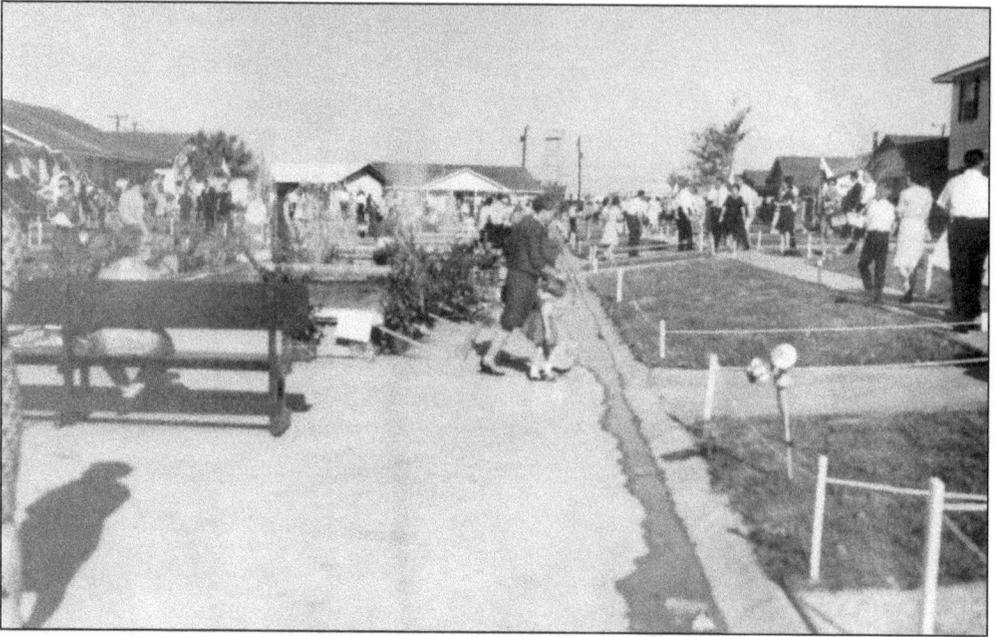

Large crowds tour the offerings of the 1964 Parade of Homes, held at the Newport subdivision in League City. Visitors came from cities all over the Gulf Coast area, as the Parade of Homes had become a popular annual regional event. (Courtesy of CLACC.)

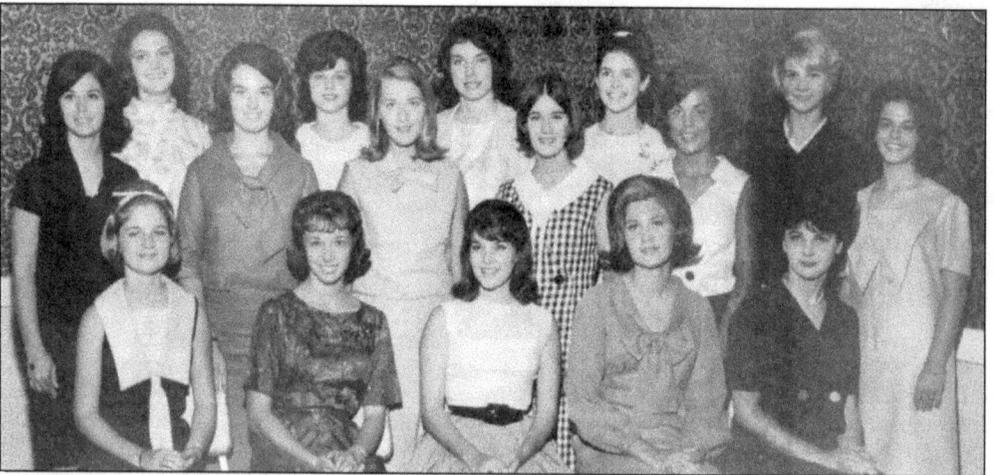

One of these beauties was named Miss Parade of Homes at the closing ceremony at the Newport subdivision, the site of the 1964 Parade of Homes at League City. Prizes and awards were given to the contest winner. Congressman Bob Casey officiated the crowning of Miss Parade of Homes, who was selected from 20 young women who served as hostesses during the event. (Courtesy of CLACC.)

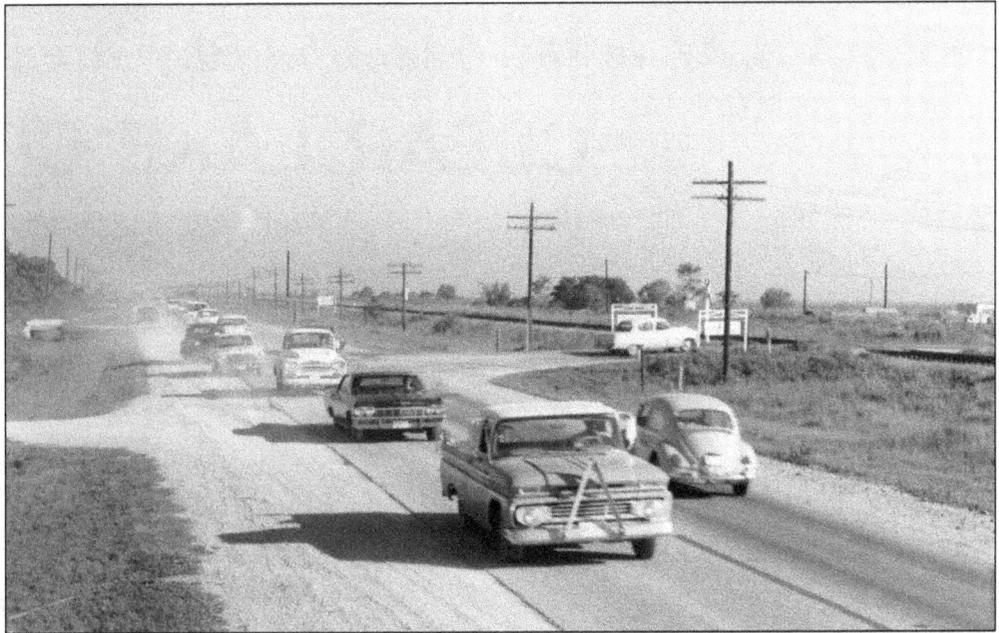

This photograph shows the newly built NASA Road 1 as it traveled through the town of Webster between Interstate 45 and Highway 3. The photograph looks west and shows an unusual event in 1965—a traffic jam. (Courtesy of CLACC.)

This photograph, also taken in 1965, shows motorists traveling north and south on Highway 3 near what is now the intersection with Bay Area Boulevard. (Courtesy of CLACC.)

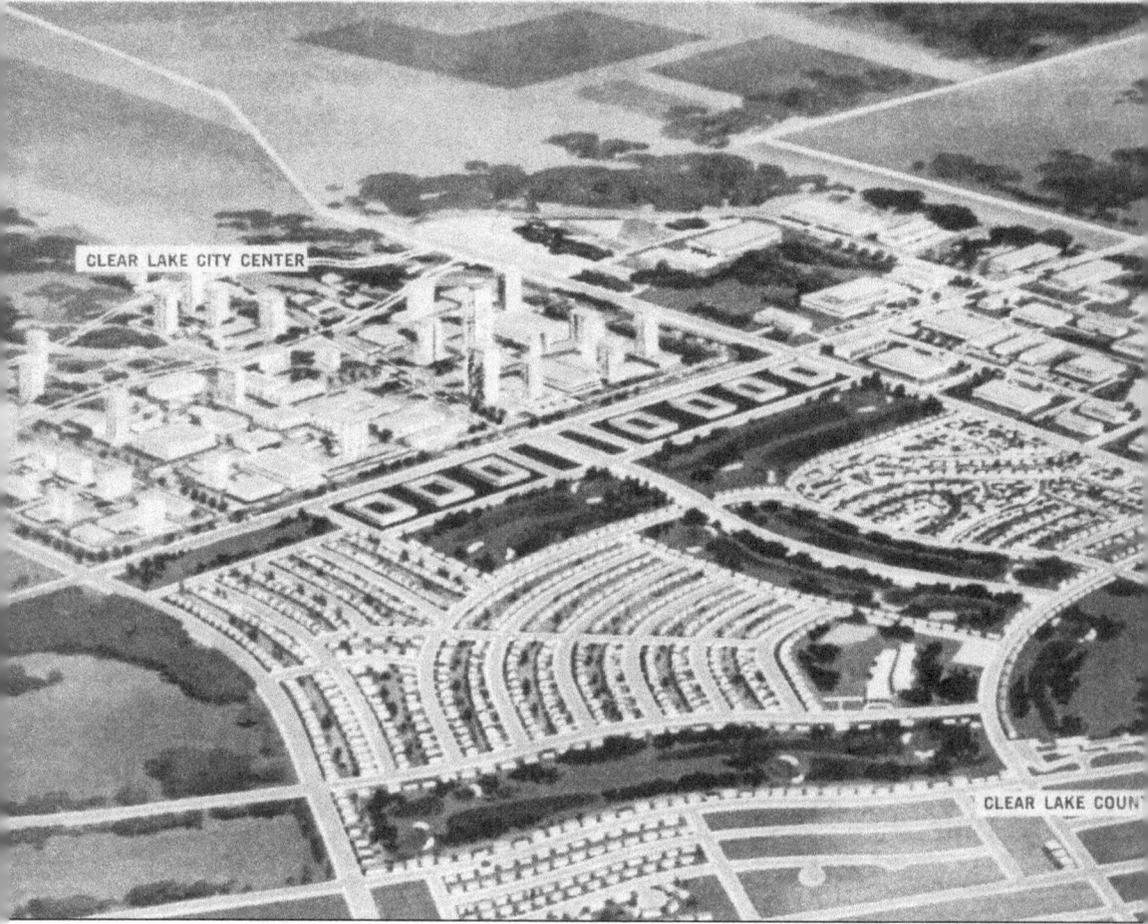

CLEAR LAKE CITY CENTER

CLEAR LAKE COUN

The *Houston Chronicle*'s May 31, 1964, edition of *Texas* magazine, entitled "Houston to the Moon: A Special Issue on Man in Space," featured this double-page illustration of Clear Lake City, a planned community that was being developed by Humble Oil and the Dell E. Webb Corporation

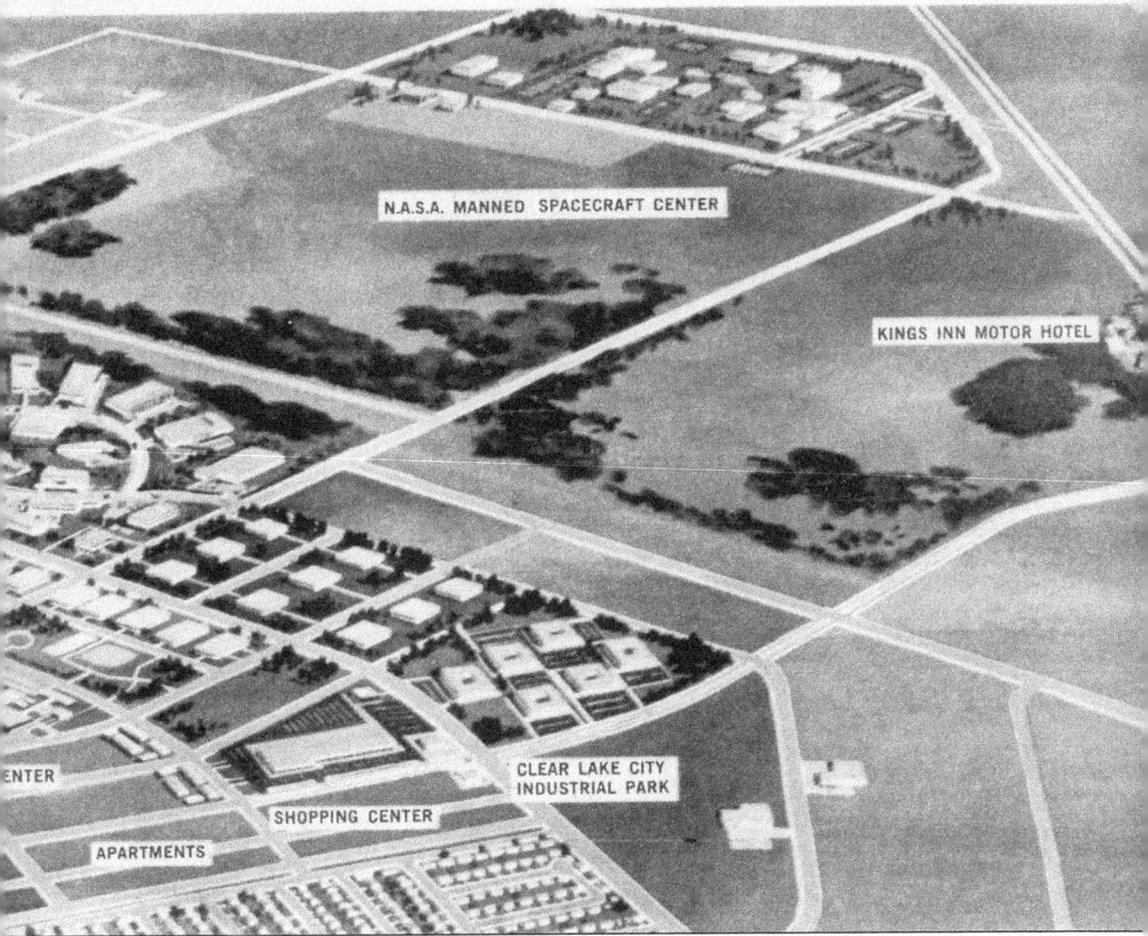

N.A.S.A. MANNED SPACECRAFT CENTER

KINGS INN MOTOR HOTEL

ENTER

CLEAR LAKE CITY INDUSTRIAL PARK

SHOPPING CENTER

APARTMENTS

for the Friendswood Development Company. The area adjoined the Manned Spacecraft Center on the west and was to cover approximately 15,000 acres. (Courtesy of CLACC.)

The Clear Lake Area Chamber of Commerce was founded in 1962 with the merger of the Seabrook and Kemah Chambers of Commerce. It was a time when bulldozers were slicing through cow pastures to meet the nation's newest, most urgent technological mission: manned space flights. Nassau Bay, Clear Lake City, El Lago, Webster, and Taylor Lake were all served by the newly formed chamber. In 1974, the League City Chamber of Commerce merged with it as well. (Courtesy of CLACC.)

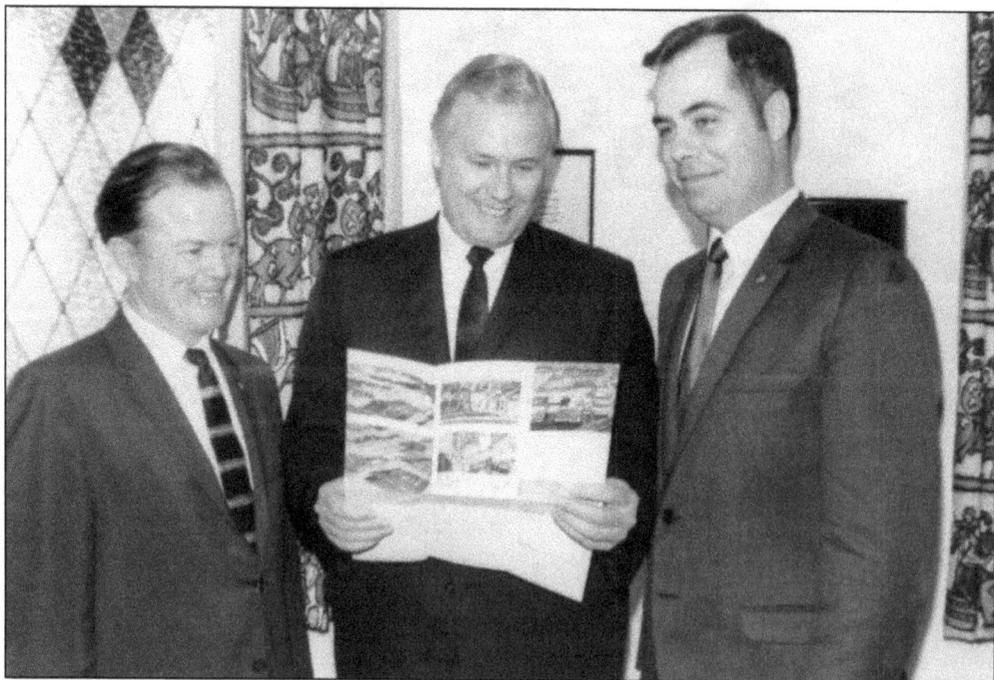

Martin Gracey (left), the Clear Lake Area Chamber of Commerce chairman of the board from 1967 to 1968, Bob Scott (right), the chairman of the board from 1969 to 1970, and an unidentified man look at a brochure advertising a new development in April 1969. (Courtesy of CLACC.)

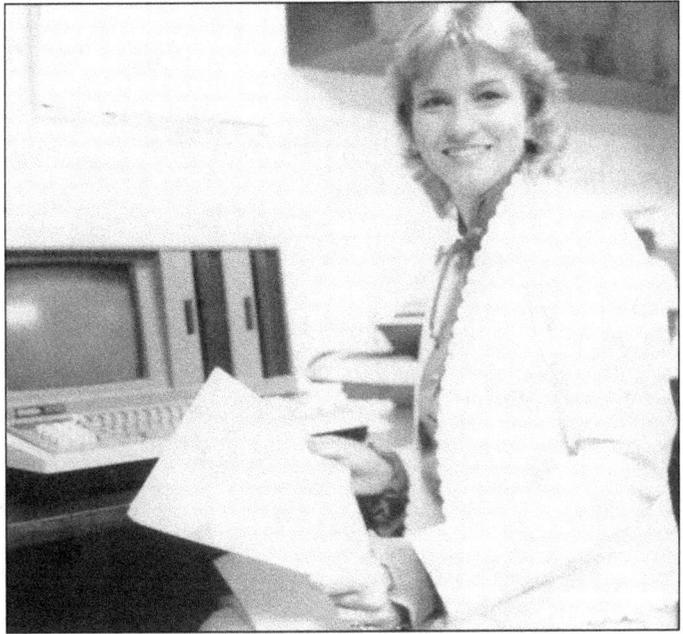

Cindy Harreld is seen here working on a Wang computer. She joined the staff of the Clear Lake Area Chamber of Commerce in November 1983 as the director of software, responsible for the chamber's bookkeeping, billing, and computer operations. Within a few years, she became the director of special projects, a position she held for 20 years, until 2008, when she was promoted to her current position as president and CEO of the Clear Lake Area Chamber of Commerce. (Courtesy of CLACC.)

This photograph shows new technology being demonstrated at NASA's new visitor center, installed in 1984. With a touch of the button on the phone that corresponded to the number of a featured advertised business, spoken directions and information were provided and printed. (Courtesy of CLACC.)

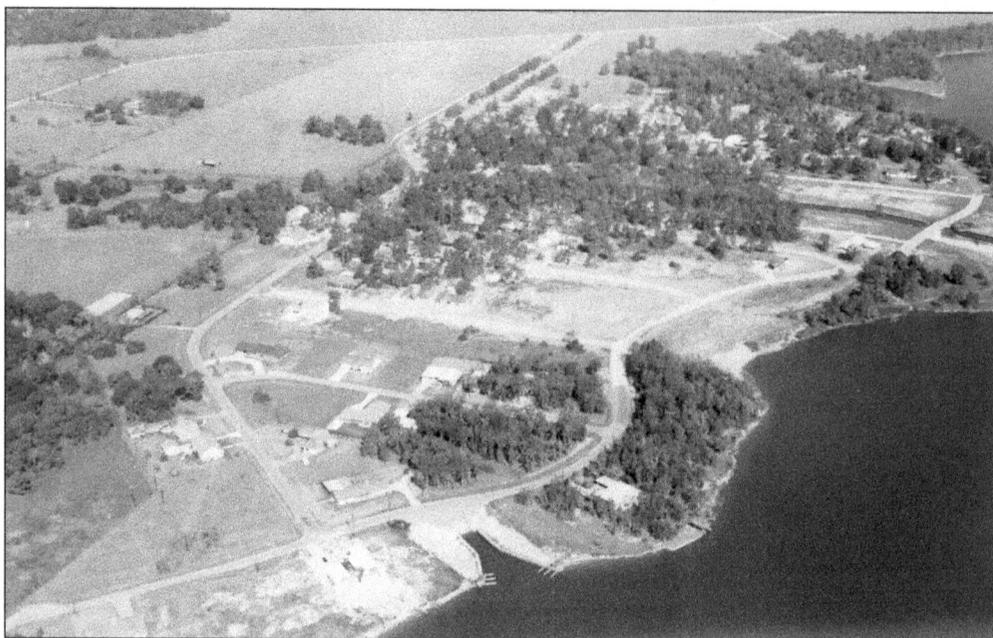

Taylor Lake Village developed in the area shown in this photograph fronting Taylor Lake, which bears the namesake of Anson Taylor, a noted pirate who traveled with Jean Lafitte. It was incorporated in 1961. Because of the development of the Manned Spacecraft Center, Houston was interested in annexing the area around Clear Lake. In response, the local communities banded together and formed townships like Taylor Lake Village, which was originally part of the Ritson Morris League. The city is mostly made up of subdivisions with single-family homes. (Courtesy of Taylor Lake Village.)

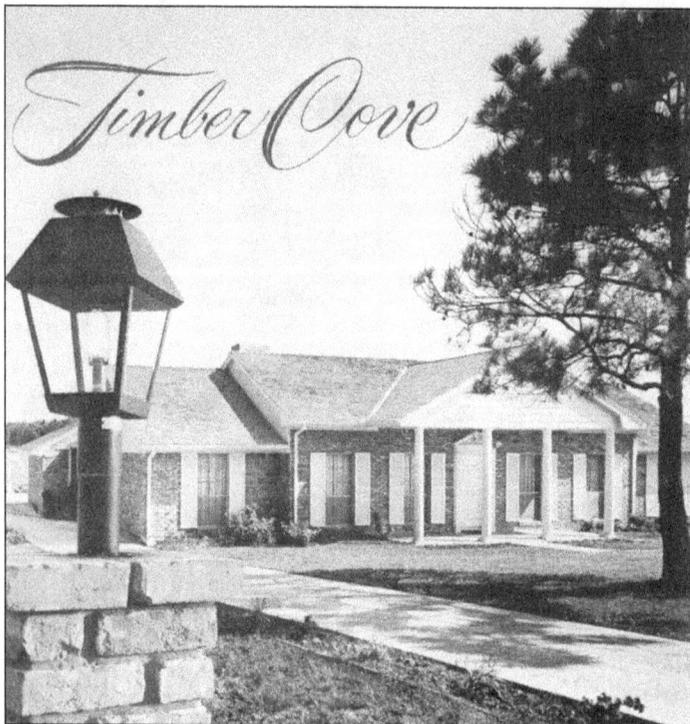

This advertisement promoted Timber Cove as the premier development in Taylor Lake Village. It offered homes on beautiful wooded lots with canals for boat access in the backyard. The first and second Americans to orbit the earth, John H. Glenn Jr. and Navy commander M. Scott Carpenter, lived side-by-side on a canal lot. Gus Grissom, Gordon Cooper, and Walter Schirra also lived in Timber Cove. Together, they asked for the neighborhood swimming pool to be shaped like the Gemini capsule, and it was. (Courtesy of Taylor Lake Village.)

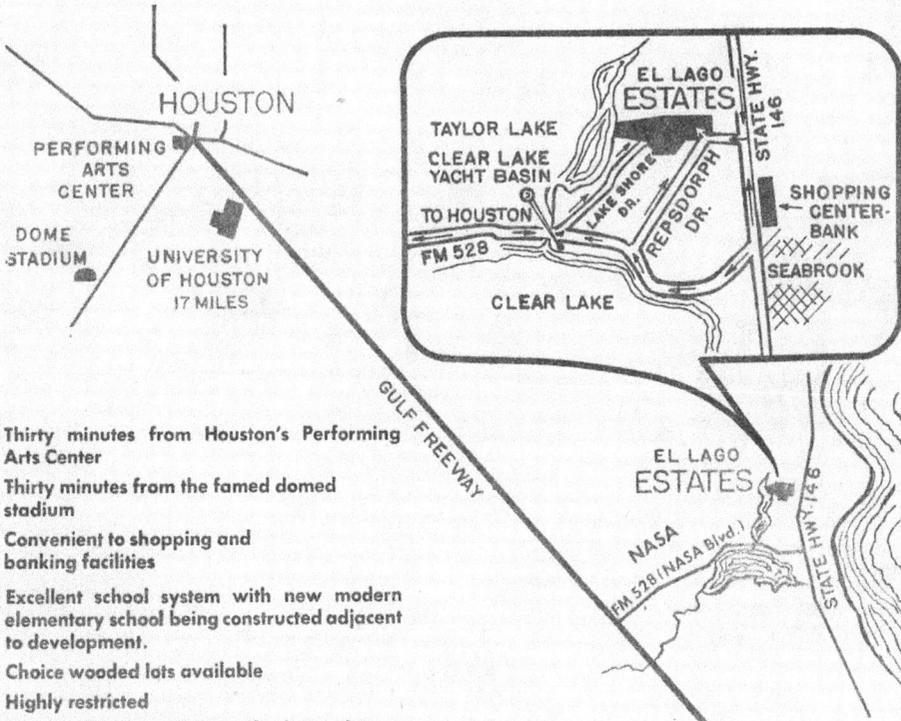

EL LAGO
ESTATES

HOUSTON

PERFORMING
ARTS
CENTER

DOME
STADIUM

UNIVERSITY
OF HOUSTON
17 MILES

EL LAGO
ESTATES

TAYLOR LAKE

CLEAR LAKE
YACHT BASIN

TO HOUSTON

FM 528

CLEAR LAKE

STATE HWY. 146

LAKE SHORE DR.

REPSDORPH DR.

SHOPPING
CENTER-
BANK

SEABROOK

GULF FREEWAY

EL LAGO
ESTATES

NASA

FM 528 (NASA Blvd.)

STATE HWY 146

- Thirty minutes from Houston's Performing Arts Center
- Thirty minutes from the famed domed stadium
- Convenient to shopping and banking facilities
- Excellent school system with new modern elementary school being constructed adjacent to development.
- Choice wooded lots available
- Highly restricted
- Bowling lanes, auditorium facilities, theatre only six miles away in La Porte.
- Recreation park and boat launch for exclusive use of residents.
- Twenty eight foot curb and gutter streets . . . no open drainage.
- Close to NASA and Ellington Field.
- Two hundred thirty five lots adjacent to Taylor Lake.

For more information call El Lago Estates

HU 8-2333

The concept for a modern planned community to house the influx of NASA employees began in 1962 under the guidance of the Friendswood Development Company, which was created by Humble Oil and the Webb Corporation. In that same year, El Lago became an incorporated city. It referred to itself as "the City of Astronauts," and the successes and tragedies of astronauts affected the community as a whole. The Space Hall of Fame was created by the El Lago Historical Society to preserve this unique history. (Courtesy of CLACC.)

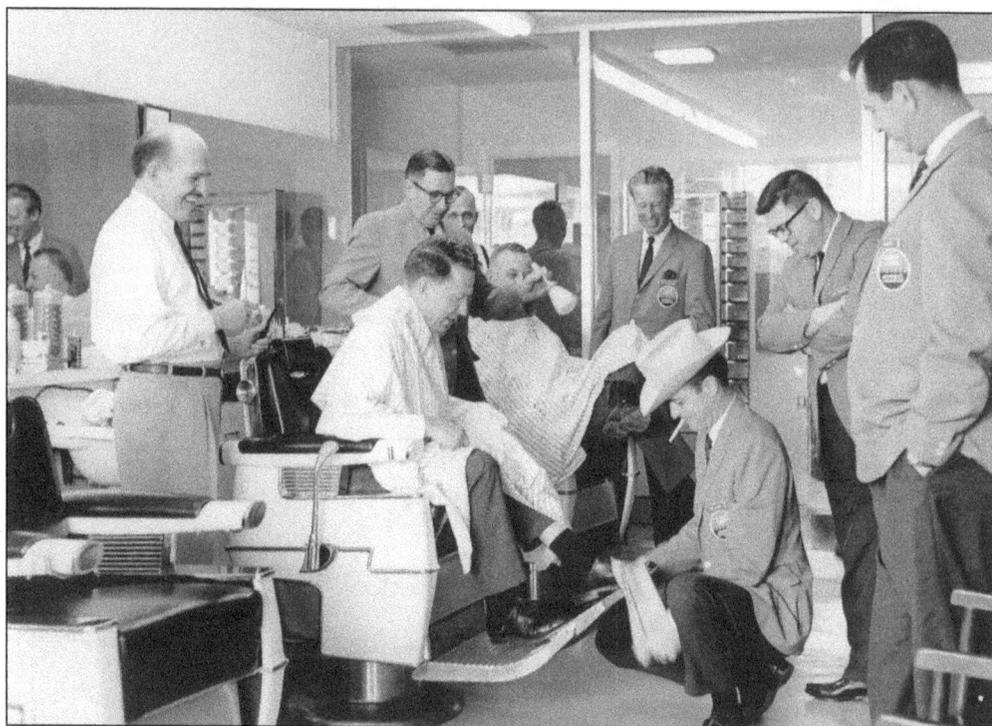

The men in these photographs wearing identical jackets with the Clear Lake Area Chamber of Commerce emblem prominently displayed were the official welcoming committee for the chamber from its inception in 1962. The coats were blue in color, thus giving the group of 25 men their official title, the Blue Coats. They were charged with the responsibility of officially greeting all new businessmen in the area and representing the chamber at ground-breaking ceremonies, city hall dedications, and other events. They also traveled to other cities and states to tell the Clear Lake story. Below, from left to right, are Mel Safer, Ray Williams, Harry Smith, Roy Holbrook, Eugene Lindquist, and Phil Hamburger. (Both courtesy of CLACC.)

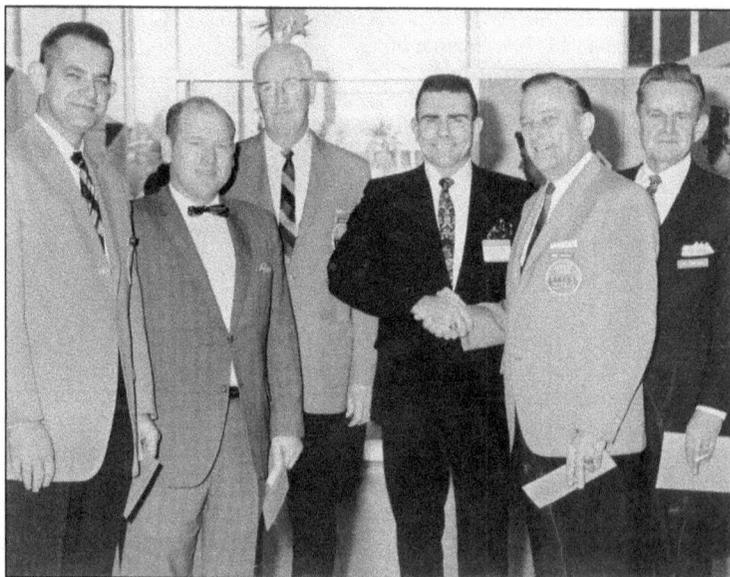

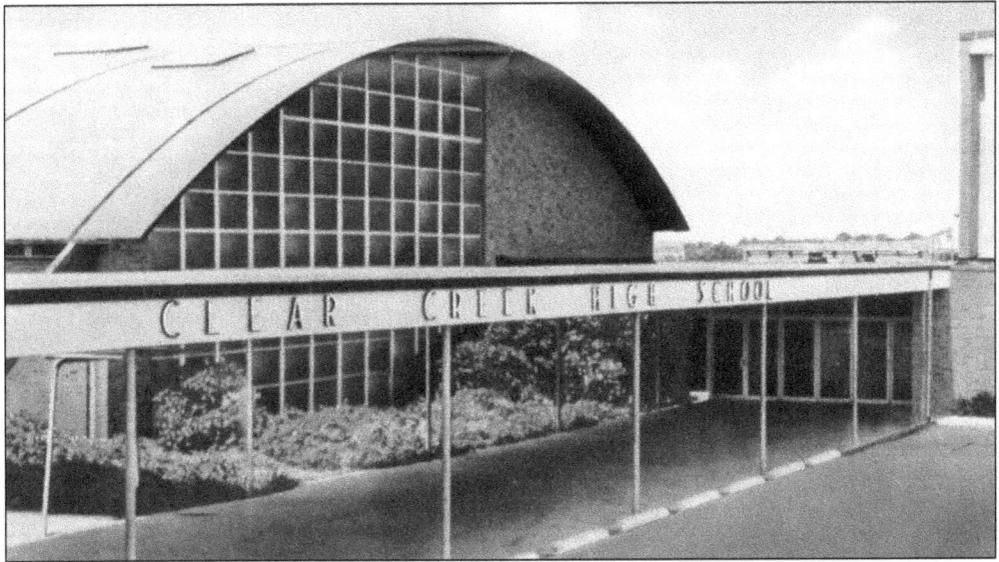

In the early 1960s, the Kemah, Seabrook, Webster, and League City school districts consolidated, forming the Clear Creek Independent School District. By September 1964, more than 4,000 pupils were enrolled in the district, which consisted of a high school in League City (seen here), a junior high school in Webster, and elementary schools in Clear Lake City, League City, Webster, Seabrook, and Kemah. (Courtesy of CLACC.)

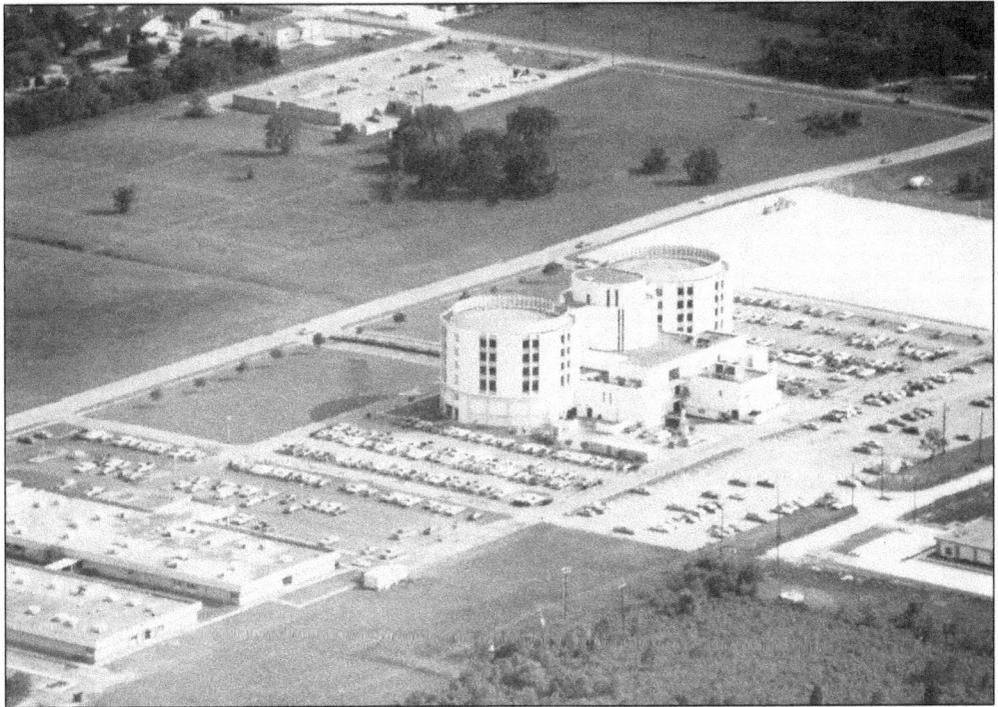

In 1972, an ultra-modern 150-bed hospital was built in Webster with an attached "shell" for future expansion. However, within weeks of opening, the hospital was filled to capacity, and the interior of the "shell" was finished within three years. Currently, the hospital is part of the Clear Lake Regional Medical Center. (Courtesy of CLACC.)

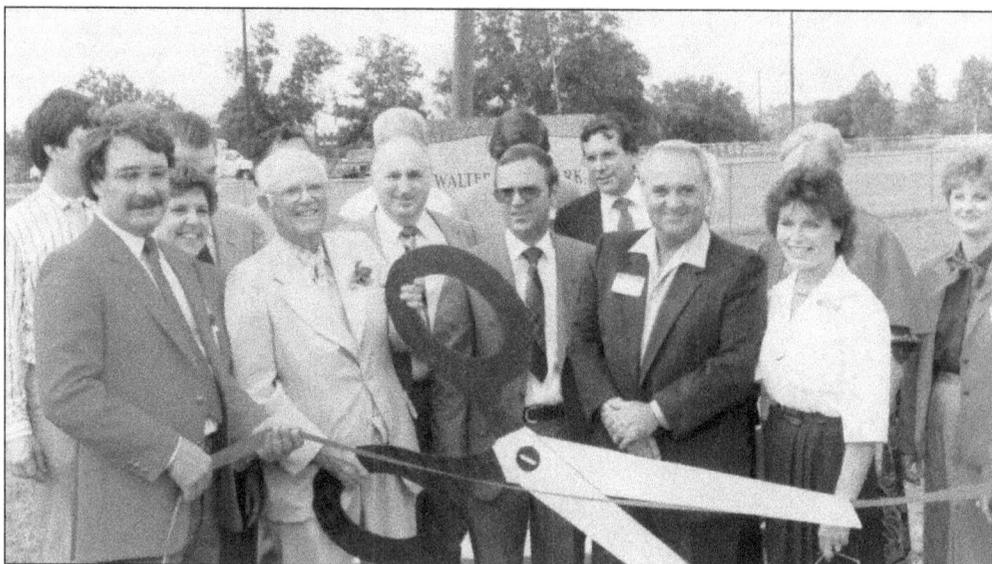

Walter Hall (in a white suit holding scissors) poses with other participants at the Walter Hall Park dedication ceremony. Hall owned controlling interest in the Citizen State Bank and, later, owned banks in League City, Dickinson, Webster, and Alvin. He is credited with incorporating League City schools and the surrounding schools into the Clear Creek Independent School District in 1948. (Photograph by Albert Kiecke; courtesy of League City Helen Hall Library.)

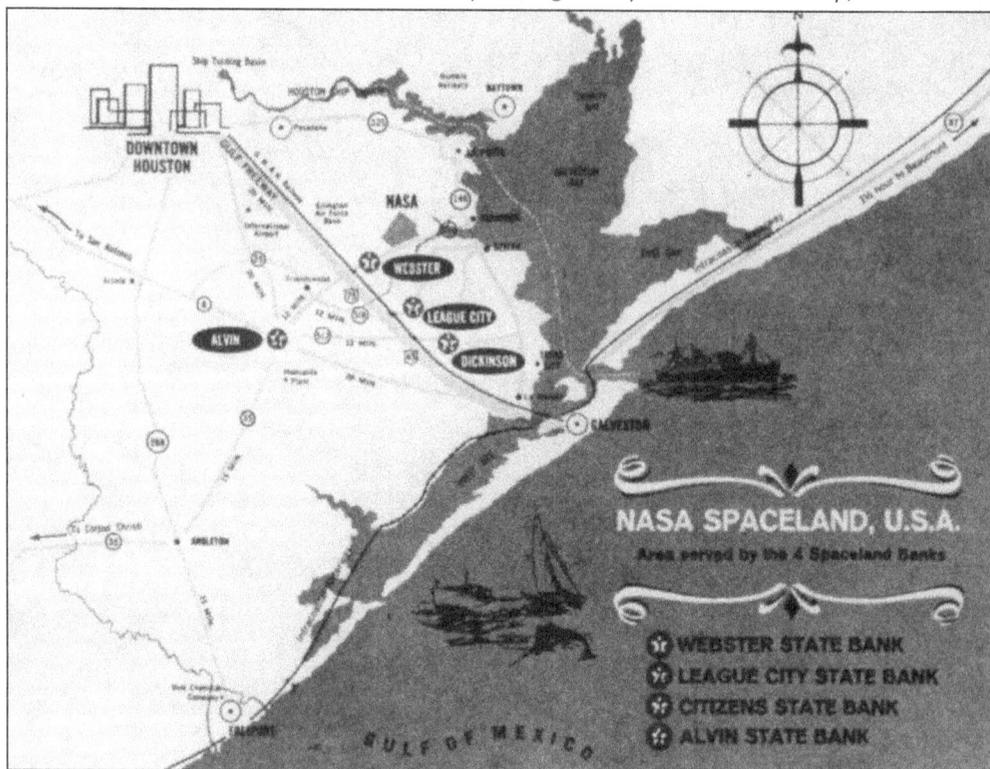

Walter Hall named the area around the Manned Spacecraft Center NASA Spaceland, USA, in this 1964 advertisement for his banks, which served the area. (Courtesy of CLACC.)

90

On February 6, 1964, the *Spaceland Star* newspaper announced that the Harris County Houston Ship Channel Navigation District would build a new channel and port facilities on Galveston Bay at the site of the former West Ranch. Humble Oil planned an industrial district along with the port, which was to be called Bayport. This photograph shows Clear Lake Area Chamber of Commerce "Blue Coats" welcoming the development. (Courtesy of CLACC.)

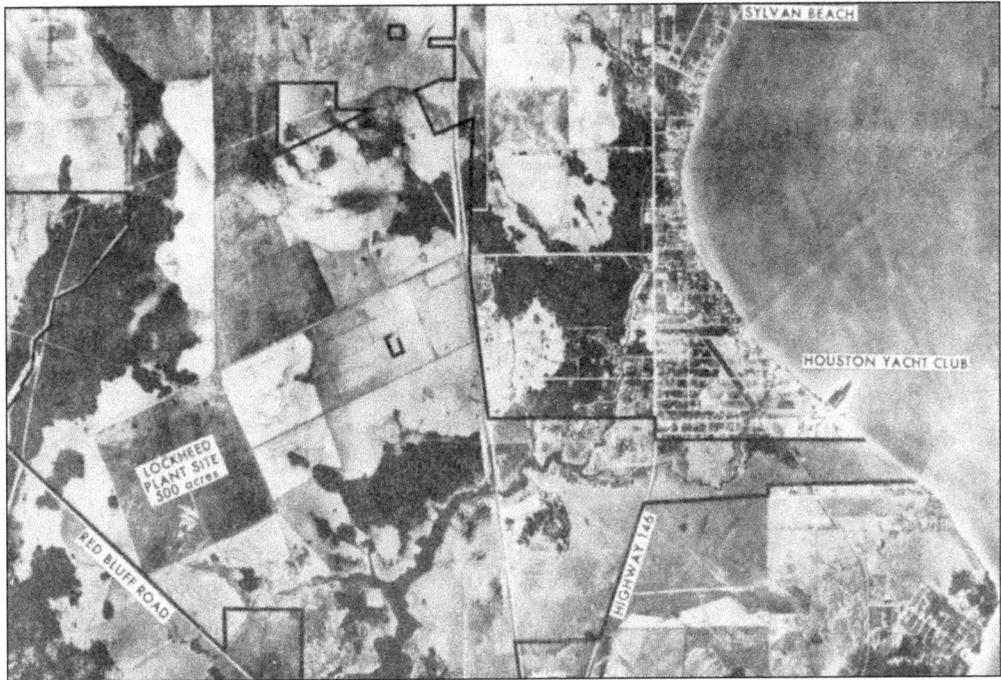

Humble Oil donated 725 acres just north of Seabrook for the new Bayport industrial district in 1964, making it a total of 7,250 acres. The area is seen in this aerial photograph taken west of the Houston Yacht Club. The tremendous project, with an initial cost of $30 million, brought a new labor force of 25,000 people into the area and was the economic trigger needed to launch the Clear Lake Area. (Courtesy of CLACC.)

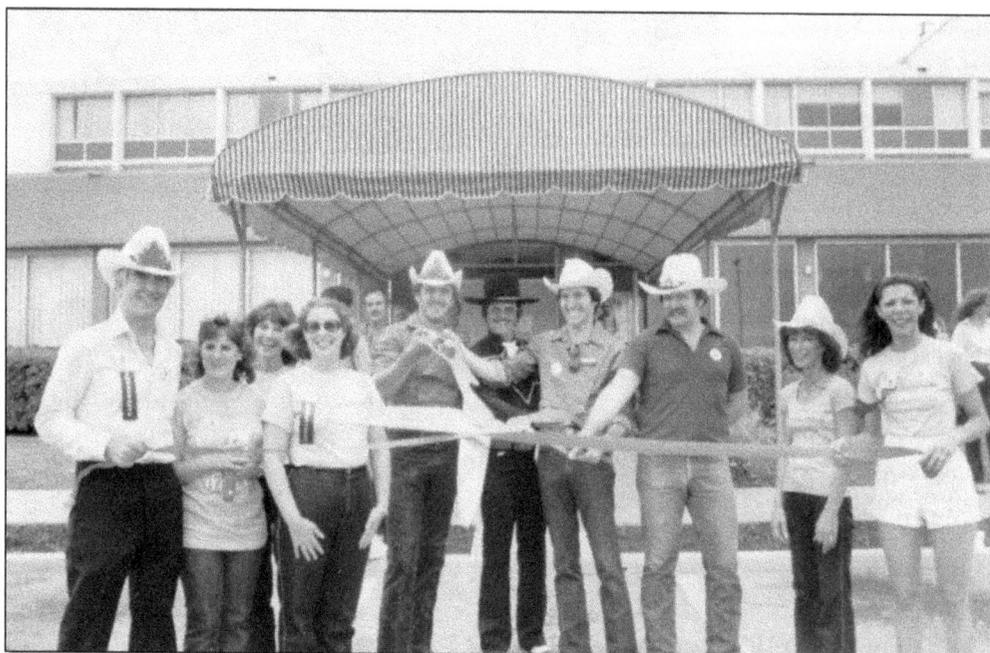

The grand opening of the Holiday Inn Ballroom in the early 1980s was attended by delegates from the Clear Lake Area Chamber of Commerce. A Texas-style welcoming was held for the hotel, located across the street from NASA. This building was later demolished to make way for new development. (Courtesy of CLACC.)

The Nassau Bay Resort Inn was built in the 1960s across the street from NASA. Television reporters such as Walter Cronkite reported the news about space missions as they were happening from the hotel. The hotel was demolished in the 1990s to make way for road expansion and new developments. (Courtesy of CLACC.)

The Hilton Hotel began construction on the north side of Clear Lake, across from the space center, in 1981. The new hotel was the first concrete-and-steel-beam high-rise hotel built overlooking Clear Lake. The tall structure forever changed the skyline of the area. (Courtesy of CLACC.)

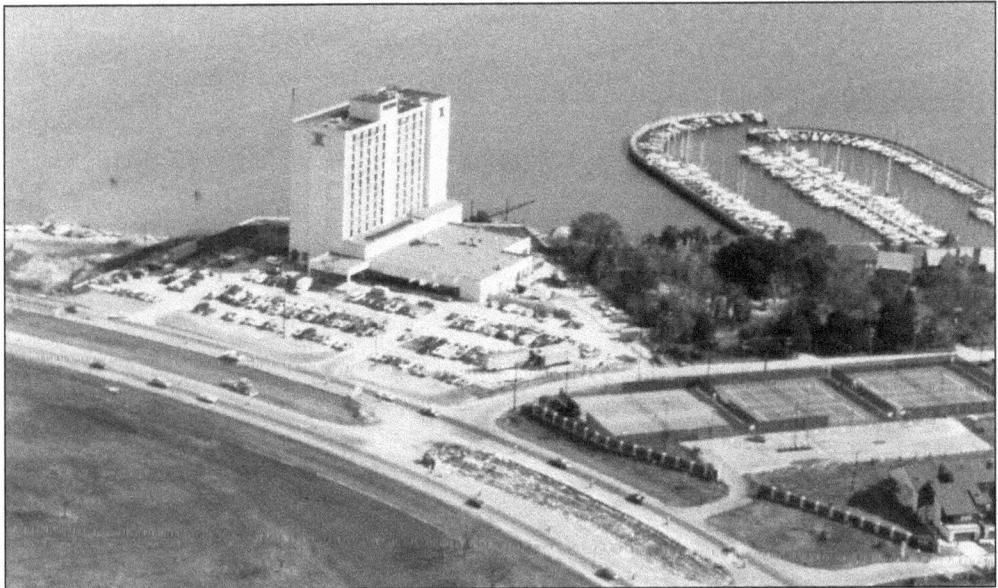

On March 12, 1983, the Nassau Bay Hilton Hotel celebrated its grand opening with a gala ball chaired by Maggie Plumb DeNike. In an article in the *Exchange News*, she said of the celebration, "Clear Lake's 400 will enjoy the biggest party of the spring." Tickets for the event were $150 a piece and space was limited to 400 people. The Hilton provided the new facility as a venue to raise money for the Bay Area Museum. (Courtesy of CLACC.)

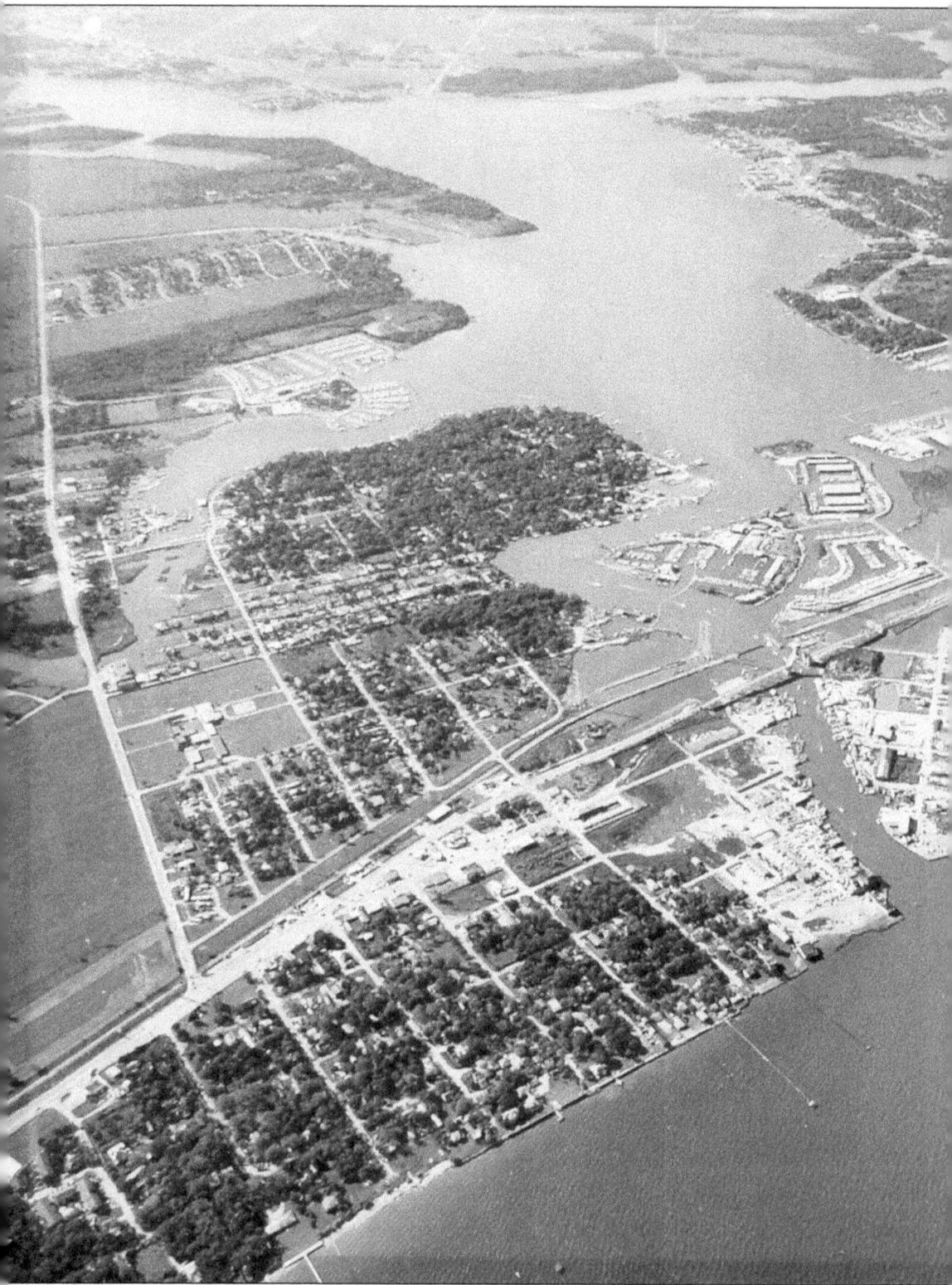

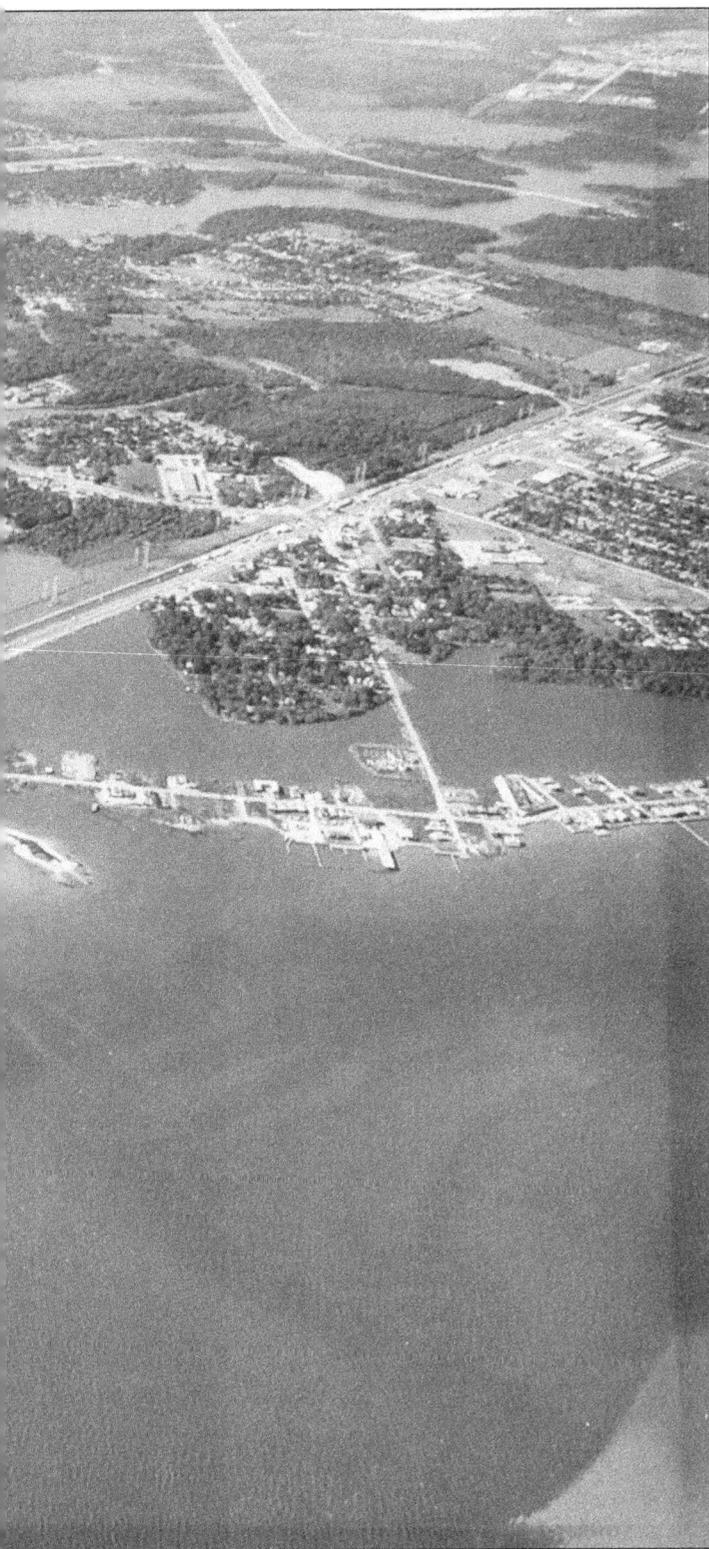

This photograph was taken in the late 1960s, around the time Neil Armstrong spoke to Mission Control at NASA from the lunar surface. The large body of water in the upper part of the photograph is Clear Lake, and the larger body of water in the bottom is Galveston Bay. The small inlet between the two is Clear Creek Channel. Harris County is on the north side of the lake, and Galveston County is on the south side. The space center is located in the middle, on the north side of the lake, along with the new subdivisions of Clear Lake City, Nassau Bay, Taylor Lake Village, and El Lago. Older communities such as Clear Lake Shores and League City are on the south side, with Webster in the top left. Kemah is on the south side of the inlet, with Seabrook on the north side. The area is wooded and green with small bodies of water feeding into the lake, making an attractive area for waterfront development with easy access to water-related recreational activities. (Courtesy of CLACC.)

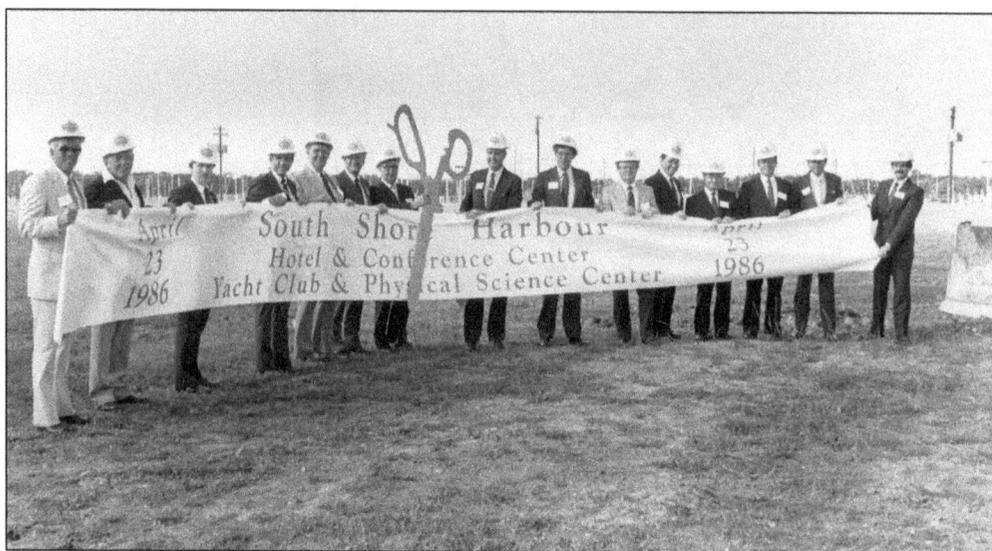

Above, the Clear Lake Area Chamber of Commerce ambassadors were on hand to celebrate the official ground-breaking ceremony for the South Shore Harbour Hotel and Conference Center, held on April 23, 1986. The South Shore Harbour development began as a $1-billion, 1,500-acre project offering residential and commercial areas, sports clubs for golf, tennis, health, and fitness, and a resort hotel and conference center. The development is located on the south shore of Clear Lake in League City. In 1983, Bob Hope was honored at the Shamrock Hotel in an event hosted by Adm. Alan B. Shepard (left). It was the first formal meeting of the South Shore Harbour Golf Club's board of governors, and Hope was officially placed on the board. (Both courtesy of CLACC.)

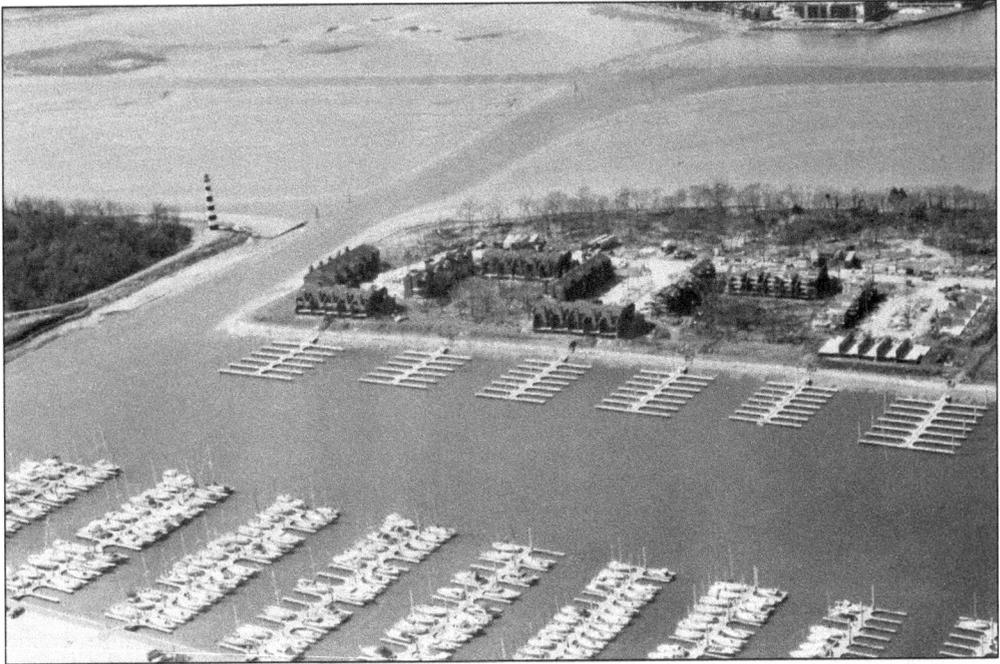

In 1984, Phase II of the South Shore Harbour Marina development began, led by local developer R.B. "Bob" Taylor. A total of 530 additional slips, from 30 feet long to 60 feet long, were added. The marina was the first in the area constructed exclusively with a laminated floating dock system. When Hurricane Alicia hit in August 1983, every boat in the marina escaped undamaged because of the floating dock system and its protected location on the south shore of Clear Lake. (Courtesy of CLACC.)

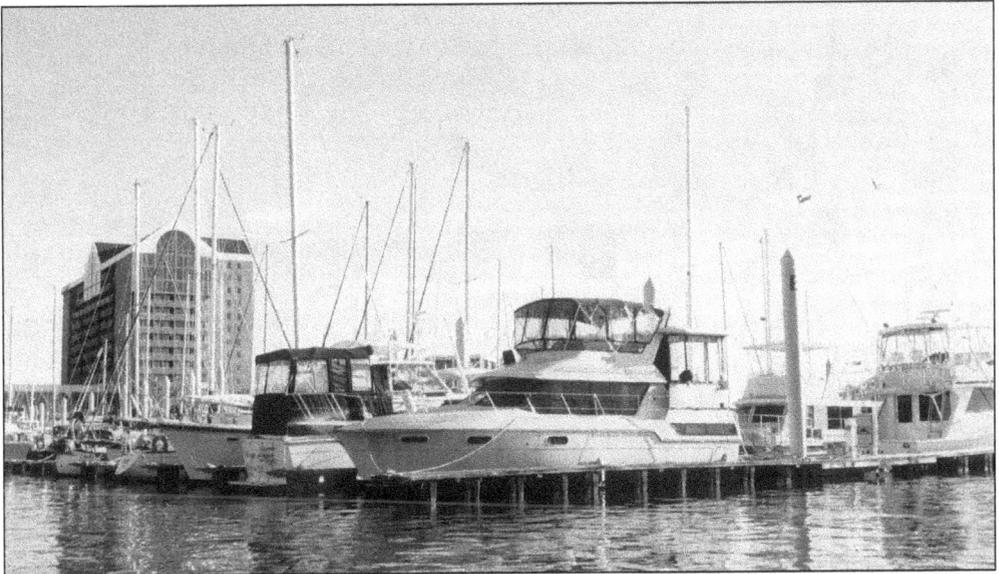

The South Shore Harbour Marina and Hotel has been a major attraction on the south shore of Clear Lake from its beginnings in the 1980s through today. In 1984, an announcement was made about five new homebuilders for the development. Homes from 2,400 square feet to 5,000 square feet were offered at prices from $160,000 to $265,000. (Courtesy of Ruth Burke.)

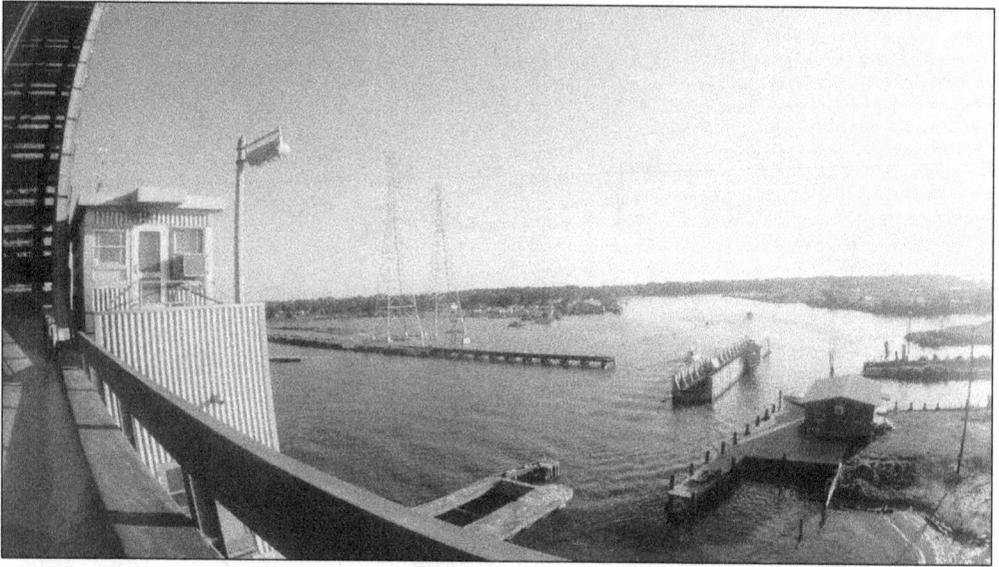

The Southern Pacific Railroad built the first swing bridge in 1907 on the line that ran from Houston to Galveston along Highway 146. The swing trestle allowed boats to navigate from Galveston Bay into Clear Lake, while automobile traffic was ferried across the channel in the early days. The photograph shows the railroad bridge as it looked from the top of the drawbridge in 1979. This is the second drawbridge constructed over this passage. In 1986 a fixed-span bridge opened. (Courtesy of Ruth Burke.)

On April 1, 1987, the removal of the old Southern Pacific Railroad trestle swing bridge spanning the Clear Creek Channel began. The removal was a 15-year effort by members of the Clear Lake Area Chamber of Commerce and the communities of Clear Lake. The railroad structure had become a hazard to modern navigation, and the removal allowed vessels safe two-way passage for the entire length of the channel from Clear Lake to Galveston Bay. (Courtesy of CLACC.)

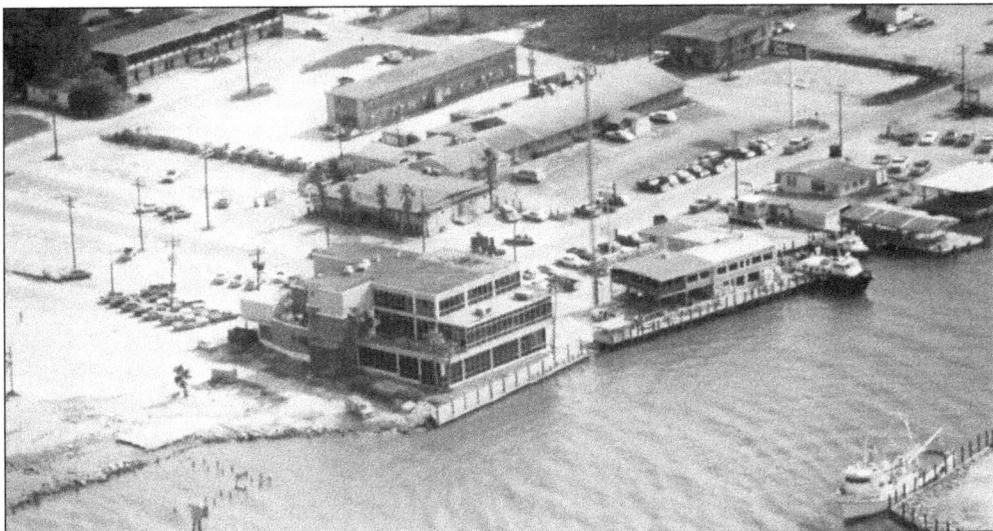

This photograph shows the restaurants located near the Clear Creek Channel in Kemah in the early 1980s, before Hurricane Alicia hit in 1983. The three-story restaurant is the famous Jimmie Walker's Edgewater Restaurant, built after Hurricane Carla in 1961. The low white building behind the waterfront is the Clear Creek Inn, a successful family-owned restaurant for 44 years, and in front, on the water, is Joe Lee's, which opened in 1979. The area in the distance was dredged in the late 1980s for a marina. (Courtesy of CLACC.)

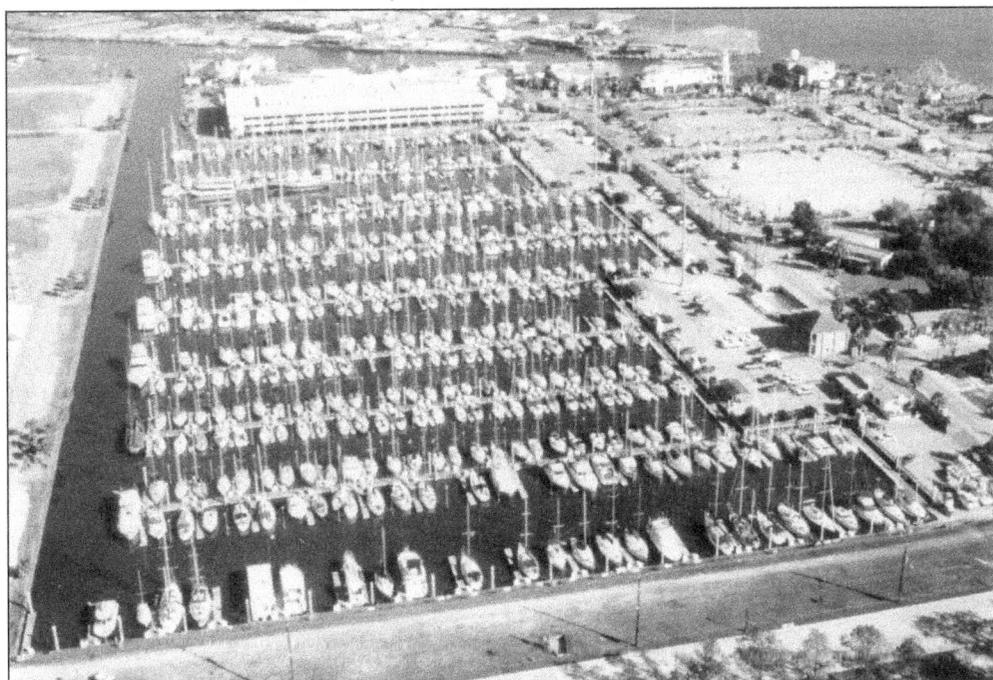

The area south of the waterfront in Kemah was affected by subsidence, which resulted in persistent flooding. Mayor Ben Blackledge worked to have the area condemned and turned into a marina development. Named Lafayette Landing, it opened in 1988 with 420 slips for boats up to 90 feet long. Landry's Corporation later acquired the marina and renamed it Kemah Boardwalk Marina, which is seen here around 2001. (Courtesy of CLACC.)

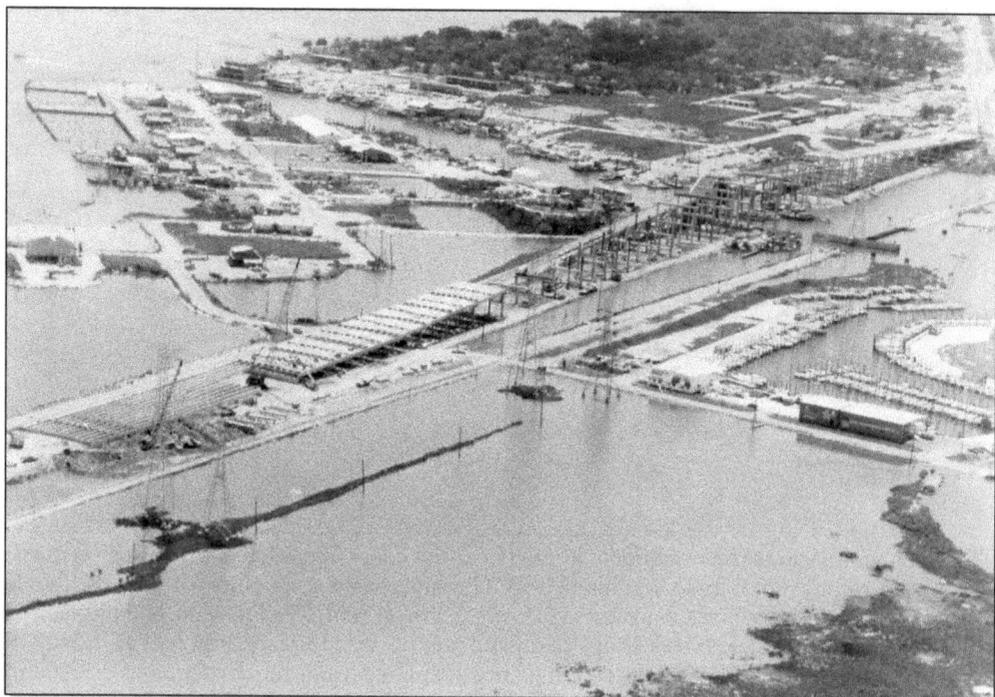

Construction began in 1985 on a fixed-span bridge to replace the two-arm drawbridge that opened in 1961. Due to subsidence and increased recreational sailboat traffic, a bridge that would allow boats with masts higher than 42 feet to pass was needed. The new bridge opened in 1986 to much fanfare. This photograph shows the Kemah (top) and Seabrook (bottom) waterfronts at the time. (Courtesy of CLACC.)

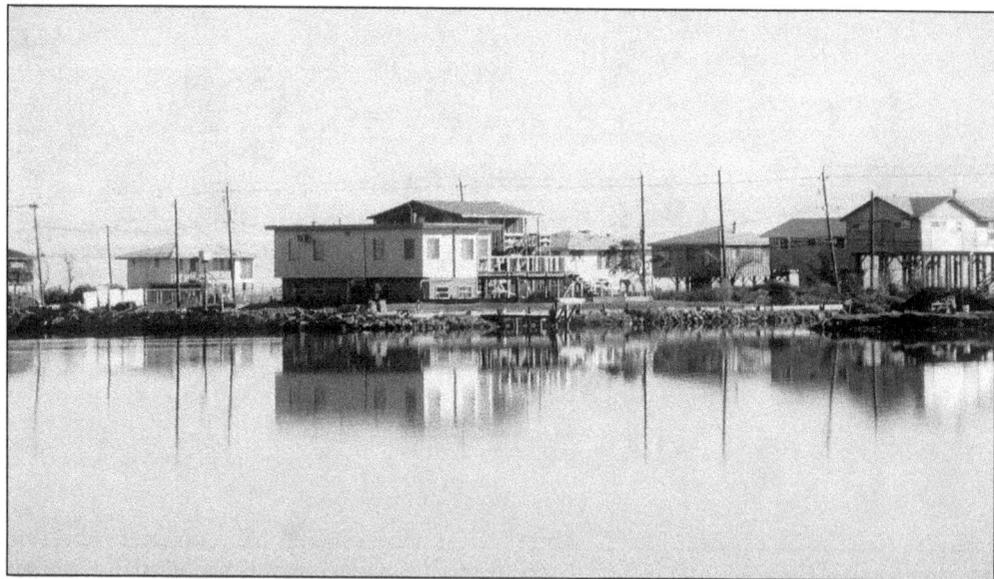

The homes built on stilts along Todville Road in Seabrook, fronting Galveston Bay, are listed in tax records as being in Morris Cove, which was part of the original Ritson Morris land grant. Most of the homes seen in this 1981 photograph were destroyed when Hurricane Ike struck the coast in September 2008. (Courtesy of Ruth Burke.)

In 1989, local artist Ruth Burke (above) opened the Seaside Gallery in the newly developed Old Seabrook area on Second Street. She featured her local photography and offered custom framing services. Her photographs of the Clear Lake Area were published on the covers of local telephone books, magazines, and newspapers. Framed art pieces are also in restaurants, offices, and homes. She expanded her store in 1999 when she moved about two miles west, near NASA Parkway off of Kirby Road in Taylor Lake Village. The photograph below shows the ribbon-cutting ceremony for her new gallery with the Clear Lake Area Chamber of Commerce in 1999. The Seaside Gallery continues to feature local art and serve the community with creative custom framing and printing services while maintaining its local, personal feel. (Both courtesy of CLACC.)

The University of Houston–Clear Lake is located on a 487-acre tract bordered by the Lyndon B. Johnson Space Center and the Armand Bayou Nature Center. Established in 1971 and opened in 1974, the institution began on a 50-acre tract donated by the Friendswood Development Company, a subsidiary of Humble Oil. In 1983, Texas governor Mark White signed a bill changing the name of the University of Houston at Clear Lake City to the University of Houston–Clear Lake. The new name was proudly put on a flag and a patch that was flown aboard the Space Shuttle *Columbia* by Col. John Young. The UHCL flag, which circled the earth 145 times, is now housed in the Neumann Library. (Both courtesy of UHCL University Archives, Photograph Collection, General Photos, UHCL Subjects, University Archives, Neumann Library, University of Houston–Clear Lake.)

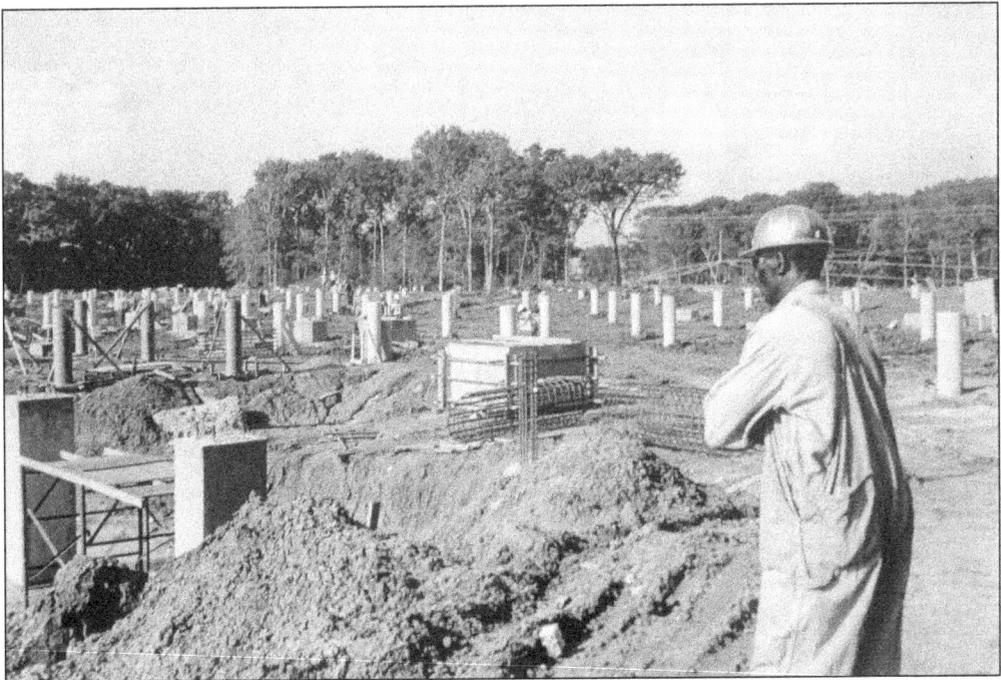

The Bayou Building at the University of Houston at Clear Lake City opened in September 1974, and classes began at UHCLC under the leadership of the institution's founding chancellor, Alfred R. Neumann. The first-day enrollment was 1,069 students, with 60 professors comprising the charter faculty. (Both courtesy of UHCL University Archives, Photograph Collection, General Photos, UHCL Subjects, University Archives, Neumann Library, University of Houston–Clear Lake.)

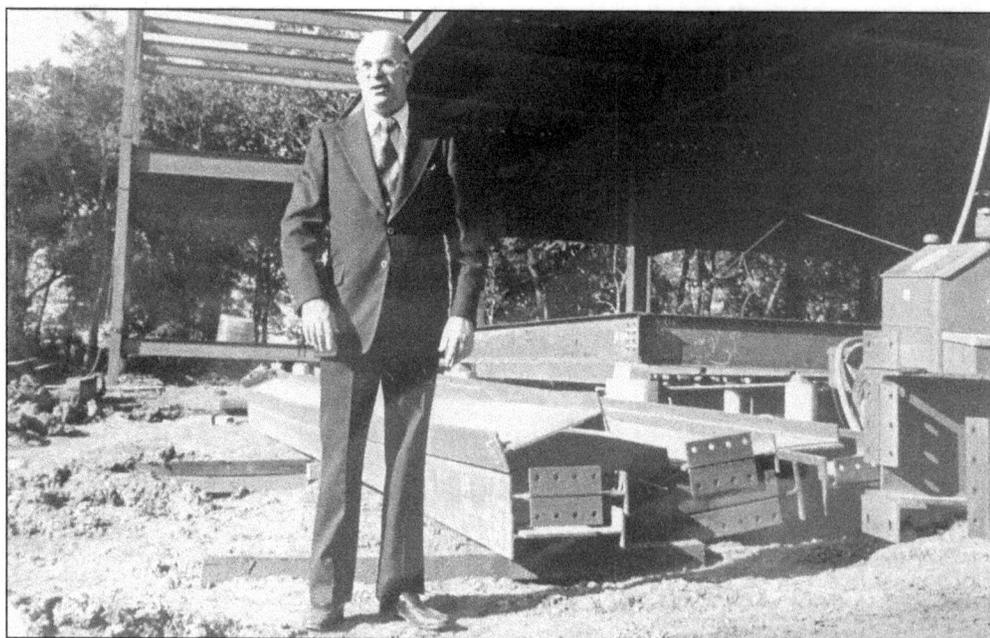

Alfred R. Neumann (above) was the University of Houston at Clear Lake City's founding chancellor, a position he held from 1972 to 1982. According to campus folklore, Neumann and other dignitaries first came to look at the future university site by boat because there were no roads at the time. The boat capsized upon reaching the site, landing them all in Armand Bayou. The Neumann Library occupies 80,000 square feet in the Bayou Building and includes the university archives, which house the NASA Johnson Space Center History Collection. (Both courtesy of UHCL University Archives, Photograph Collection, General Photos, UHCL Subjects, University Archives, Neumann Library, University of Houston–Clear Lake.)

Above, from left to right, Louis Rodriguez, Phillip Hoffman, Gov. Dolph Briscoe, Betty Jane Briscoe, and Selma Neumann are seen during the dedication ceremony for the University of Houston at Clear Lake City in 1974. Selma Neumann graduated from the University of Michigan, receiving her bachelor's and master's degrees in piano performance. While in college, she met Alfred R. Neumann. The two married and moved from Ann Arbor, Michigan, to Houston, where they both taught at the University of Houston. Ultimately, Dr. Neumann became the founding chancellor of University of Houston at Clear Lake City in 1974, and Selma continued his legacy in the bay area upon his death in 1983. Below, Selma Neumann makes a speech during the dedication ceremony. (Both courtesy of UHCL University Archives, Photograph Collection, General Photos, UHCL Subjects, University Archives, Neumann Library, University of Houston–Clear Lake.)

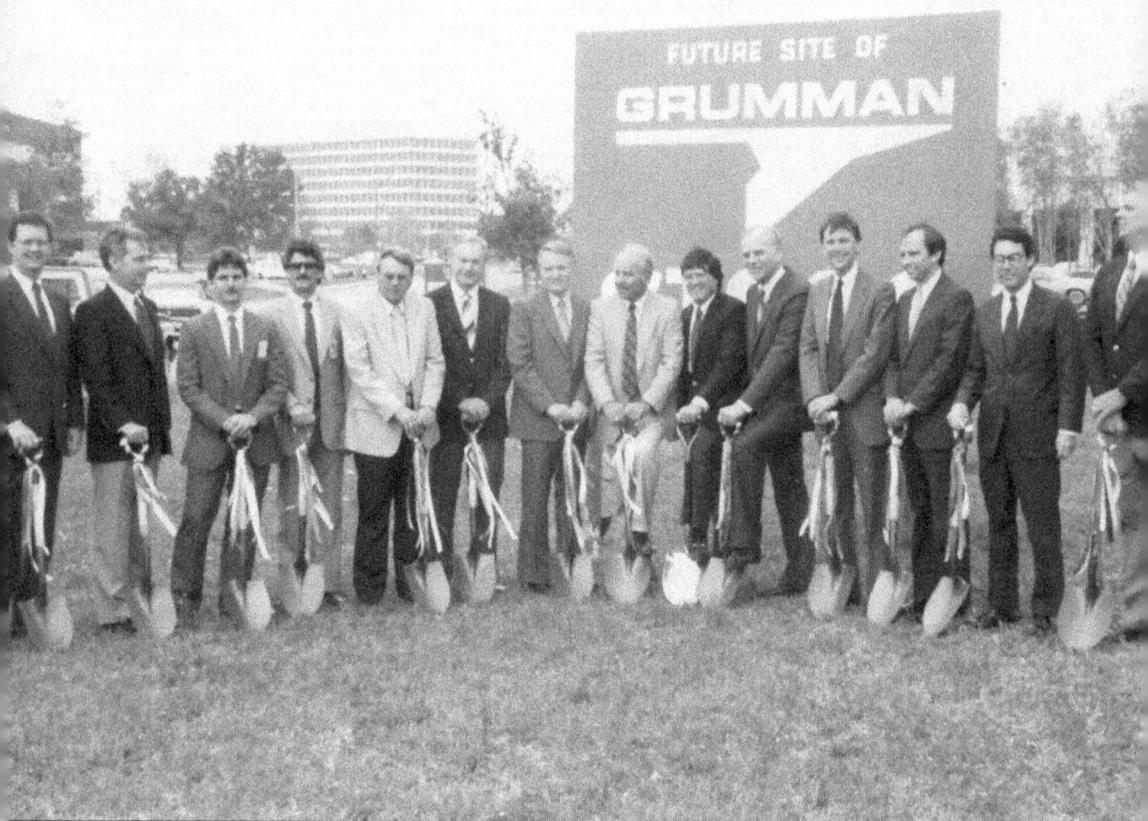

The Grumman Aircraft Engineering Corporation, later renamed the Grumman Aerospace Corporation, was a leading 20th-century producer of military and civilian aircraft. Founded on December 6, 1929, by Leroy Grumman, Jake Swirbul, and William Schwendler, its independent existence ended in 1994 when it was acquired by the Northrop Corporation, creating Northrop Grumman. Grumman was the chief contractor on the Apollo Lunar Module, which landed men on the Moon. It received the contract on November 7, 1962, and built 13 Lunar Modules. As the Apollo program neared its end, Grumman was one of the main competitors for the contract to design and build the Space Shuttle but lost out to Rockwell International. The company ended up involved in the Shuttle program nonetheless as a subcontractor to Rockwell, providing the wings and vertical stabilizer sections. In 1969, the company changed its name to Grumman Aerospace Corporation, and, in 1978, it sold its American division to Gulfstream Aerospace. (Courtesy of CLACC.)

CLEAR LAKE Chamber of Commerce AREA *thanks* METRO AIRLINES FOR 15 YEARS OF CONTINUOUS SERVICE JUNE 16() - JU 8,1984

In 1969, Metro Airlines was founded to serve the Houston area with "cross-town" flights. Houston Metro Airlines constructed its own 2,500-foot short takeoff and landing (STOL) airstrip, along with a passenger terminal building and a maintenance hangar, adjacent to Clear Lake City, near NASA's Johnson Space Center. The Clear Lake City STOLport was essentially Houston Metro's own private airport. The airline's initial route linked Clear Lake City (CLC) with Houston Intercontinental Airport (IAH). According to the February 1976 edition of the *Official Airline Guide* (OAG), the airline was operating 22 round-trip flights every weekday in a passenger shuttle operation between Clear Lake City and Houston Intercontinental. The route system was later expanded to include a number of destinations in southeast and south Texas with flights to Houston Intercontinental. At one point, the airline also flew between Laredo and San Antonio. Metro Airlines later moved its headquarters to north Texas. (Courtesy of CLACC.)

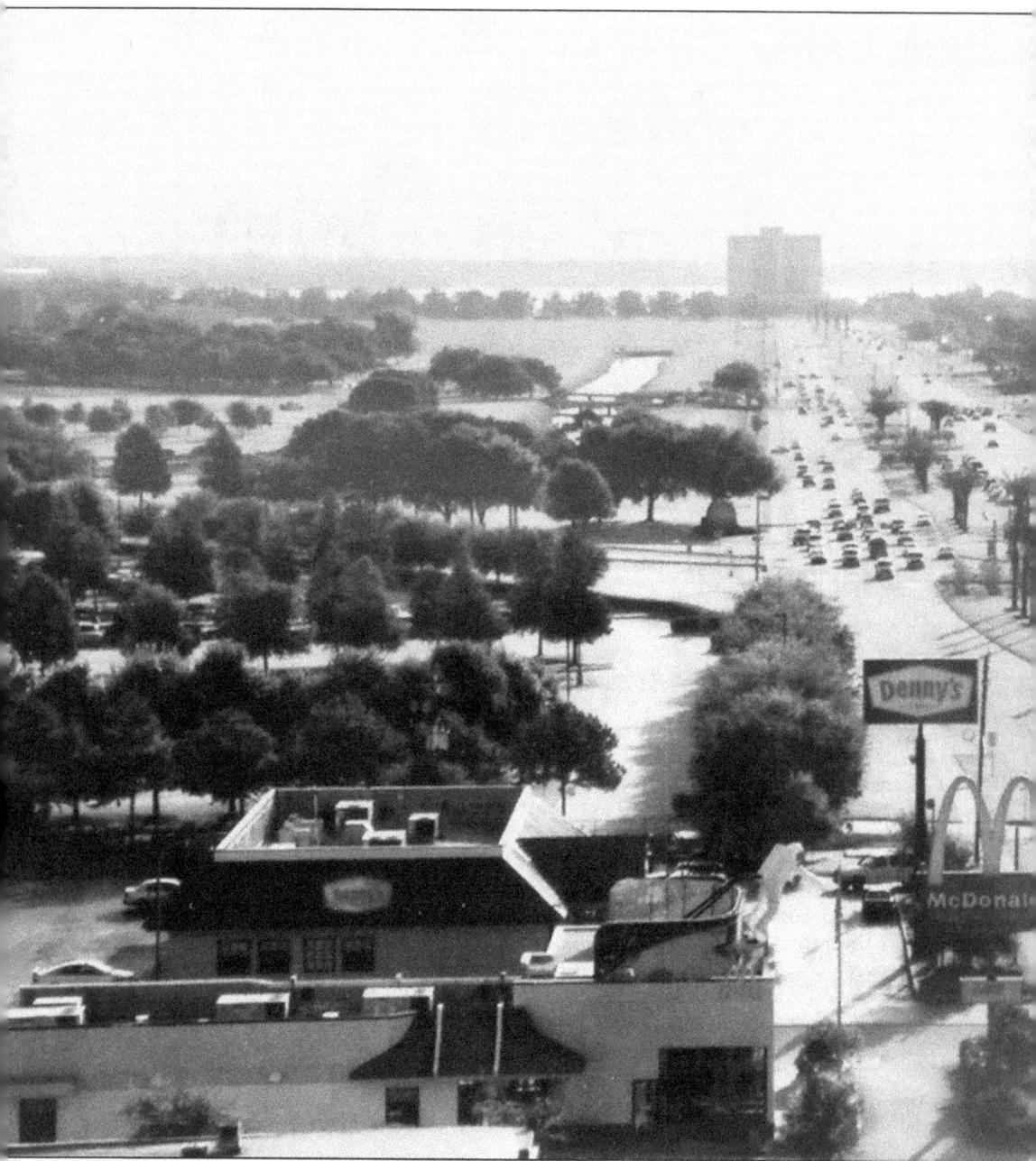

NASA Road 1 is seen in this 2002 photograph of the section that runs in front of the Space Center. The Hilton Hotel is the tall building in the distance, overlooking Clear Lake. The office buildings on the right were demolished in 2007 and replaced with a new mixed-use development.

After the six-lane widening project, NASA Parkway became the road's official name. (Courtesy of Ruth Burke.)

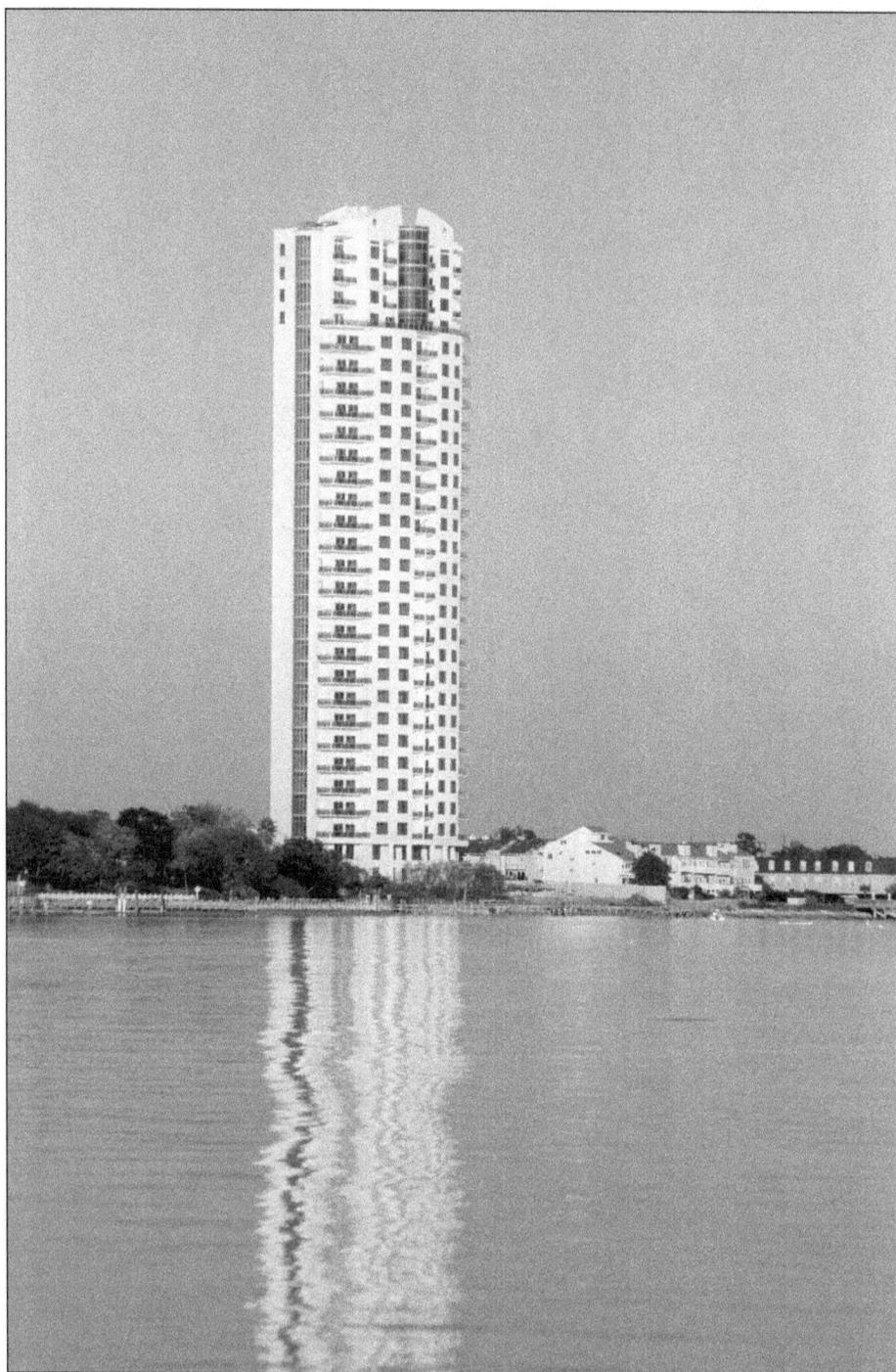

Endeavour Clear Lake is the first waterfront high-rise condominium in Houston's bay area, overlooking the north shore of Clear Lake. Designed by world-class architects in Houston-based EDI Architecture, this 30-story tower is an intimate community of 80 residences, ranging in size from 1,300 to 6,000 square feet. It opened in 2006. The beauty of living on the lake in a resort setting is emphasized in the development. (Courtesy of Ruth Burke.)

Six

CLEAR LAKE EVENTS

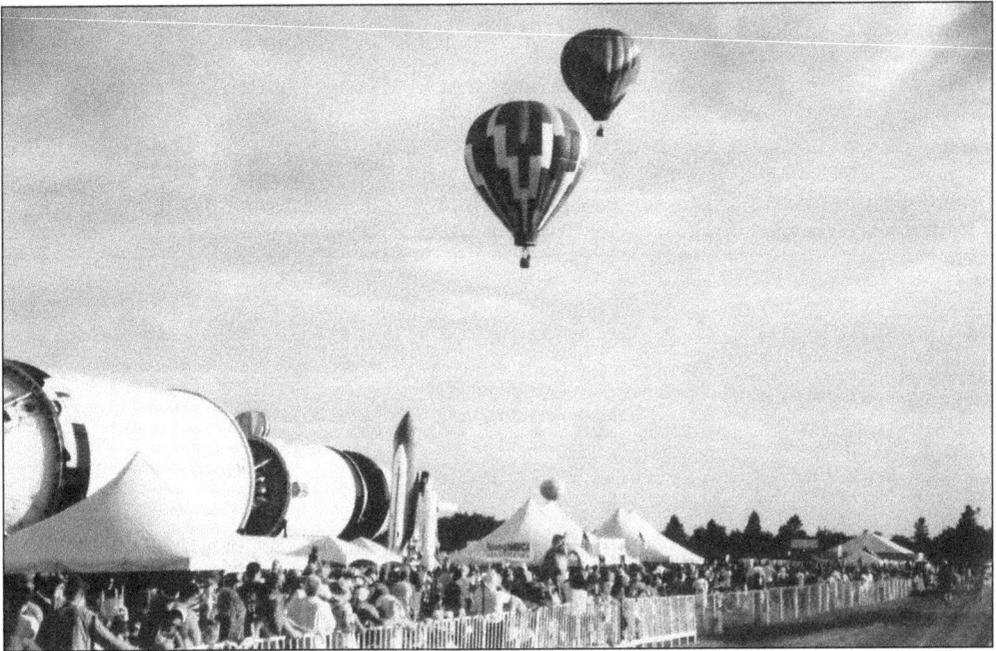

To commemorate the 200th anniversary of the first manned flight in France, Steve Lombardi decided to organize a small rally in celebration of this historical event. His flight of fancy: combine man's first form of flight with today's most technical form of flight and hold the event at NASA's Johnson Space Center. In May 1993, the first meeting was held with Richard Filip and the promotions and public relations department at Space Center Houston. They elected to hold the first annual Ballunar Liftoff Festival that August. RE/MAX Realty of Texas became a major sponsor, and the Clear Lake Area Chamber of Commerce jumped in with its full support. The festival continues to be held at the Johnson Space Center every September. (Courtesy of Ruth Burke.)

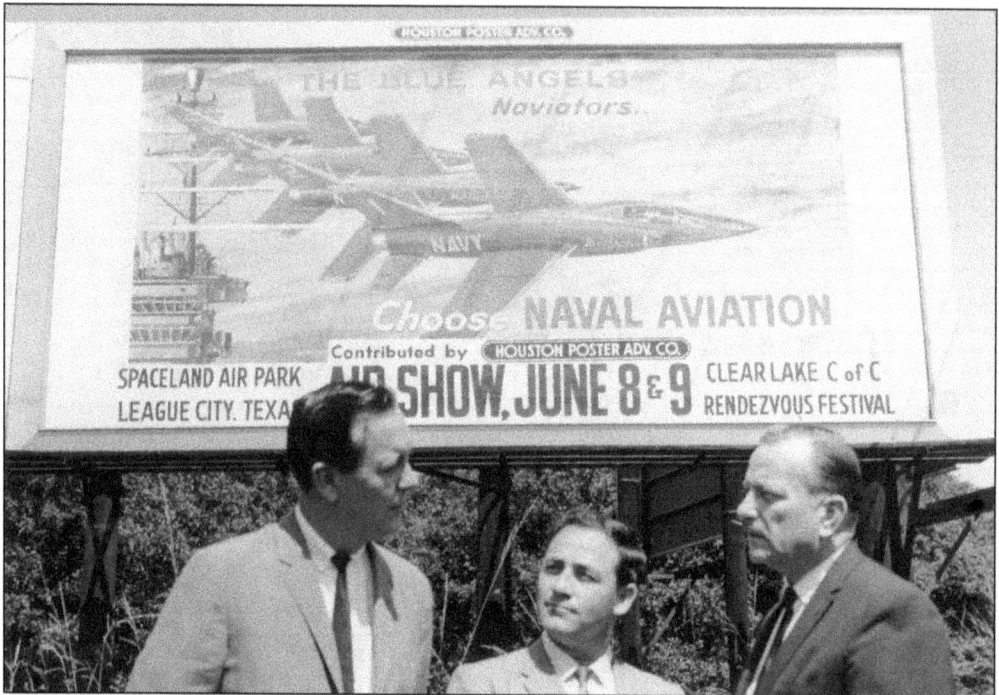

As shown above and below, an aerial performance by US Navy and Marine jet pilots known as the Blue Angels were part of the Lunar Rendezvous celebration held at the Spaceland Airpark in the 1960s. In 1966, Roger Davis, the secretary of the Clear Lake Area Chamber of Commerce at the time, built his own airpark with a 5,000-foot runway off of Farm to Market Road 1266 in League City. He named it Spaceland Airpark, and it was to be used primarily for private planes. The Tuscan Lakes subdivision is currently in this location. (Both courtesy of CLACC.)

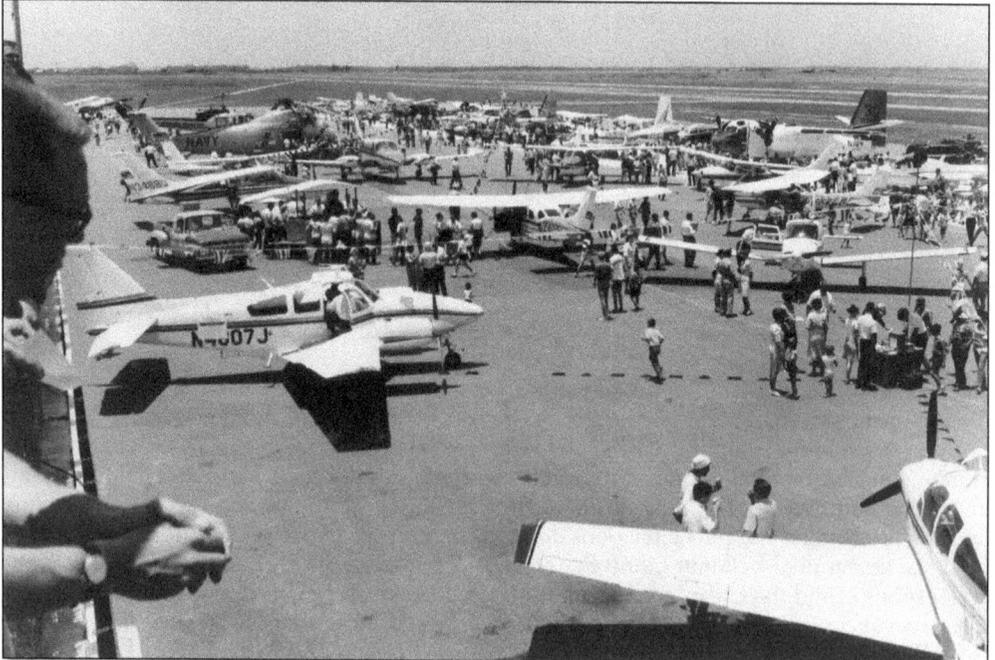

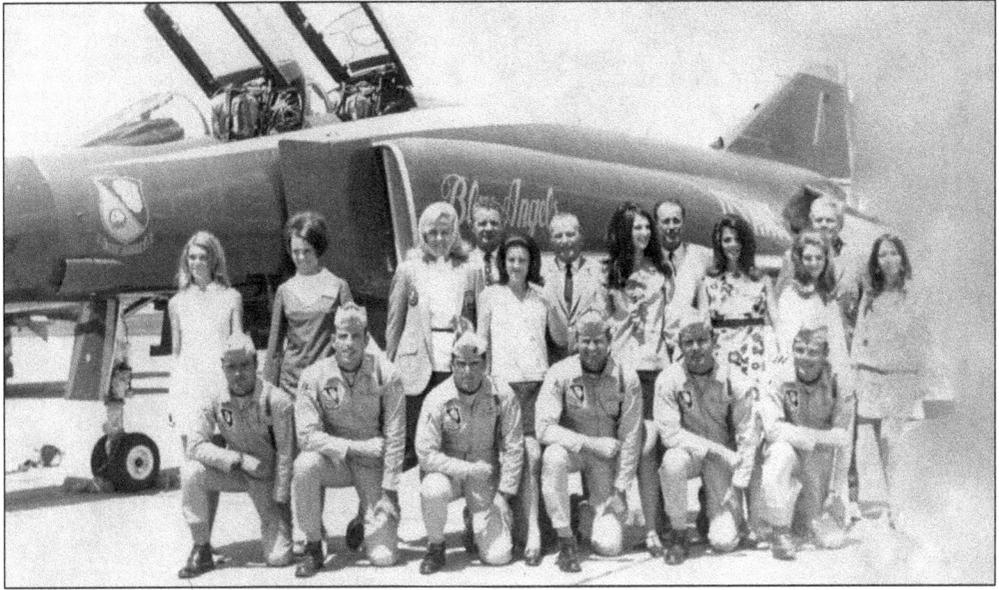

The Clear Lake Area Chamber of Commerce "Blue Coats," some of whom are seen below, were the official welcoming committee when the Blue Angels (above) came to town in the 1960s. Members of the 25-man group in 1966 included local businessmen Tommy Benson, John Bonney, Dick Allen, Don Kirk, Darwin Gilmore, Eugene Lindquist (president), Jack Rowe, Martin Gracey, Ray Williams, Jack Crumpler, Larry Doty, Dr. Jack Birdwell, Pete van der Mayden, Ben Blackledge, Don Heard, Bill Lawson, Joe Camp, Waymon Armstrong, Marvin Pounders, Harry Smith, Bob Robertson, Bruce McCabe, Mel Safer, Bob Chuoke, and Wimpy Wismer, who provided a DC-3 airplane for excursions to other cities and states around the country. (Both courtesy of CLACC.)

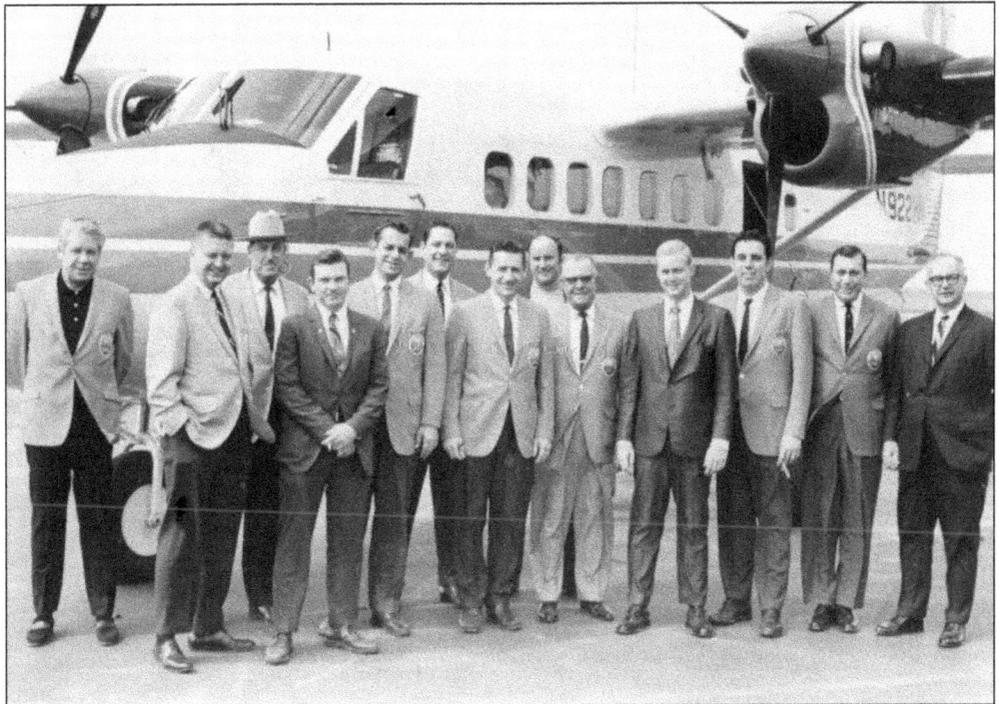

Ross Norman (foreground) was the chairman of the board of the Clear Lake Area Chamber of Commerce from 1980 to 1981. This photograph shows the Budweiser Cydesdales when they came to the Clear Lake Area for the St. Patrick's Day parade. They are marching down NASA Road 1 in front of the Sheraton Kings Inn, which was torn down in the 1990s. (Both courtesy of CLACC.)

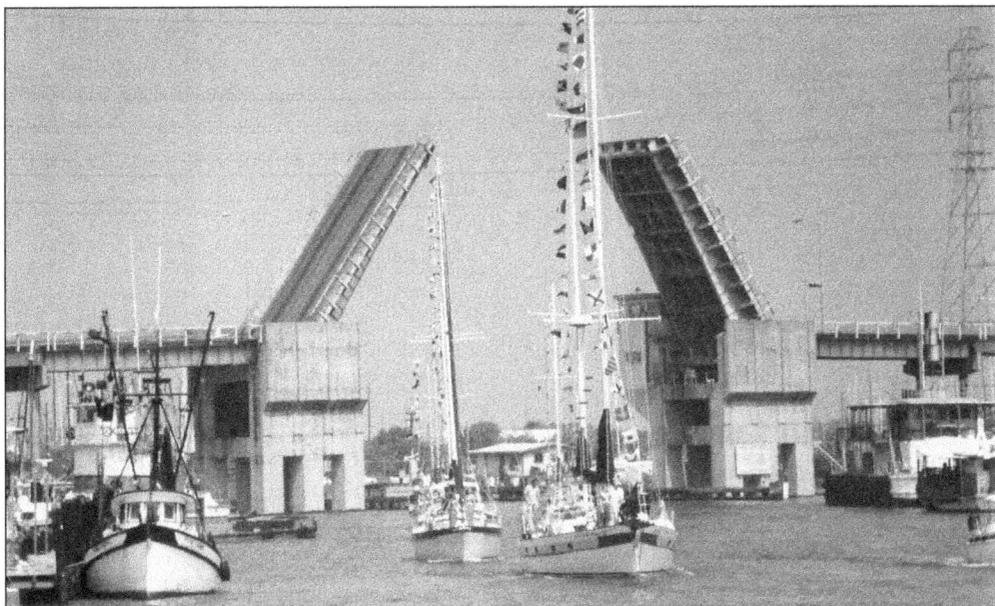

Seen here is a common sight in the 1970s, when the drawbridge opened for sailboats to pass. Sailboats would share in the blessing of the fleet festivities by decorating their boats for the parade. (Courtesy of CLACC.)

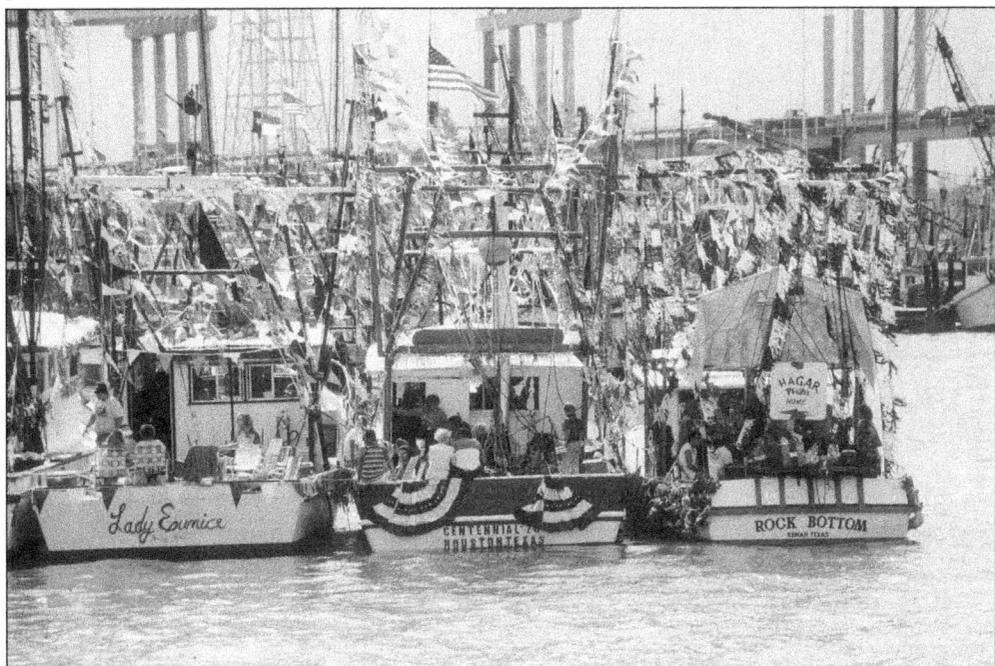

Going back many centuries, the blessing of the fleet is a time-honored tradition. Legends attribute its origins back to ancient Greek fishermen. Predominantly Catholic, a local priest performs the blessing to ensure a safe and bountiful season. In Texas, the tradition is performed in July marking the start of the commercial shrimp season. The cities of Kemah and Seabrook have celebrated the blessing of the fleet for over 45 years. The celebrations include an on-the-water parade of vessels and a mass. (Courtesy of Ruth Burke.)

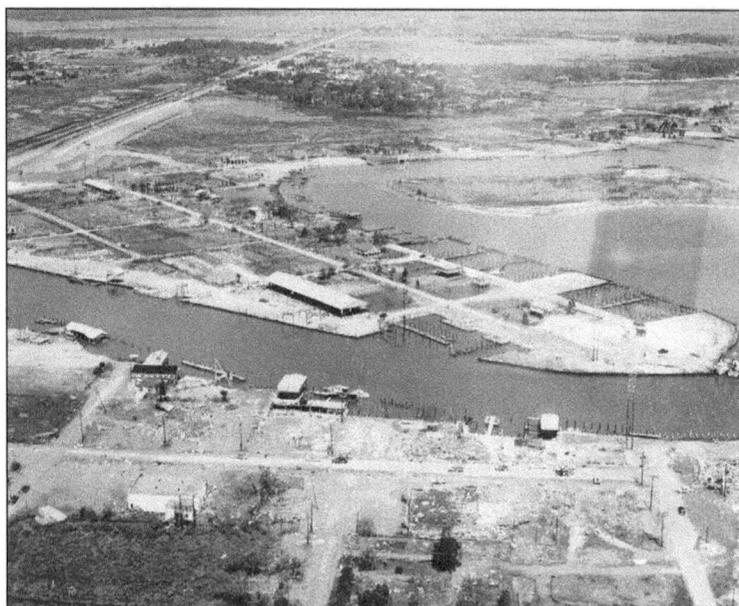

On September 11, 1961, Hurricane Carla approached the upper Texas coast as a category four storm. It devastated the cities and communities around Clear Lake. This photograph shows that just a few buildings were left in Seabrook and Kemah along the Clear Creek Channel, which feeds from Clear Lake into Galveston Bay. (Courtesy of Ruth Burke.)

On October 22, 2011, the City of Seabrook celebrated its 50th anniversary. Residents of Seabrook and surrounding communities joined in the festivities at Rex Meador Park. The celebration included family activities and a parade. Seen here are Cody Hix (left), two parade volunteers, and Charles Hix (right) with pelicans from the Pelican Path Project parade float. The Hix brothers, of the Lafitte Project, are currently researching the possibility of a family link with the pirate Jean Lafitte. (Courtesy of Rebecca Collins.)

116

In 2011, the Clear Lake Area Chamber of Commerce celebrated 50 years of sponsoring the Christmas boat lane parade, held each year on the second weekend in December. Seen here in the early 1990s at the parade awards brunch is a presentation of the Jack Campbell Award for outstanding committee member. From left to right are Maggie Plumb DeNike, Jim Stoa, Jack Campbell, R.B. "Bob" Taylor, and Jan Brown. (Courtesy of CLACC.)

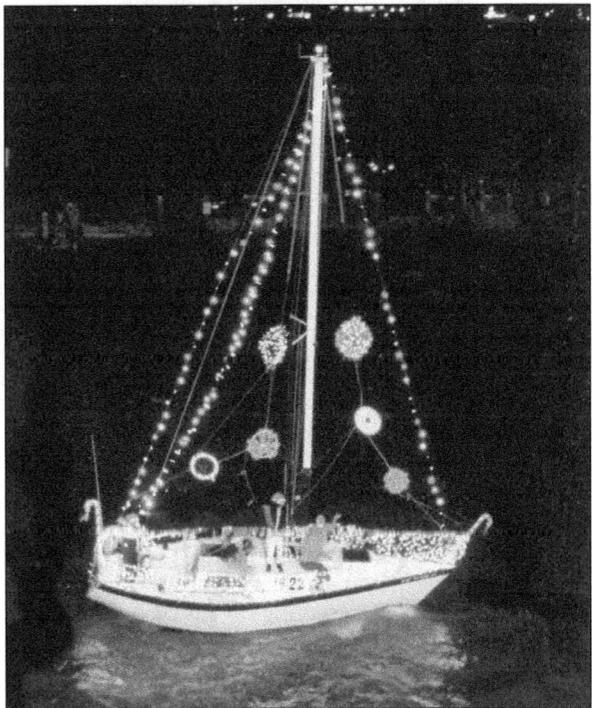

The annual Christmas boat lane parade began in December 1961 with five decorated boats leaving Lakewood Yacht Club for a sail around Clear Lake. Currently, the parade features more than 100 brightly decorated power boats and sailboats that traverse the channel in Clear Lake from the South Shore Harbor Marina through the Clear Creek Channel to Galveston Bay. The parade can be viewed along the shoreline in Seabrook and from the Kemah boardwalk. (Courtesy of CLACC.)

Maggie Plumb DeNike came to the Clear Lake Area in the 1950s, when NASA was hardly a dream. In an interview with the *Clear Lake Shores Pioneer* in 1983, she recalled, "There wasn't anything here, not a thing." She bought a home in Clear Lake Shores and became the driving force behind events that promoted cultural arts in the area. She was a founding member of the Lunar Rendezvous festival and was the first chairperson of the Festival of the Ten Days to Rendezvous in 1966. She started a community theater movement, promoted art festivals, and acted as an early environmentalist, fighting against encroachment by oil wells into Galveston Bay. She was interested in preserving the history of the Clear Lake Area. She accomplished that goal by raising money with the Lunar Rendezvous festival to preserve Webster Presbyterian Church, one of the oldest buildings in the area. The church was moved to Clear Lake Park and became the Bay Area Museum in 1981. (Courtesy of CLACC.)

To honor the space program, the Clear Lake Area Chamber of Commerce formed the Lunar Rendezvous in 1966, an area-wide festival. Richard Allen, a local executive, was elected as the first president. (Courtesy of CLACC.)

Astronaut Jim Lovell Jr. dances with Linda Chadwik, the reigning Lunar Rendezvous queen, at the annual ball. Lovell became famous in 1970 as the commander of the Apollo 13 mission, which suffered a critical failure en route to the Moon but was brought back safely to Earth by the efforts of the crew and Mission Control. (Courtesy of CLACC.)

This 1990s photograph shows, from left to right, Maggie Plumb DeNike, her brother Jack Campbell, and his wife, Betty, at a Lunar Rendezvous function. (Courtesy of CLACC.)

Marcy Fryday, seen here in her Martian costume next to her husband, Jack Fryday, was the director of the Clear Lake Convention and Visitors Bureau (CVB) from 1985 to 1989. The woman in the astronaut costume is Patty Massey, the marketing director of the former Holiday Inn on NASA Parkway, and the gentleman on the far left is Dennis Waggett, the mayor of Webster at the time. They were attending a function for the CVB. (Courtesy of CLACC.)

These photographs are from the 1980s, when fashion shows were held at the Lakewood Yacht Club as part of the Lunar Rendezvous festivities. The shows featured the latest in nautical attire, along with vintage looks for fun. (Both courtesy of Ruth Burke.)

The 1983 Lunar Rendezvous ball was held at the Sylvan Beach Pavilion in La Porte. It was the main fundraiser for the moving and restoration of the Bay Area Museum, which was moved in two parts down NASA Road 1 to Clear Lake Park. It took 10 hours to make the 6.5-mile trip. At the time of the festival, the building had been moved and was in need of funds for plumbing, air-conditioning, and electricity. (Courtesy of Ruth Burke.)

Part of the Lunar Rendezvous celebration was participation in the Houston Livestock Show and Rodeo's annual trail ride, held in February before the rodeo in the Houston Astrodome. Event chairman Jack Birdwell is on the horse. (Courtesy of CLACC.)

The first Webster Presbyterian Church was built in 1896 on the corner of Houston and Moody Streets in Webster. That building was destroyed in the 1900 hurricane, and the second church, completed in 1901, is now the sanctuary side of the Bay Area Museum, as seen below. Through the efforts of the Lunar Rendezvous festival, the church building was acquired and moved to Clear Lake Park on February 22, 1981. The museum, formally dedicated in 1984, houses Lunar Rendezvous memorabilia and changing exhibits that reflect the history of the bay area. Weddings are scheduled in the chapel, and the museum is open to visitors Wednesday through Sunday. Members of the Bay Area Museum Guild arrange activities for the museum. Donations are welcome. (Both courtesy of Ruth Burke.)

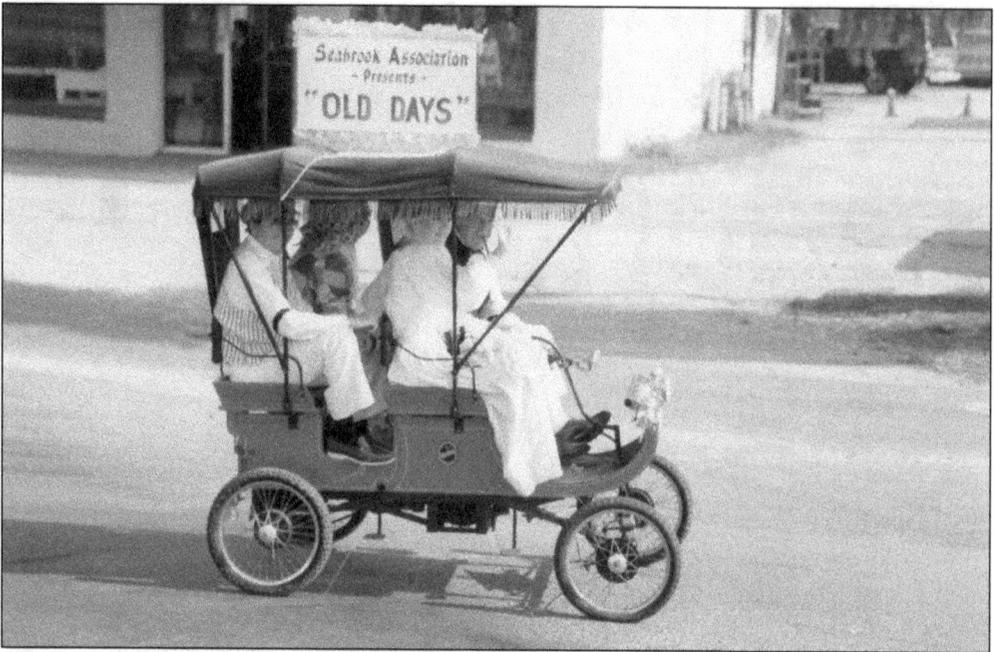

The Seabrook Association was formed in the 1980s to promote business and community activities in Seabrook. An annual festival called the Seabrook Celebration was held each year in October. This photograph shows a parade entry making its way through the intersection of NASA Road 1 and Highway 146. (Courtesy of CLACC.)

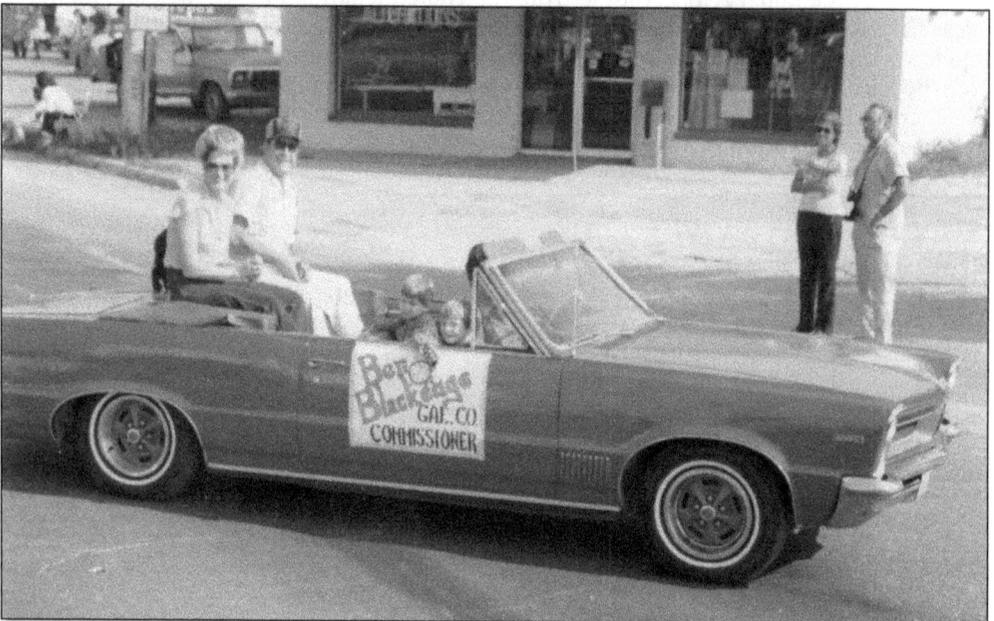

Ben Blackledge is seen here in the parade for the Seabrook Celebration. A former mayor of Kemah, Blackledge was instrumental in getting the Texas Department of Highways to build a new bridge across the channel because of the hundreds of complaints from motorists who stewed and fumed as they waited on both sides of the channel for the drawbridge to be lowered. (Courtesy of CLACC.)

Noted artist Bert Long is seen below doing what he did best, creating an ice sculpture for the Clear Lake Arts Festival in the early 1980s. Above, festival chairman Francie Phelps (far left) makes a presentation to Long. After his death in January 2013, sculptor James Surls commented about his friend to the *Houston Chronicle*, "Bert did ice sculpture in Oakland and made the front page. He did one in Providence, R.I., and made the front page. Everywhere he went he made big ice sculptures and made the front page. And when the sun set through his colored ice, it was just beautiful, like a big window in a cathedral." (Both courtesy of CLACC.)

The world's largest and fastest boats gathered in the Clear Lake Area in 1983 for the Budweiser World Championship Hydroplane Race, which included a $150,000 purse and was presented by CLEAR. Boats from as far away as Australia and Italy were part of the race. The racing format was a first for the thunderboats, which were 30 feet long, 13 feet wide, and capable of reaching 200 miles per hour. The boats threw giant rooster tails of spray high into the air behind them for a city block in length. The event included three days of qualifying runs and 11 racing heats, building to the final race on Sunday, October 2. The race was visible from the banks of Clear Lake, where bleachers were placed for spectators to watch. The man on the right in the top photograph is R.B. "Bob" Taylor, who was the general chairman and the one responsible for the organization of the race. (Above courtesy of CLACC; below courtesy of Ruth Burke.)

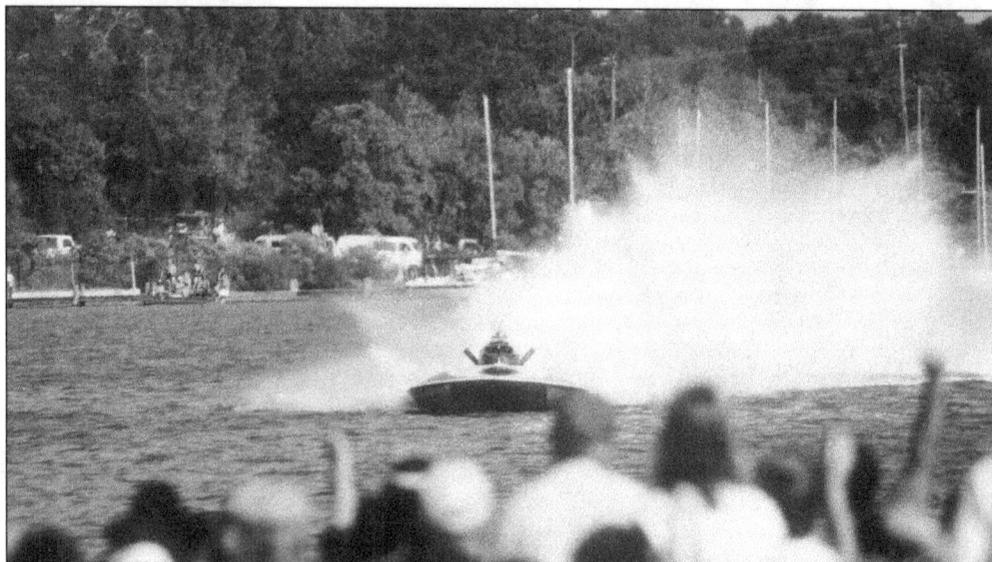

In-the-water boat shows were held at the Watergate Marina, located on Marina Drive on the south shore of Clear Lake. Another marina, Watergate Yachting Center, was built in the 1970s in Clear Lake Shores, near the entrance to Galveston Bay. It is a subdivision on the water with a swimming pool, a laundry center, a clubhouse, walking and biking trails, and playgrounds for members and live-aboards. (Courtesy of Ruth Burke.)

Visit us at
arcadiapublishing.com

www.ingramcontent.com/pod-product-compliance
Lightning Source LLC
Chambersburg PA
CBHW080550110426
42813CB00006B/1273